IRELAND
FROM THE AIR

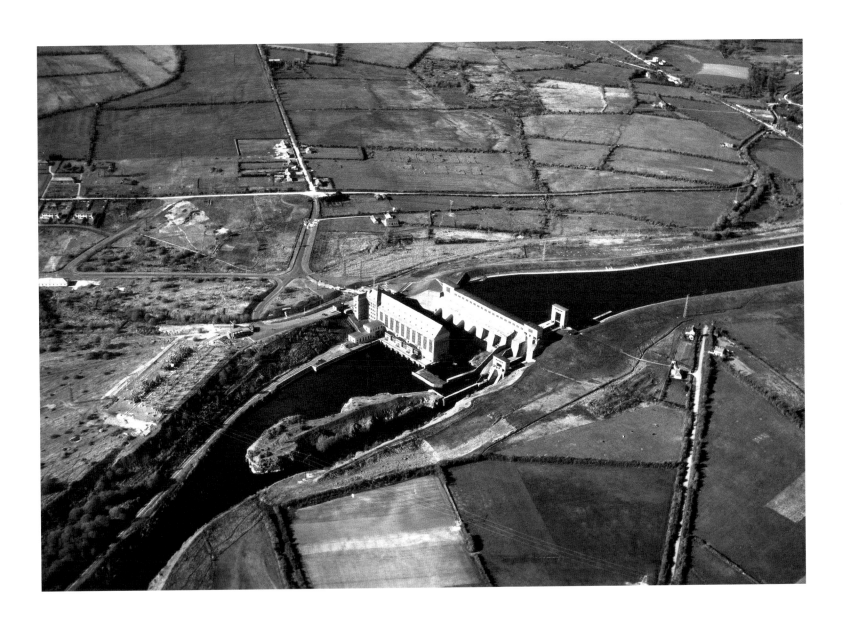

We hope you enjoy the images in this book, all of which are available to purchase from www.independentarchives.com where you can also view the rest of the *Irish Independent* photo archive.

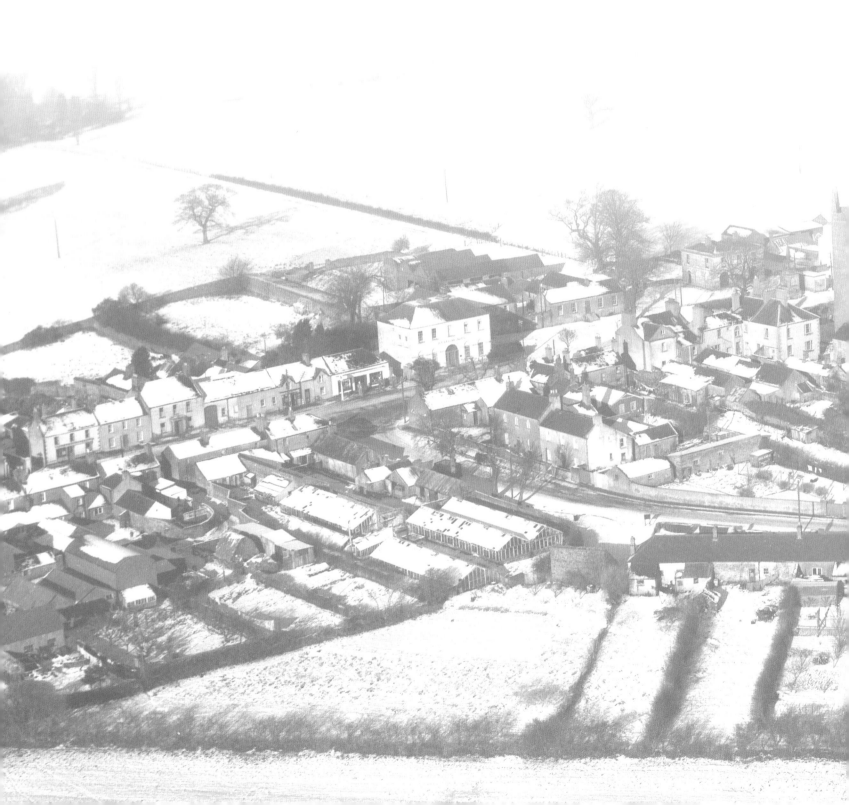

IRELAND
FROM THE AIR

Independent 🎵 Archives

1951–1958

The Collins Press

INTRODUCTION

Twelve years ago Independent Newspapers donated what was left of their entire collection of photographic negatives to the National Library of Ireland. These encompassed the years 1912 to 2000, covering most of the major political and social events of the century.

In 2011, as part of a plan to produce a series of magazines on Ireland from 1950 to 2000, I was tasked with assessing what material was contained in the Independent Collection that we could use. As I was being shown through the collection, I was directed to a series of boxes that held the Morgan collection, which the *Independent* had owned. On asking what the collection actually was, I was informed it contained over 300 aerial photographs taken over the cities, towns and villages of the island of Ireland between 1951 and 1958.

The pictures were taken by Captain Alexander 'Monkey' Campbell Morgan (1919–1958). A wartime pilot for the Royal Artillery Air Corps, he launched a peacetime career in aerial photography before his tragic death in a plane crash after flying from Shannon.

I realised that here was a goldmine of images of Ireland in its formative years as a nation. Until I scanned them I had no idea of what they contained or what areas they covered. I was elated by what we found. Covering the thirty-two counties, they showed an Ireland in transition. Images of old towns and villages caught in time mixed with new housing estates sprouting up around our cities. Places that were once little villages have today developed into sprawling towns surrounding Dublin. Belfast at the Albert Bridge in the 1950s looks nothing like it does today, with a factory, railway yards and a power station replaced by hotels and the Central Station.

On examining the index that was with the negatives I became a bit puzzled as, even though Captain Morgan died in 1958, we were still publishing his pictures in 1959. On investigation, I found the date for each picture is the publication date, not the date the picture was taken. Seemingly we bulk purchased enough pictures to continue publishing nearly two years after his death. Here, they are complemented by the original captions.

This book is a crystal ball into our past. The images are of such high quality that the detail just leaps out. I hope you will be as enthralled by the images as I am. Every time I look at them I see something new: the more you search the more you will see. I hope you get as much pleasure out of reading this book as I have had in compiling it.

I would like to thank the staff of the National Photographic Archive for the excellent work they have done in preserving the Independent Collection for the nation.

Michael Hinch
Archive Adviser to Independent News and Media

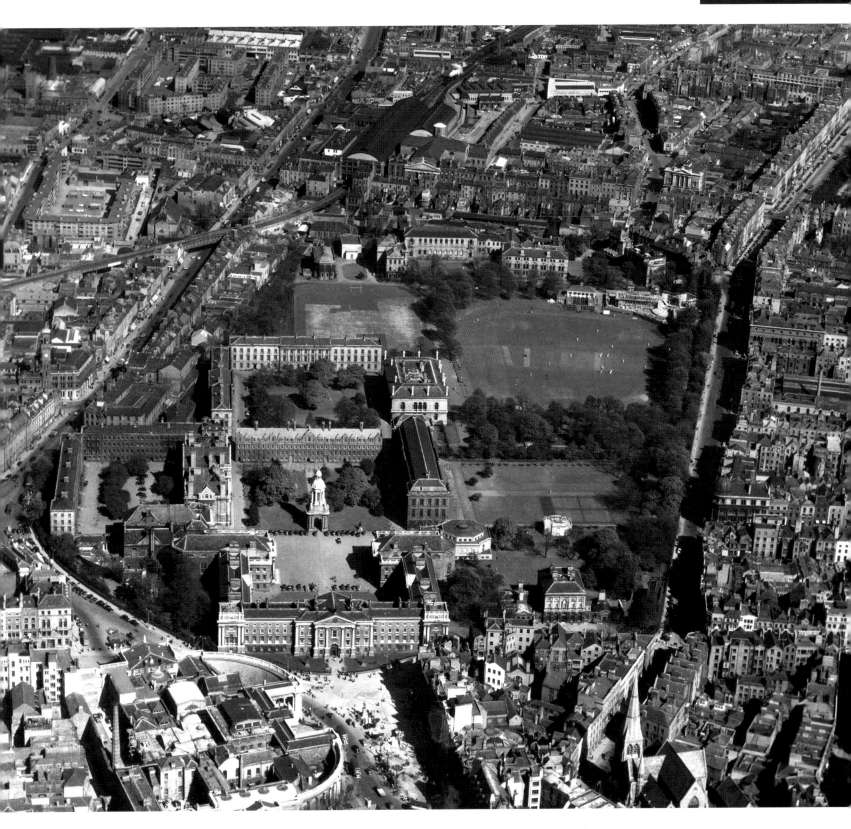

12 January 1951 Trinity College, Dublin. The college was founded in 1592 as the 'mother' of a new university, modelled on the collegiate universities of Oxford and Cambridge in England. Women were first admitted to the college as full members in January 1904. It is one of the seven ancient universities of Britain and Ireland, as well as Ireland's oldest university. **A157(A)**

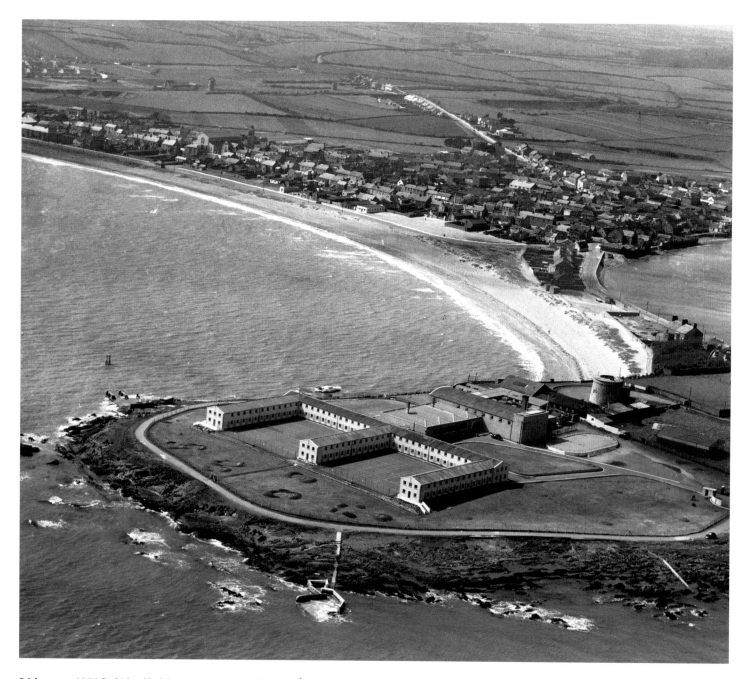

26 January 1951 Red Island holiday camp. Owned and built by Éamon Quinn, it was designed in an E shape and all 250 rooms have a sea view. **A347**

2 February 1951 Shannon Airport in County Clare. The airport was ready to be used by the many new post-war commercial airlines of Europe and North America. It was used as a stop for the Soviet Airliners on their way to the Americas. **A399**

2 March 1951 Mosney, the first Butlin's camp outside the UK. **A75**

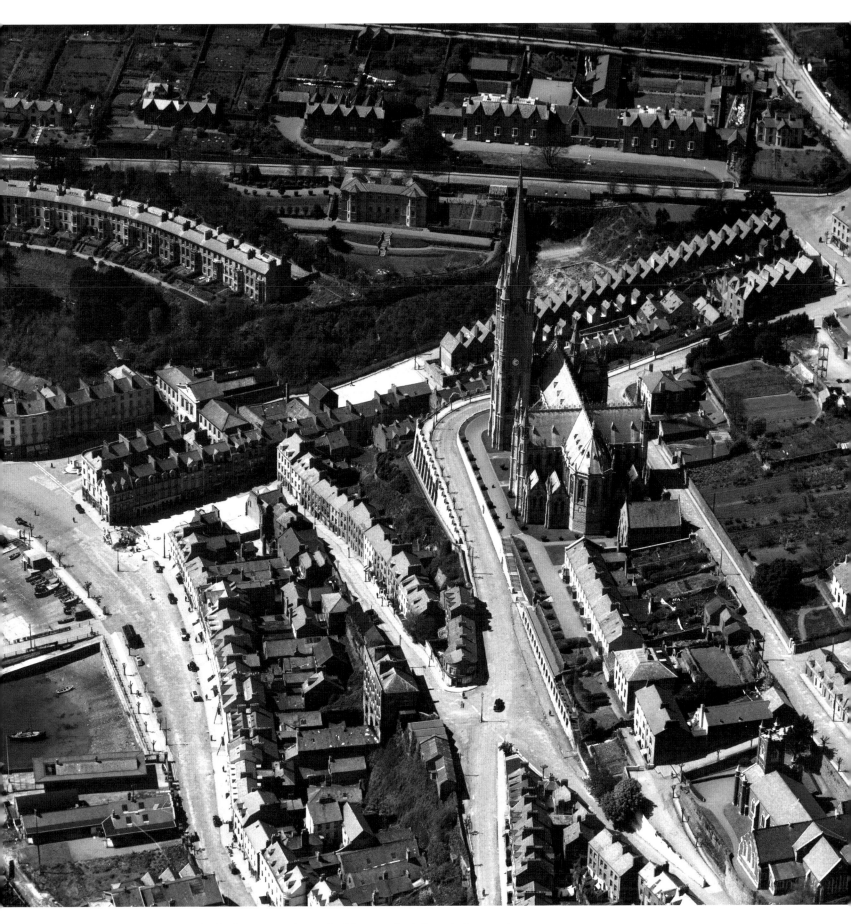

1 June 1951 An aerial view of Cobh, the County Cork port of call for transatlantic liners. In the centre is St Colman's Cathedral, the scene of Wednesday's celebration of the silver jubilee of the consecration of the Bishop of Cloyne, Most Rev. Dr Roche. In this cathedral spire is the famous carillon of forty-two bells. **A126**

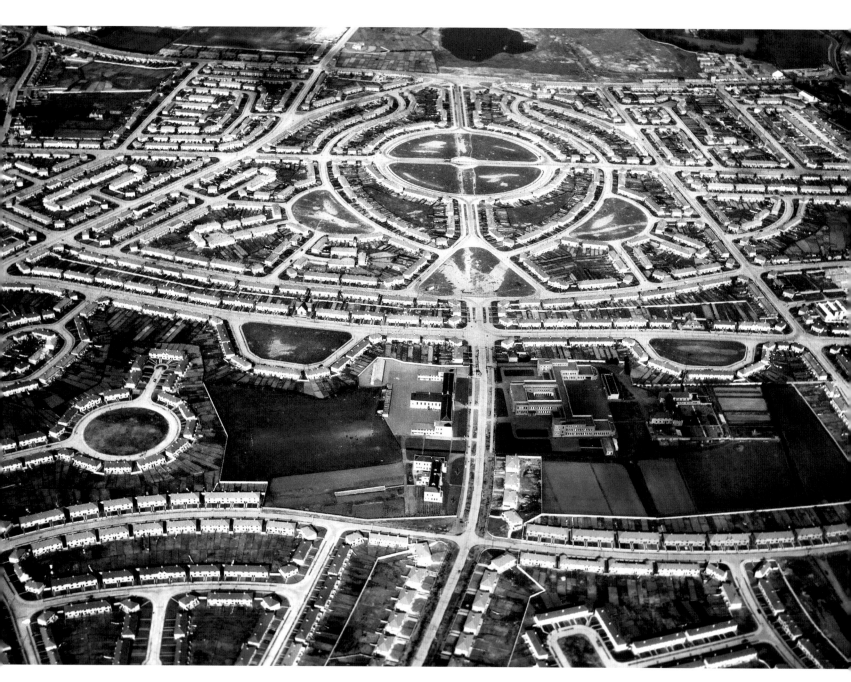

7 June 1951 Crumlin is a growing suburb on Dublin's south side. Some of the local amenities in Crumlin, such as Pearse College on Clogher Road and Ceannt Park, are named after the 1916 rebels who had a training camp in nearby Kimmage at Sundrive crossroads. **A144**

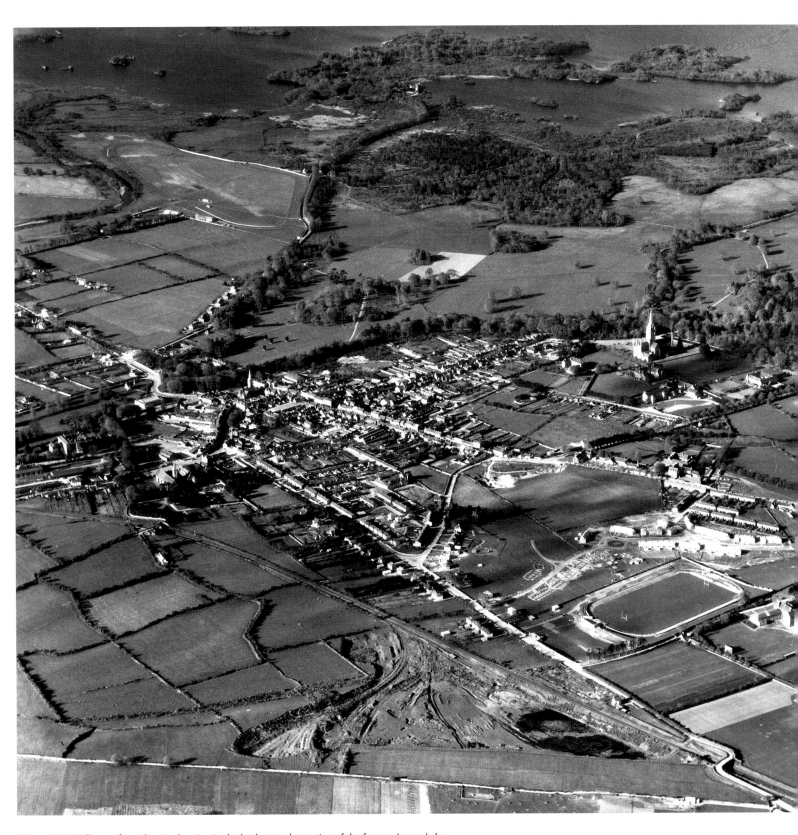

8 June 1951 Killarney from the air, showing in the background a section of the famous Lower Lake, with Ross Castle in the centre of the image. The Killarney Cathedral spire is to the right, with its adjacent seminary and bishop's house. In the right foreground is the Fitzgerald Memorial ground of the GAA. **A239**

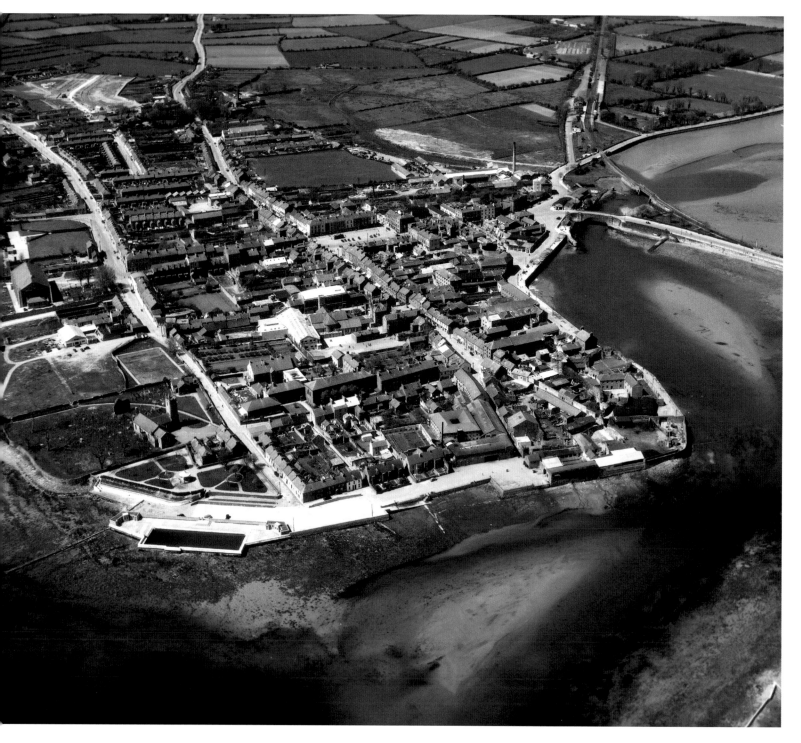

15 June 1951 Dungarvan, administrative centre for County Waterford, with its tannery factories, and in the centre, its spacious market square. In the foreground to the left are its modern swimming baths, built by the Dungarvan Swimming Club. The club's inability to raise funds necessary to the conduct of its affairs due to the closing for repairs of the Town Hall is a matter of protest at the moment. **A180**

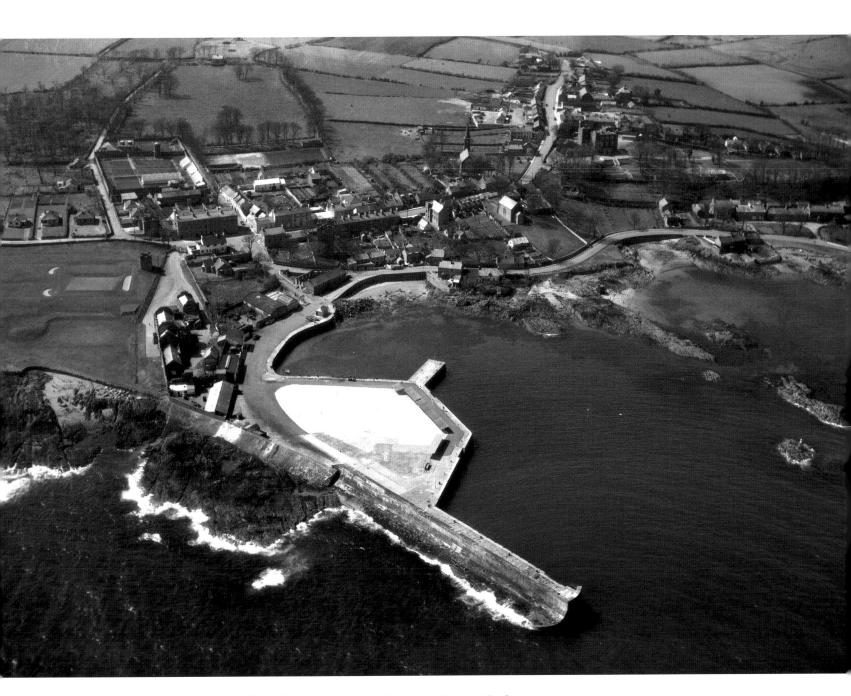

29 June 1951 The rock-strewn harbour of Castle Ardglass, on the County Down coast. The quayside of this well-known fishing village is completely deserted with the boats at sea. On the left (on the golf course and just outside the entrance gates) are two of the village's many castles. Dominating the scene (to the right) is the castle, which is now the Redemptorist Retreat House of Mount St Clement. On the opposite side of the street is the Protestant church. **A12**

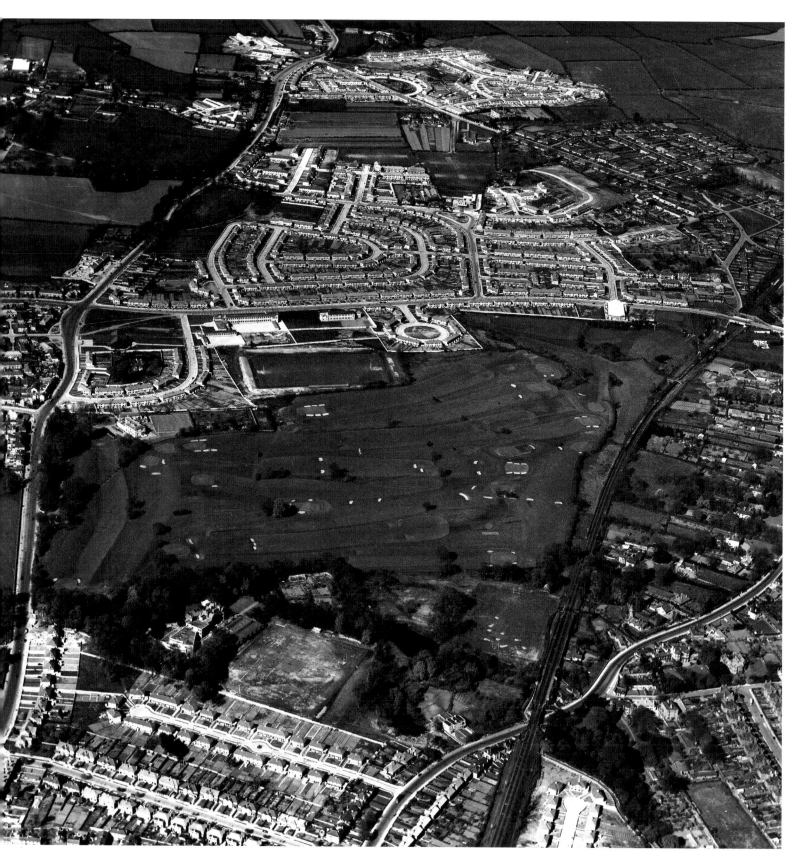

3 July 1951 This aerial photograph takes in the vista from Clontarf to Donnycarney, County Dublin, with Clontarf Golf Club separating the two. **A159**

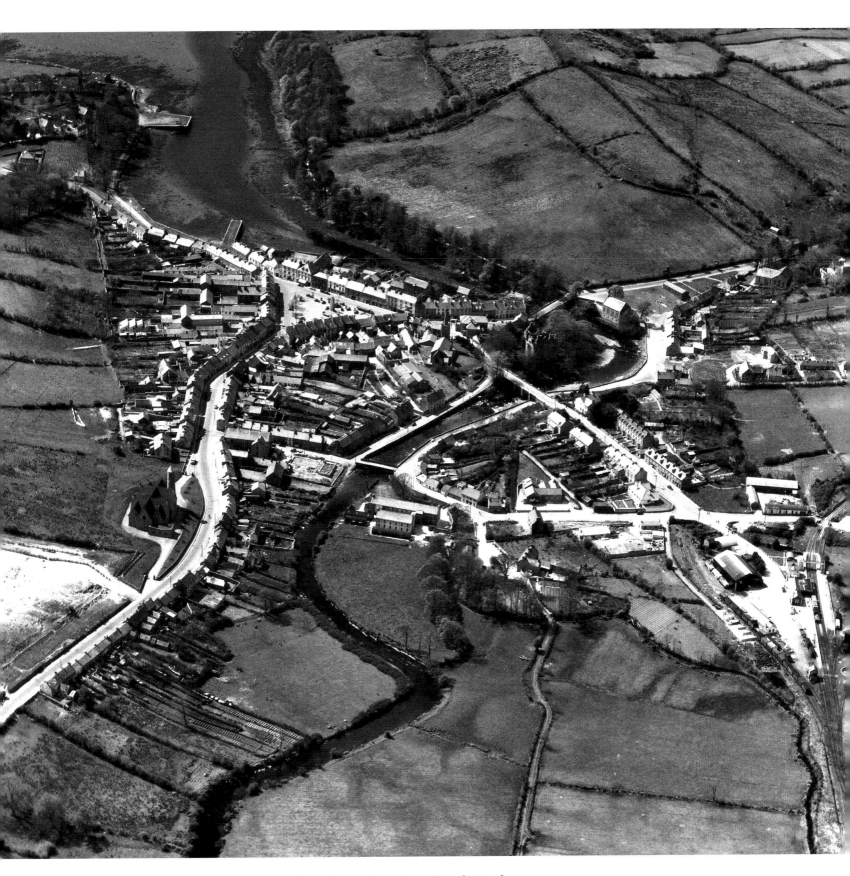

6 July 1951 Donegal town, Donegal Bay, in a county famed in song the world over. Place of origin of the Annals of the Four Masters, whose memory is perpetuated by the Memorial Church seen to the left foreground. The castle stronghold of the O'Donnells is in the centre of the picture. **A156**

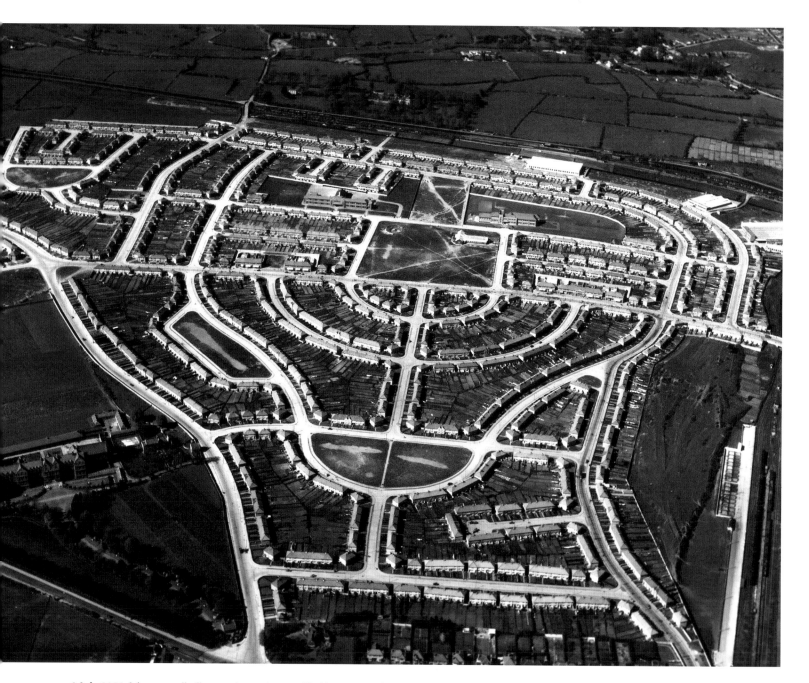

9 July 1951 Cabra, a small village to the north west of Dublin city, is undergoing major expansion.
This picture shows one of the new estates in development. **A77**

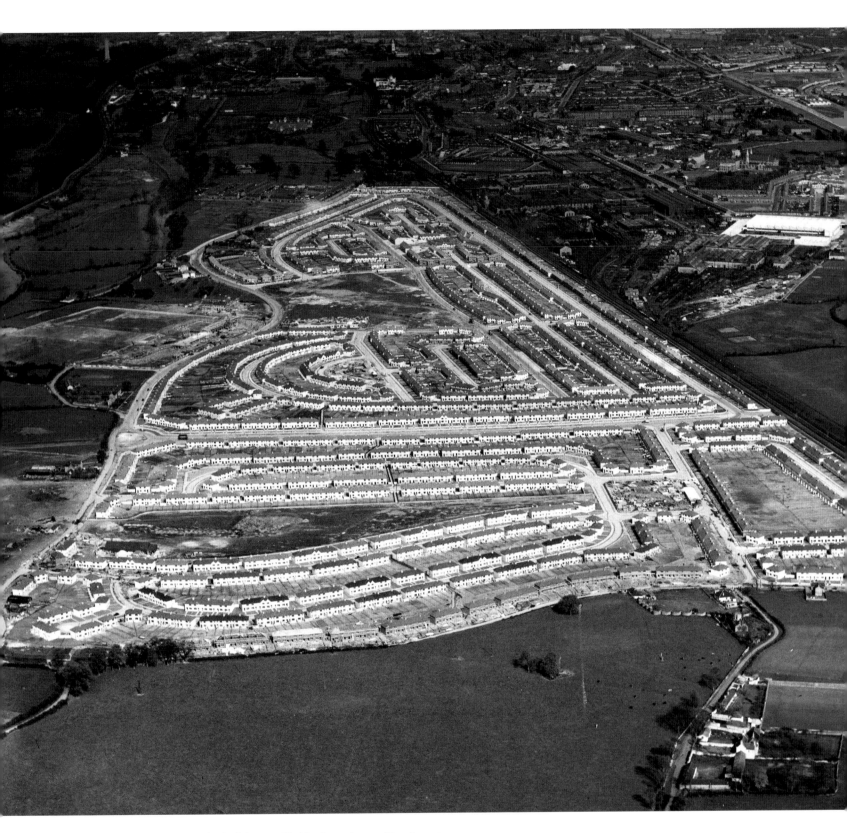

10 July 1951 Ballyfermot is a suburb of the city of Dublin, located west of the city centre and south of the Phoenix Park. **A163**

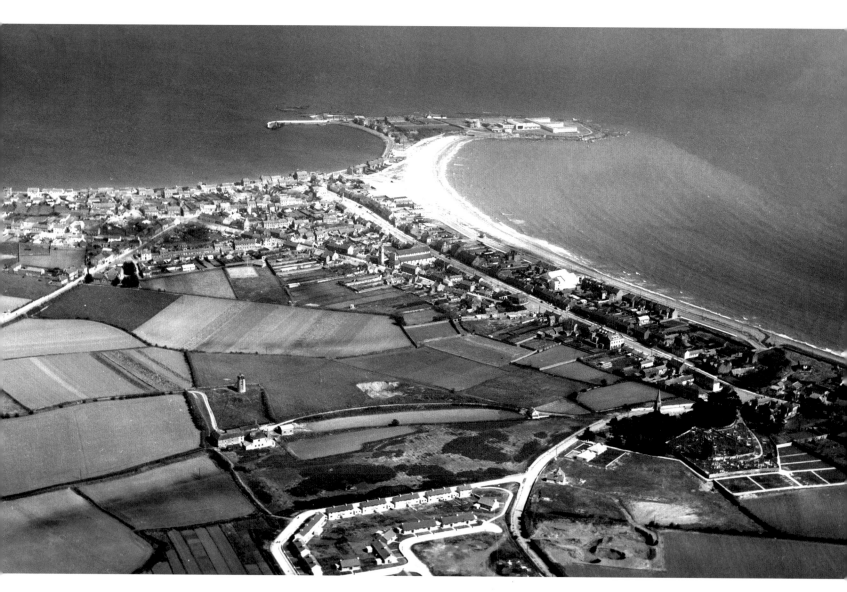

13 July 1951 Skerries, popular north County Dublin holiday resort, with its Strand Street running parallel to its strand, leading to Red Island and the harbour. The old windmill tower dominates the well-tilled inland area. In the right foreground is the ancient church and burial ground of Holmpatrick. **A401**

3 August 1951 Galway city, focal point for the holidaymakers and racing fraternity this week. Flowing through the City of the Tribes is the Corrib River, coming from Lough Corrib. The houses in the foreground are of the new Claddagh. Like ribbons at the top of the picture are the highways from the east, which carried many travellers here yesterday and on Wednesday. **A209(a)**

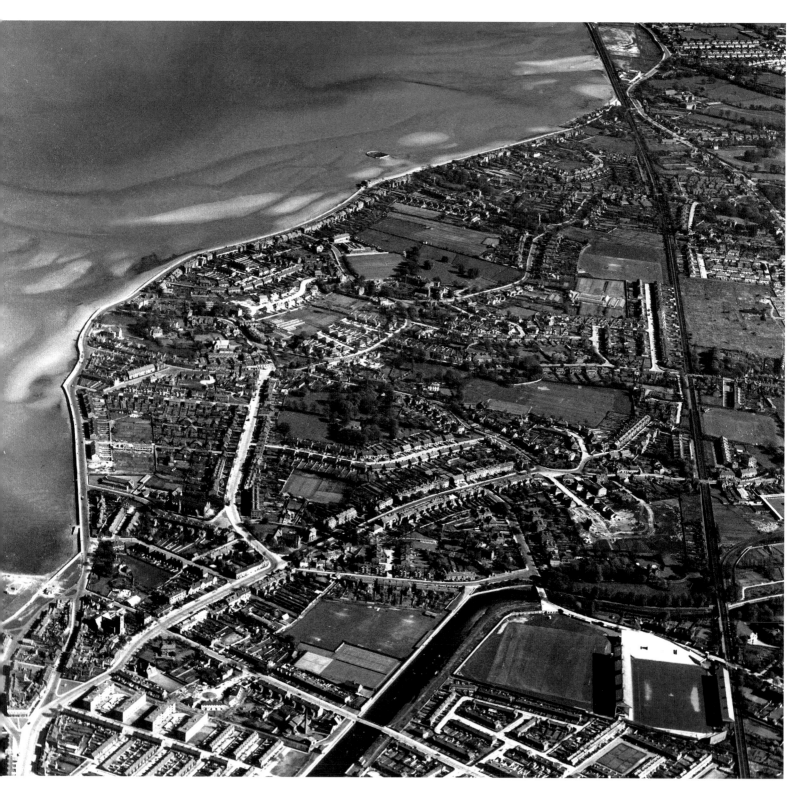

7 August 1951 An excellent view of the coastline stretching from Sandymount to Booterstown with Mount Merrion on the right-hand side. Clearly visible is the main Dublin-to-Rosslare railway line. **A396**

10 August 1951 Dublin city centre: the Liffey barge on its upstream journey has left in its wake the last bridges before the river mouth: the 'Halfpenny' footbridge, O'Connell Bridge and Butt Bridge. On the quayside stands the Custom House, with the new, unfinished Bus Station towering behind it. In Abbey Street, parallel to the river and to the left of the picture, Independent House is located by its familiar twin turrets and serrated roof. **A175**

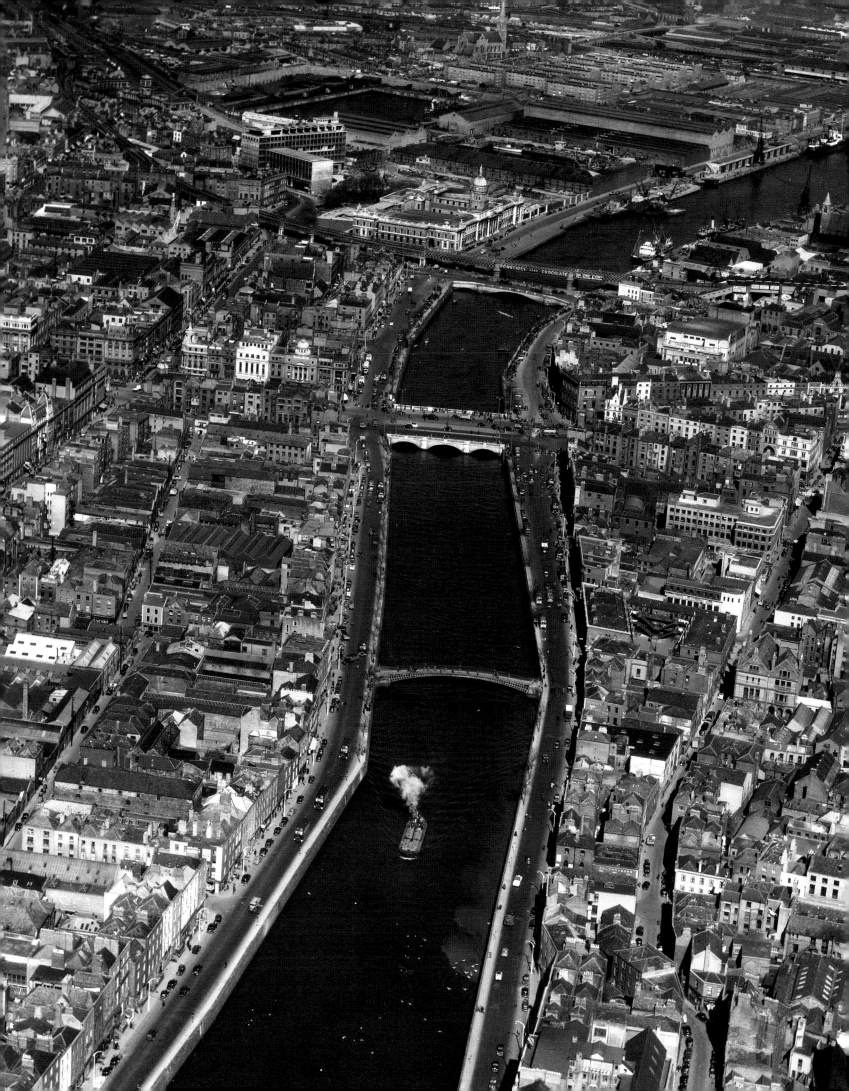

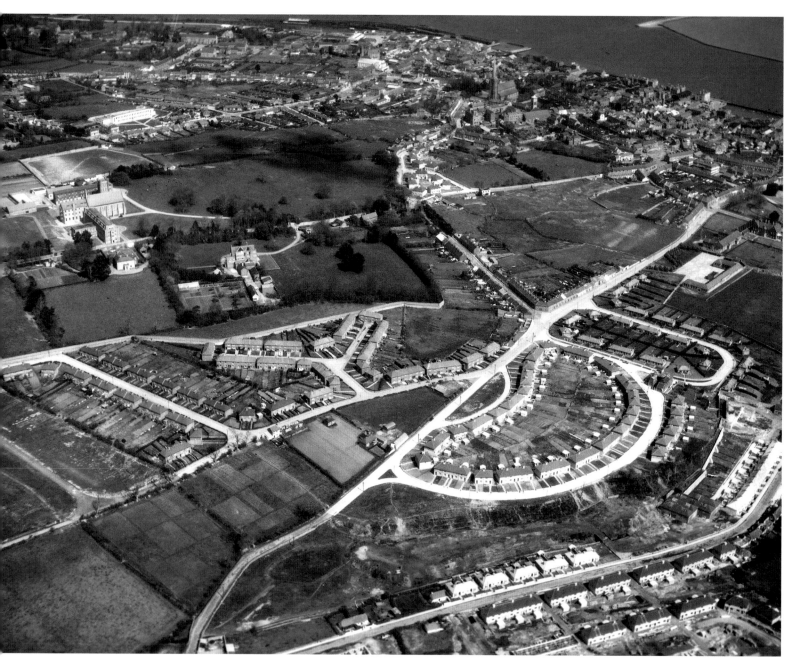

17 August 1951 Wexford — where the annual Muintir na Tíre Conference is taking place this week.
The town, famed in history, lies along the Slaney River, in the background. To the left of the town is
St Peter's College, and the large, new housing scheme occupies the foreground. **A445**

24 August 1951 Kilkee – a favourite Clare watering place. This view shows to advantage the delightful curving strand, ideal for the holiday bathers. **A231**

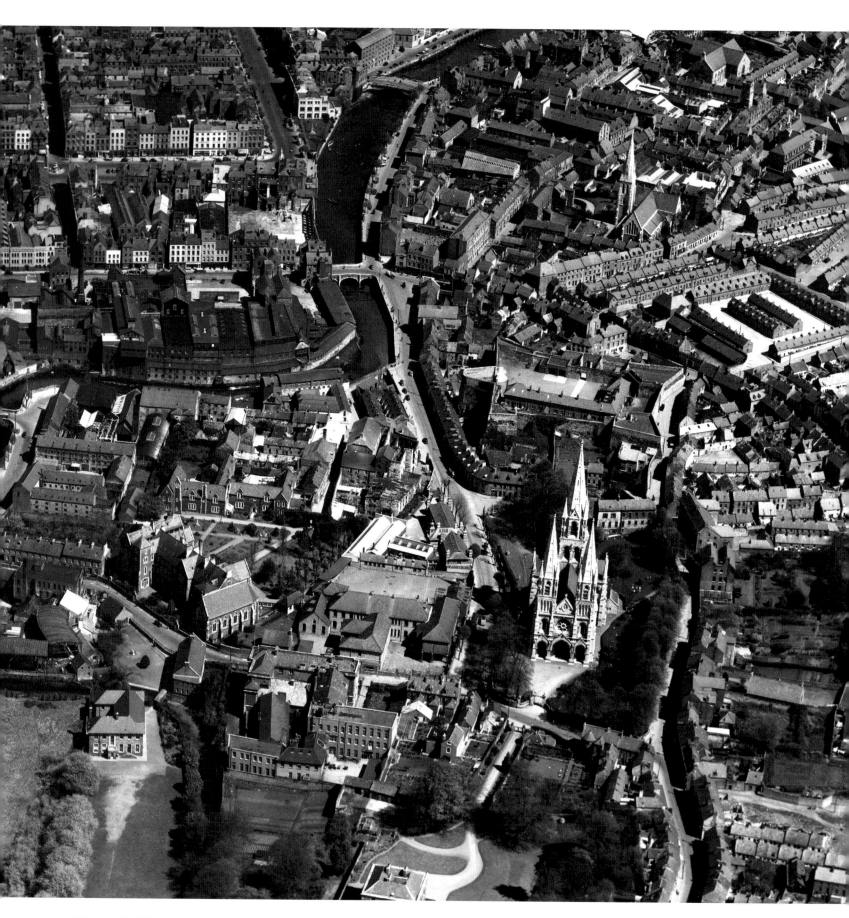

31 August 1951 A colourful section of Cork city, including a stretch of the River Lee. In the foreground is St Fin Barre's Cathedral. Grand Parade runs horizontally, in from the top left of the picture, connecting with South Mall. At the top is the Holy Trinity Church spire. **A451**

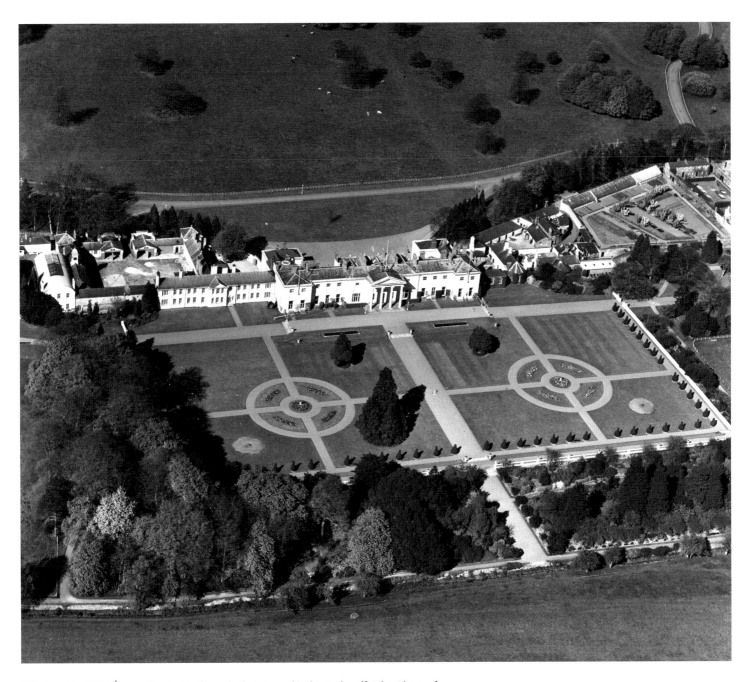

6 September 1951 Áras an Uachtaráin, formerly the Viceregal Lodge, is the official residence of the President of Ireland. It is located in the Phoenix Park on the northside of Dublin. **A22**

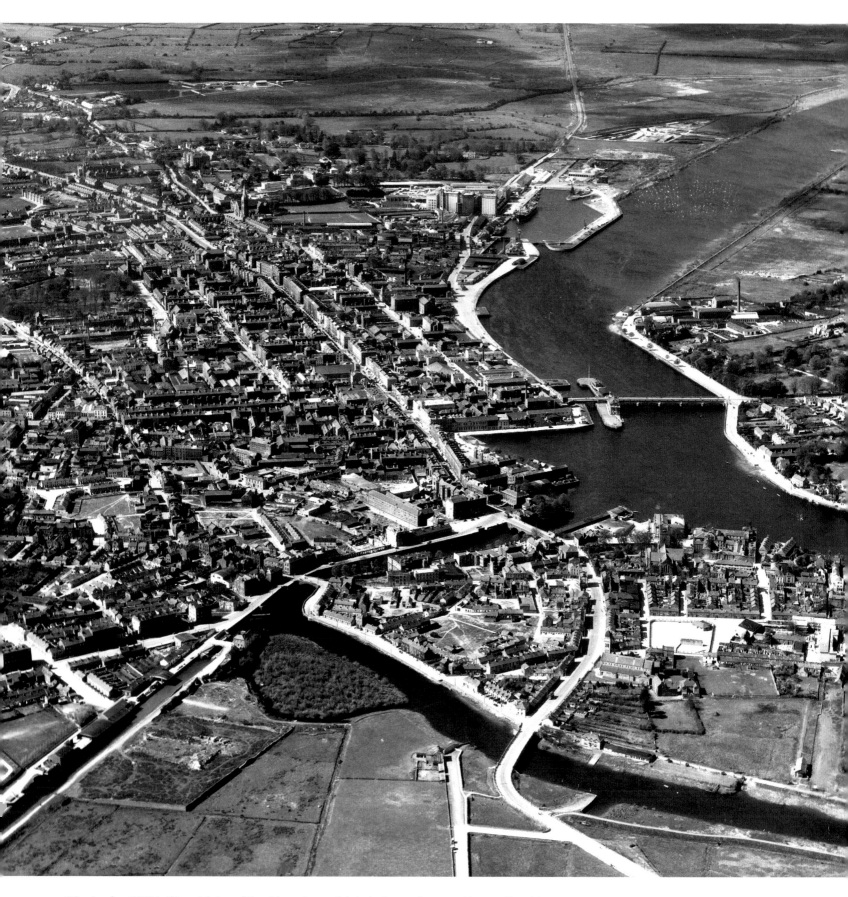

7 September 1951 In this aerial view of Limerick, on the top right is the Cement Factory, at Mungret. Limerick Docks and the Sarsfield Bridge, with Shannon Rowing and Limerick Boat Clubs are on the right of the image, and the Condensed Milk factory is on the right bank of the river. St Mary's Cathedral and traces of old Limerick walls are all shown. 'The Island' – the old city – is seen, as well as the junction of the Grand Canal with the Abbey River, a tributary of the Shannon, at the bottom right. The full length of O'Connell Street runs diagonally through the picture. **A265**

14 September 1951 Tralee, capital of Kerry, a busy centre during this, its Race Week. The railway yards are at the right foreground. The Thomas Ashe Memorial Hall (County Hall) stands prominently on its own on the left and, near it, St John's Parish Church spire, and Presentation Convent. The main thoroughfare seen is Castle Street. **A425**

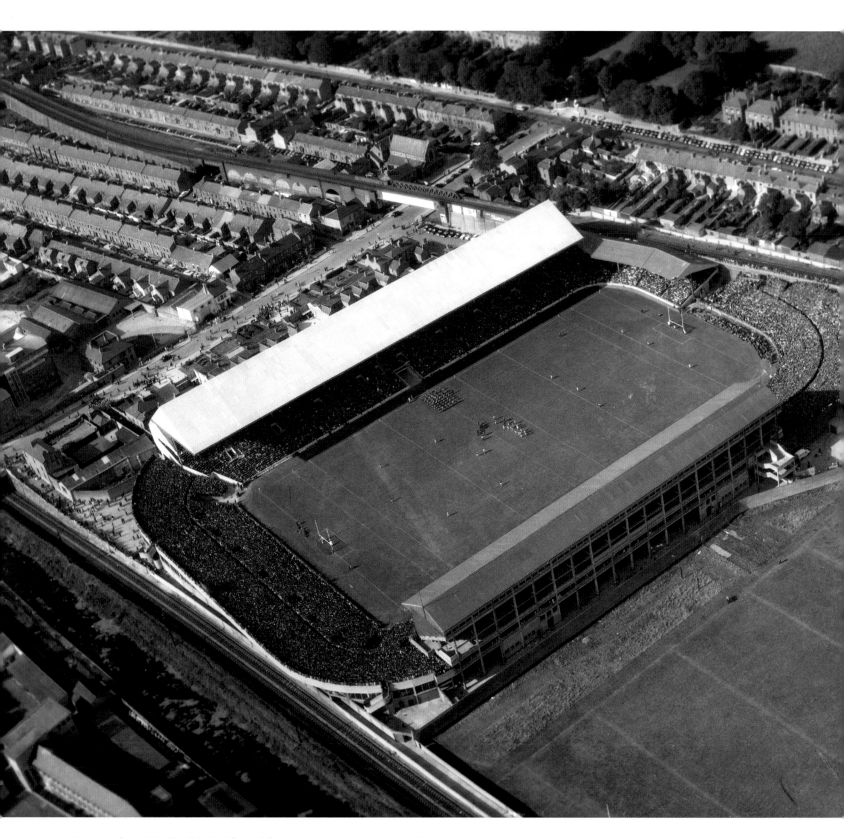

23 September 1951 The All-Ireland football final 1951 at Croke Park, a GAA stadium in Dublin, named in honour of Archbishop Thomas Croke and often called Croker by GAA fans. It is the principal stadium and headquarters of the Gaelic Athletic Association (GAA). **A141(A)**

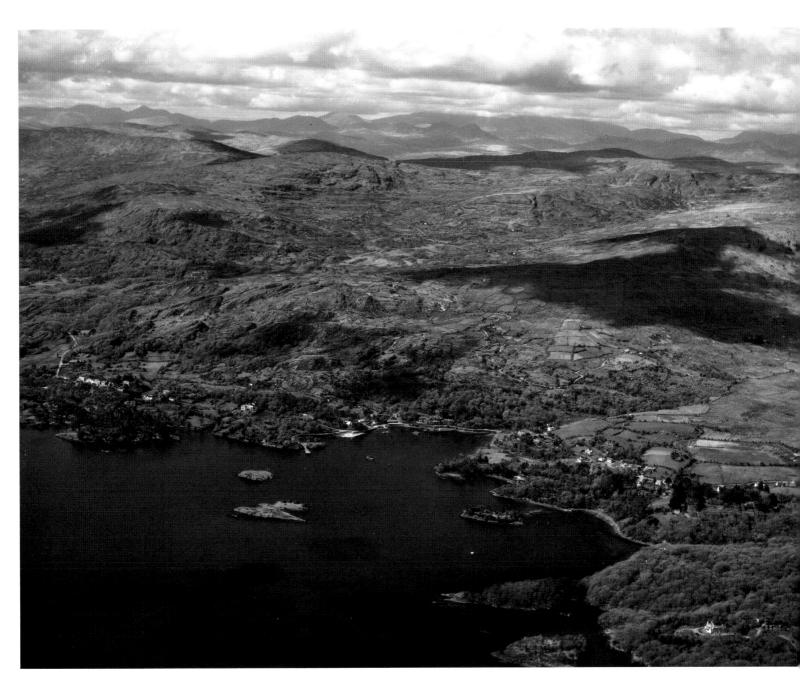

28 September 1951 Glengarriff, County Cork, in all its splendour. The village nestles in the innermost bay of the great Glengarriff Harbour. It sends out its roads to the right and left for the wonderland of Bantry Bay, and across the centre of the picture to conquer the Healy Pass, making for Kenmare beyond the Caha Range. **A214**

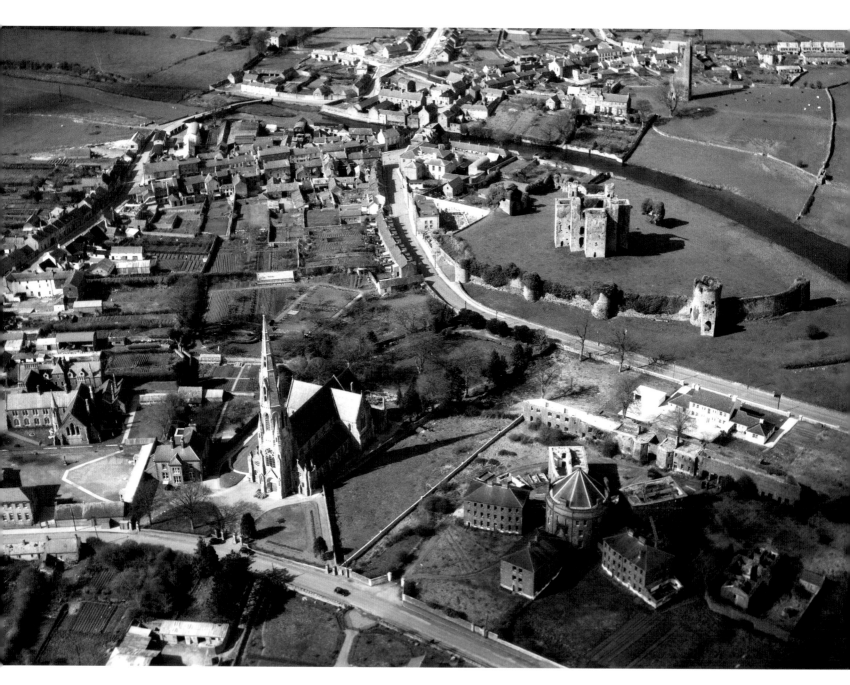

5 October 1951 Trim, on the River Boyne in County Meath, is rich in historic ruins, making it a place of exceptional interest to antiquaries. The great structure of King John's Castle is seen to the top right, and beyond it, the Yellow Steeple. **A428**

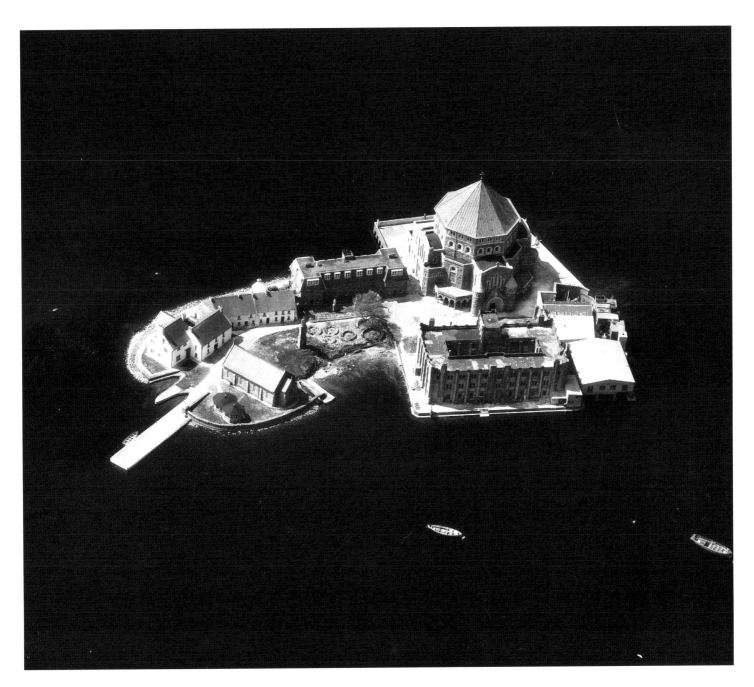

2 November 1951 The little island of Lough Derg, famous Donegal place of pilgrimage, where thousands, for the spiritual welfare of themselves and all souls, perform rigorous penitential exercises. Ferry boats lying off the island are seen at the bottom right corner of the picture. The various buildings, stations and Basilica of the retreat are clearly discernible. **A277**

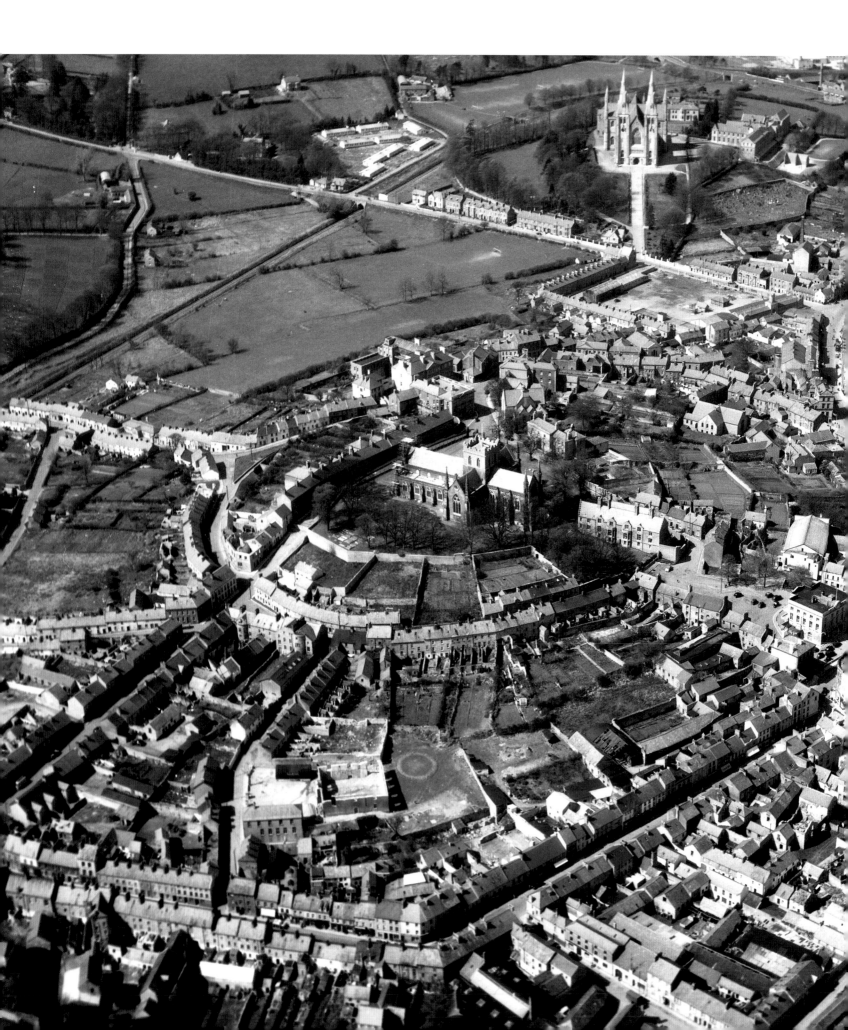

12 October 1951 Armagh: St Patrick's Cathedral of the Archbishop of Armagh and Primate of All-Ireland stands on its eminence at the top of this aerial view of the primatial city in Northern Ireland. In the left centre is the old Cathedral of St Patrick, on its rath site. The spire to the right is the Presbyterian Church on The Mall. **A20**

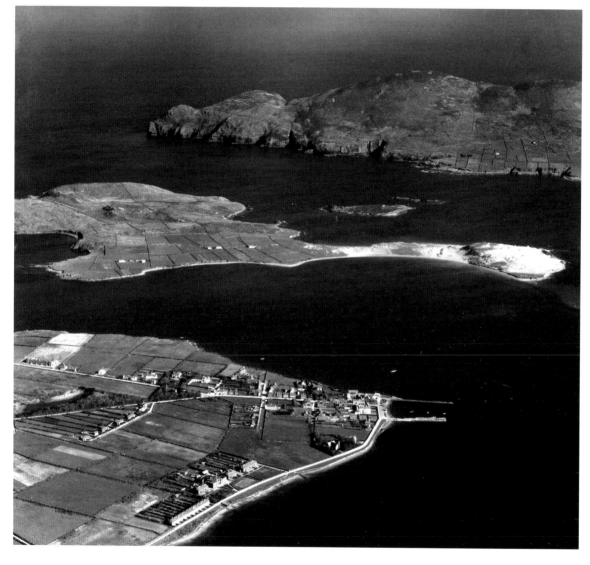

9 November 1951 Valentia Island, important transatlantic cable terminus off the Kerry coast. On the section of the island in the foreground is Knightstown, with its church in the patch of trees by the shore. In the nearer foreground are the terrace buildings of the cable station. The island in the centre of the picture is Beginish, with, beyond it, Doulus Head. **A435**

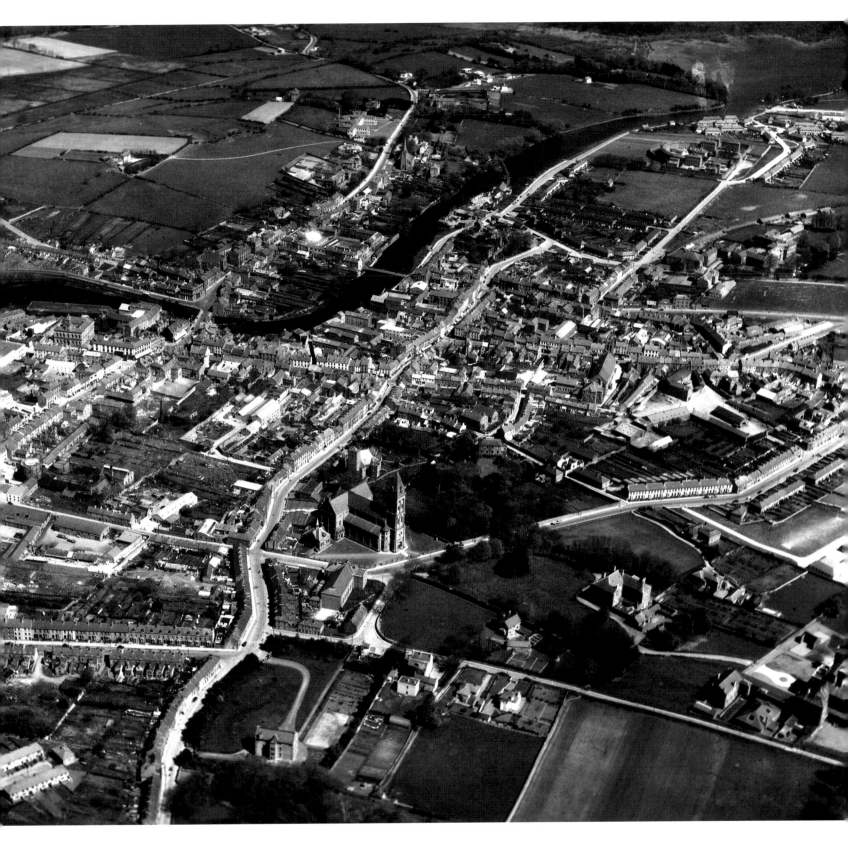

23 November 1951 Sligo, on the River Garavogue, flowing from lough Gill (top right corner). To the left, as the river enters Sligo Harbour, the group of buildings below the bridge includes the Town Hall, GPO and Custom House. The cathedral for Elphin diocese is situated near the centre on the picture. **A406**

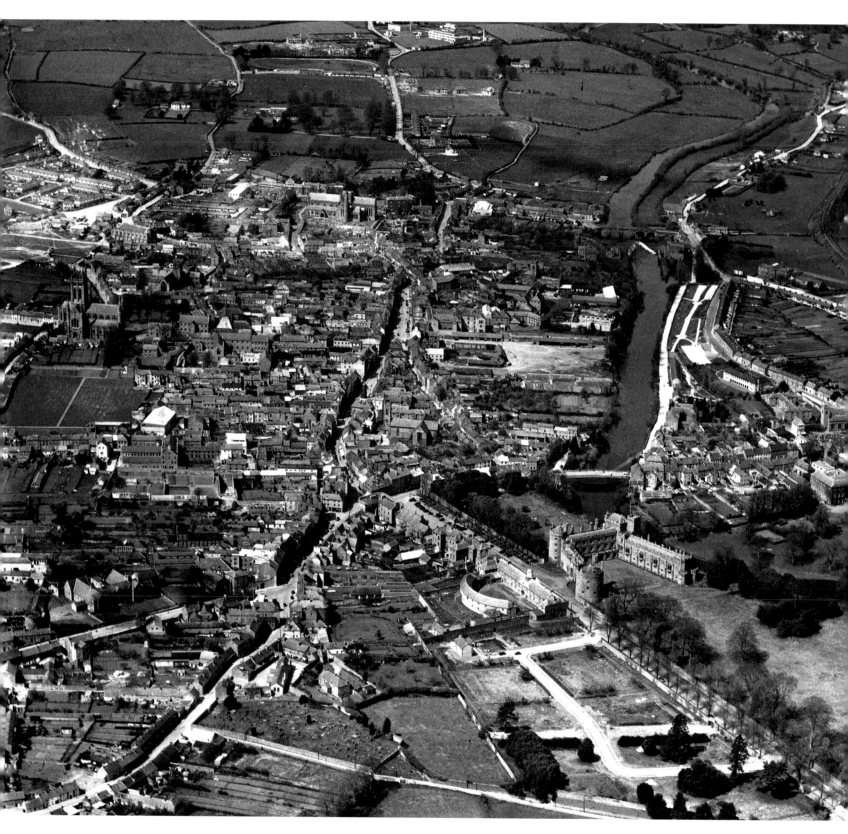

30 November 1951 Kilkenny city, on the Nore. The impressive St Mary's Cathedral is seen on the left, and the ancient St Canice's Cathedral on the far edge of the city. High Street is in the centre of the picture, with the Tholsel clock tower discernible. In front of St John's Bridge, to lower right, is the historical Kilkenny Castle. **A236**

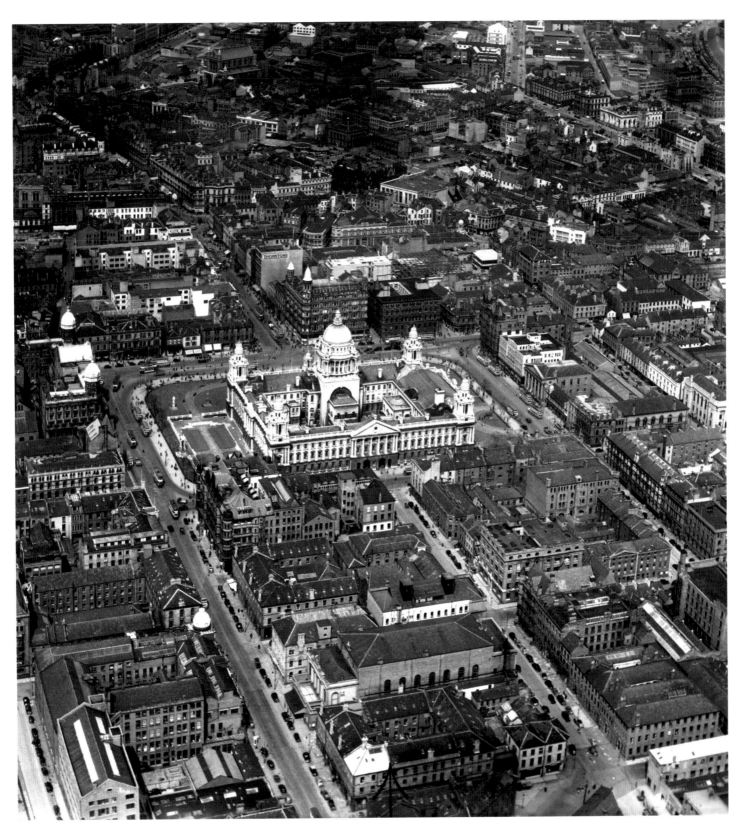

7 December 1951 Belfast City Hall, in Donegall Square, with Royal Avenue branching out towards the top of the picture, and passing through Castle Junction. Over to the right is Blitz Square, marked by the parked cars using the bomb-cleared area. In the foreground stands the Ulster Hall. **A52**

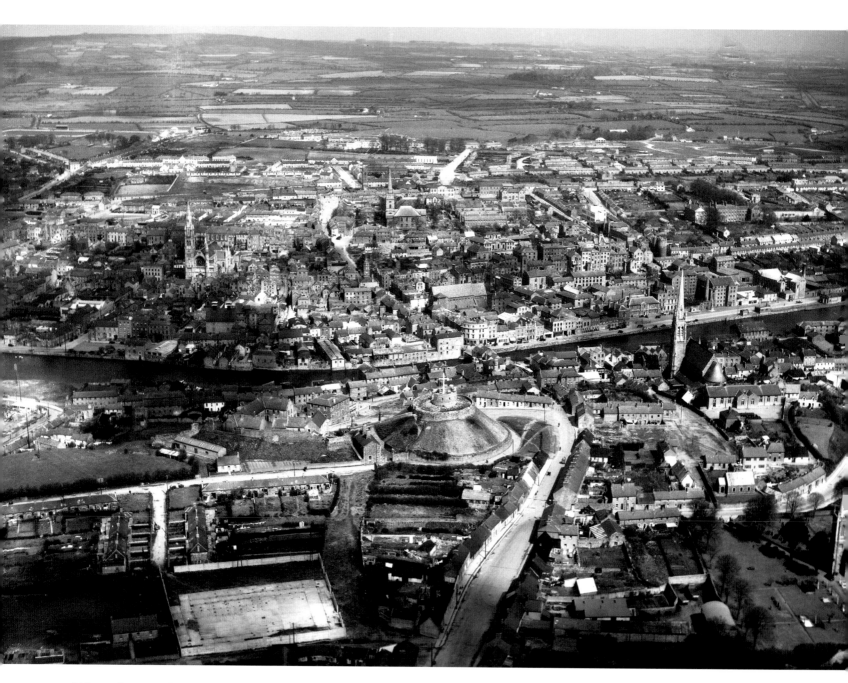

14 December 1951 The Boyne, flowing through Drogheda, dividing the town between the diocese of Armagh on the far side, with St Peter's Memorial Church to Blessed Oliver Plunkett (spire to the left), and the diocese of Meath in the foreground, with the spire of St Mary's Church and the recently erected Holy Year Cross on the historically famous Millmount. **A165**

21 December 1951 Longford town, the administrative headquarters of the county. It lies on the trunk road from Dublin to the north-west. The road is seen in this picture making its way out to the top left for Carrick-on-Shannon. To the right, St Mel's Cathedral (Armagh and Clonmacnoise) and St Mel's College are readily discernible. **A271**

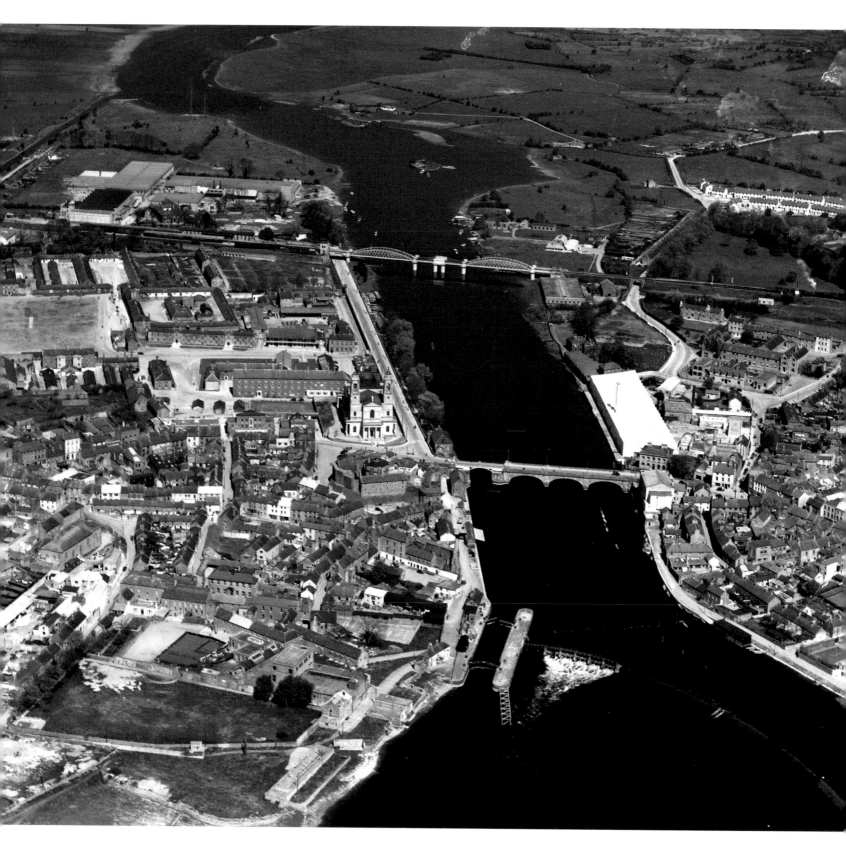

28 December 1951 Athlone, on the Shannon. To the right, Leinster, and to the left, Connacht, with the connecting bridge on the site of the famous Bridge of Athlone, scene of Sergeant Custume's famous stand during the siege of 1691. The twin-spired Church of SS Peter and Paul stands beside the bridge. Woollen and textile mills account for the larger buildings, and the bridge seen upstream carries the westbound railway line. **A27**

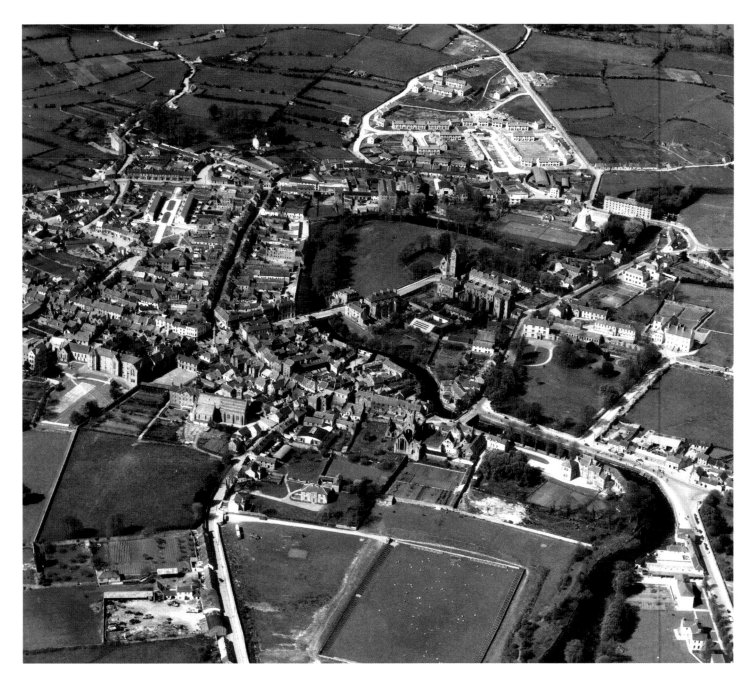

4 January 1952 Ennis, County Clare. The O'Connell column is seen as the centre of the town's star-like layout. To the centre foreground lies the old Franciscan Friary ruin. New housing in the distance is indicative of the enlivening of business by proximity to the airport, and its traditional reputation as a well-hotelled town. **A194**

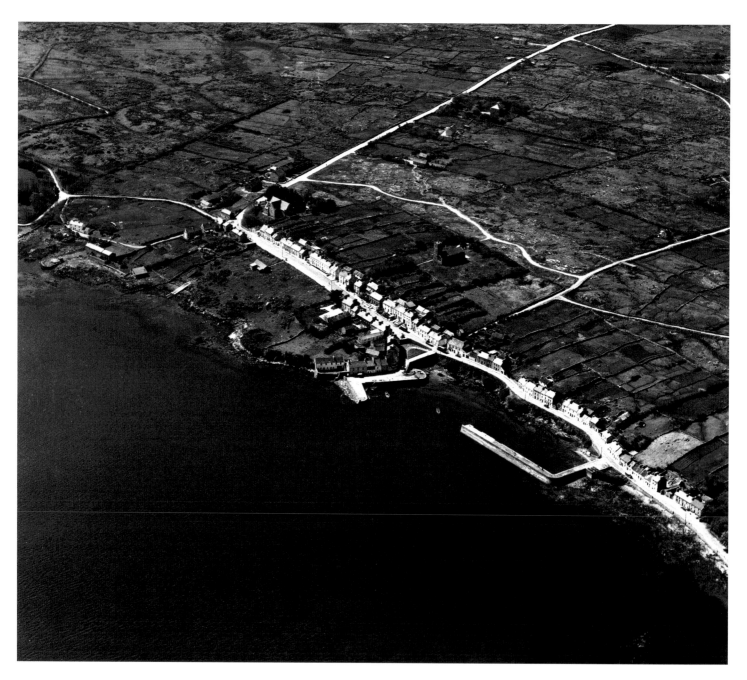

11 January 1952 Roundstone, Connemara, with its one-sided street of houses facing the morning sun and little harbour, has been the inspiration of many visiting artists. The village is backed by the rugged land ascending to Errisbeg. **A355**

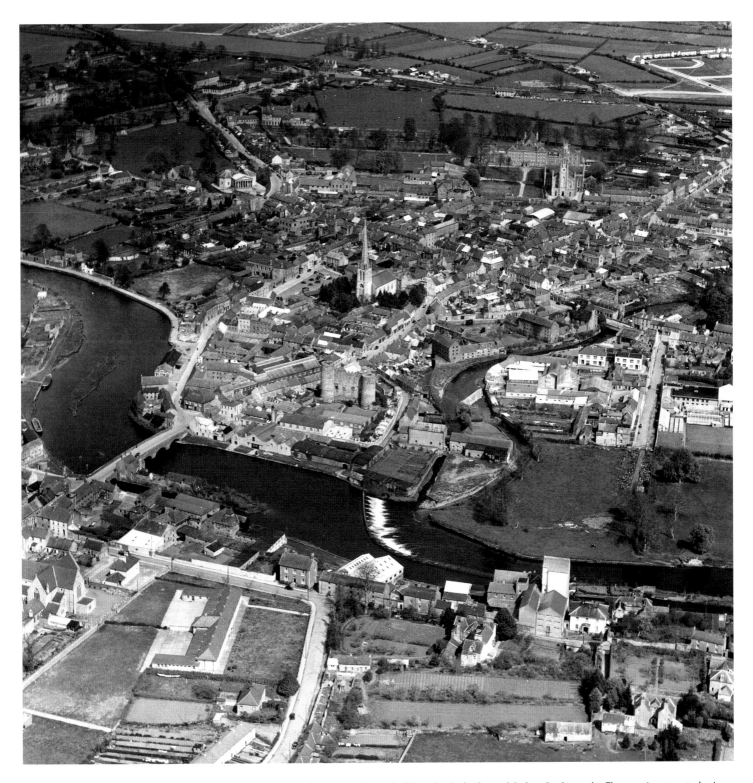

18 January 1952 Carlow. In the foreground flows the Barrow with white boathouse buildings by the bridge and Carlow Castle nearby. The prominent central spire marks the Church of Ireland edifice. To the left the Doric columns of the courthouse quickly locate its position at the junction of the Athy and Dublin roads. On a line with this, to the right, stand the Cathedral of the Assumption and St Patrick's College. **A85**

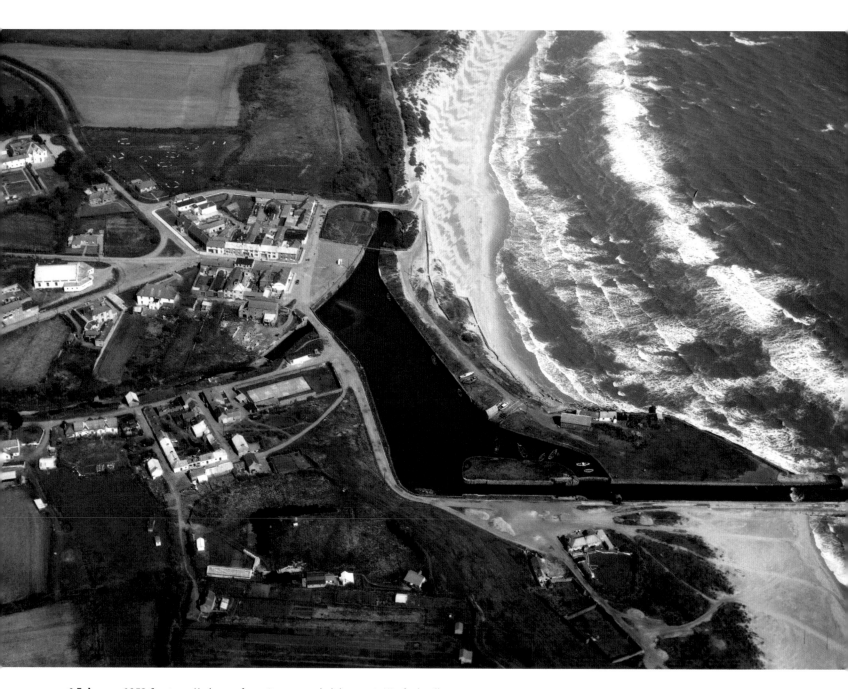

1 February 1952 Courtown Harbour, a favourite summer holiday spot in Wexford, will see some off-season liveliness this week and next during the Macra na Feirme Leader Training Conference for the county and club officers. **A137**

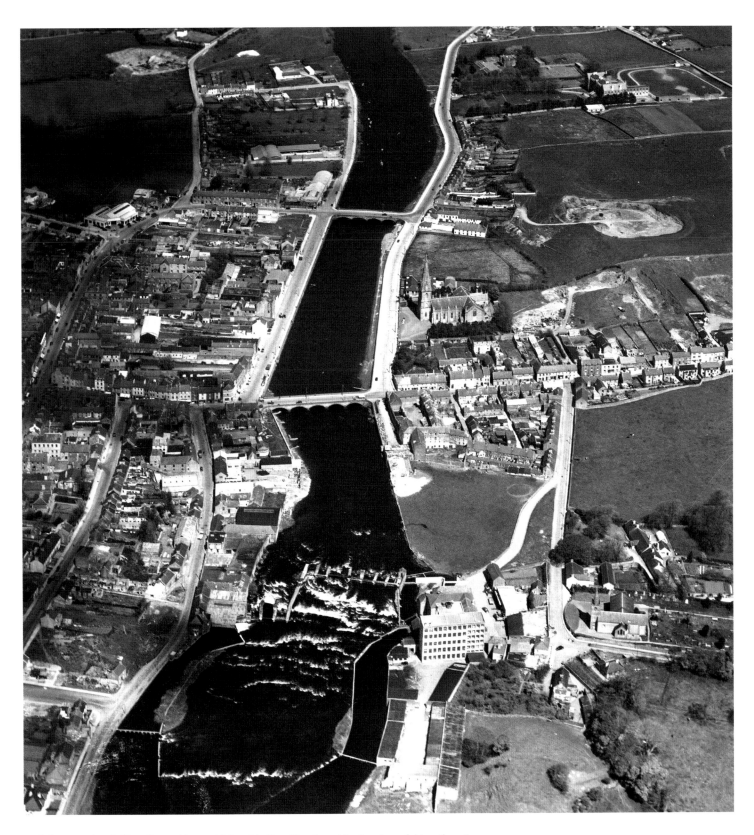

15 February 1952 Ballina, County Mayo, with its wide River Moy, famed for its salmon fishing. The spire
on the right bank is that of St Muredach's Cathedral. Near the weir, in the foreground, stands the flourmill.
A32

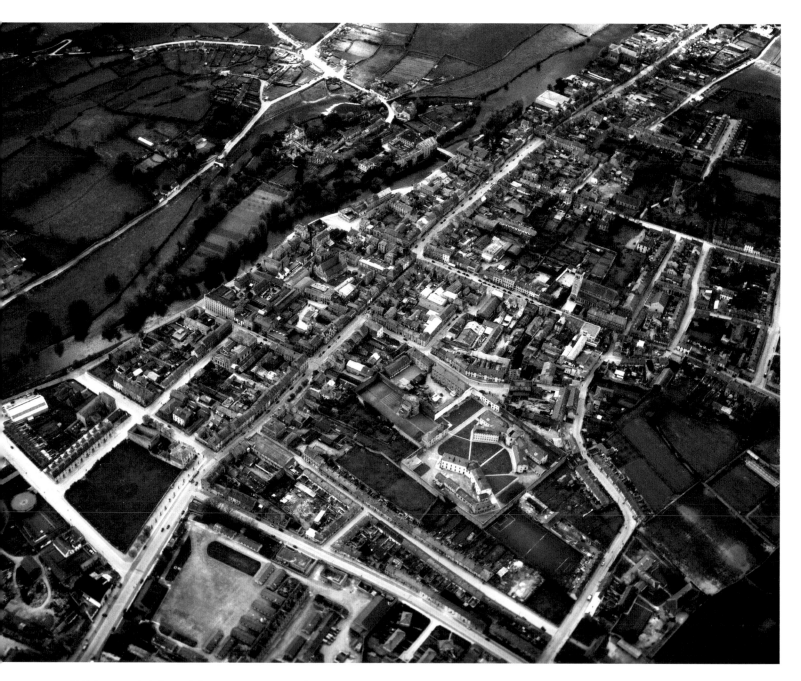

22 February 1952 Clonmel, County Tipperary, centre for the current National Cup Coursing meeting. The old West Gate entrance is seen on O'Connell's St, near the top left, where the River Suir skirts the town. Over the river lies Oldbridge. The Barracks is prominent in the foreground, and above it the SS Peter and Paul's Church. **A122**

29 February 1952 Like a patchwork quilt, the drills and furrows extend to the edge of the sea in the intensively cultivated area of Rush, County Dublin. The harbour and a section of the North Strand are on the right. The main street travels to the top in spiral formation, intersected by the Square. The South Strand extends out of the upper left. **A357**

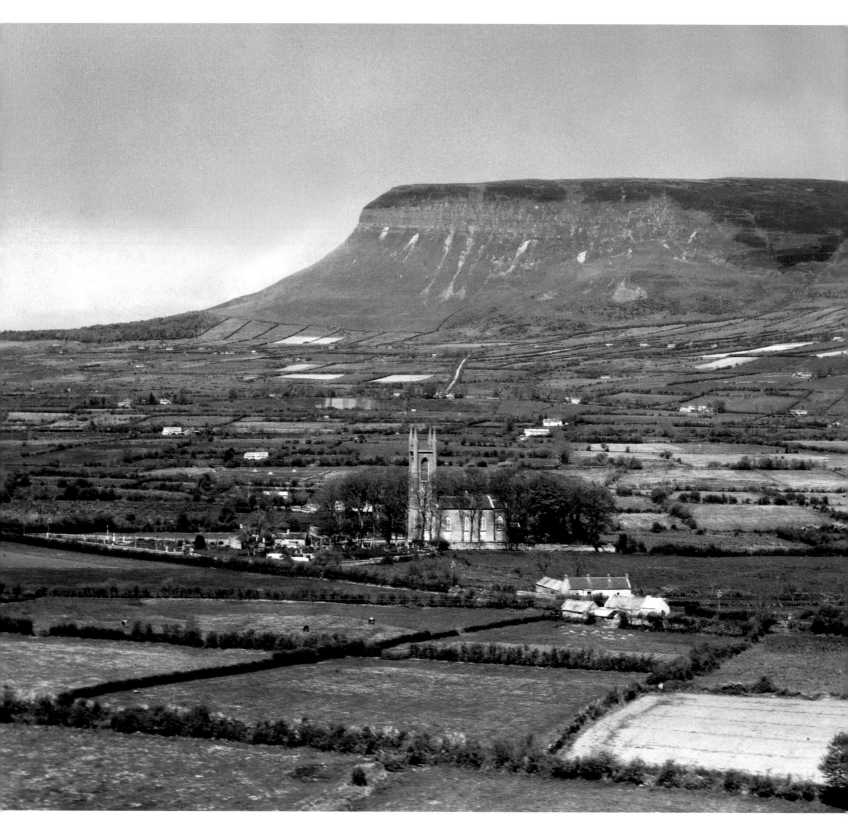

7 March 1952 Drumcliff, County Sligo: this aerial picture includes Drumcliff Church and the burial ground, where the remains of W. B. Yeats now rest. The poet's beloved Ben Bulben rises monumentally in the background. **A167**

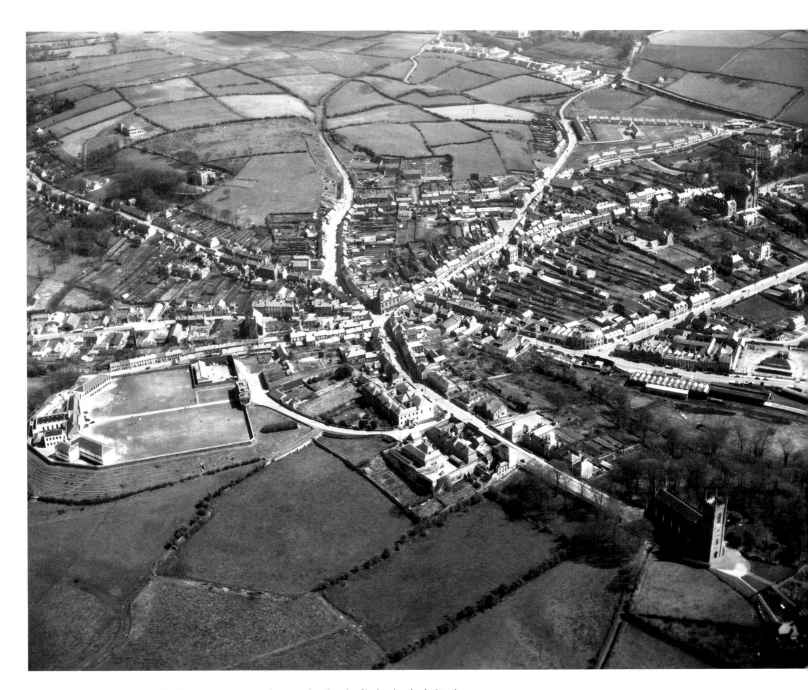

14 March 1952 Downpatrick, the County Down town, showing the Church of Ireland cathedral in the lower right-hand corner. In the adjoining churchyard a large stone marks the reputed burial place of St Patrick, who when coming from Rome, landed in Saul, a few miles away. The old County Jail in Downpatrick is where the United Ireland Leader, Thomas Russell, was hanged in 1803. Other points of interest are the Roman Catholic Church and Downe Hospital, at the top right, and the Town Hall at the centre. Downpatrick Protestant High School, with its extensive playing fields, is in the left foreground. **A162**

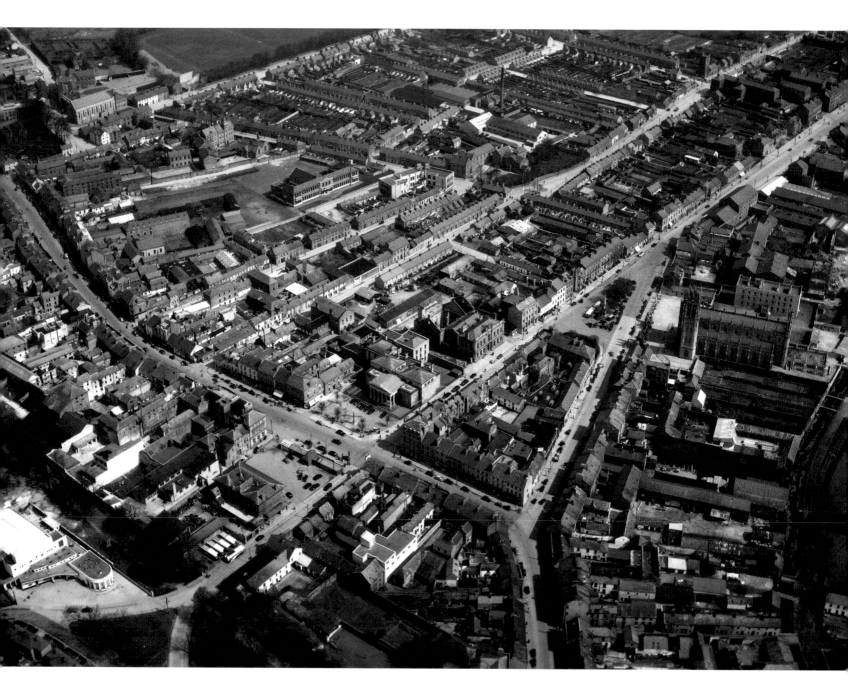

21 March 1952 Dundalk, a highly industrial town some five miles south of the Partition Border in County Louth. Its works include brewing, distilling, boat-making and manufacture of tobacco, as well as the workshops for the Great Northern Railway. The Catholic Church of St Patrick is prominent in the centre of the picture. **A179**

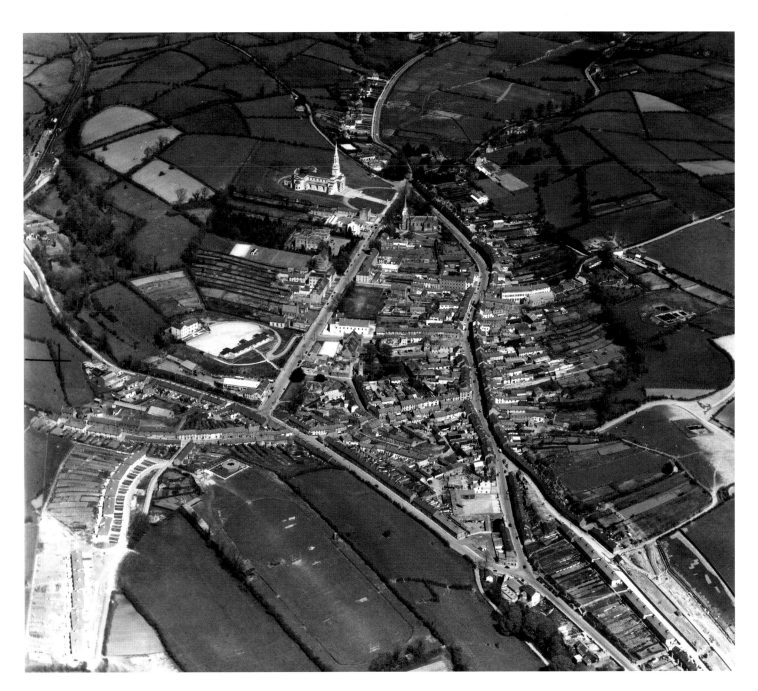

28 March 1952 Cavan, chief town of the Ulster county, south of the Border, is identified by its modern Romanesque Cathedral of SS Patrick and Phelim, which was dedicated ten years ago. In ancient times the town was seat of the O'Reilly chiefs, and the name is still largely associated with the district. **A102**

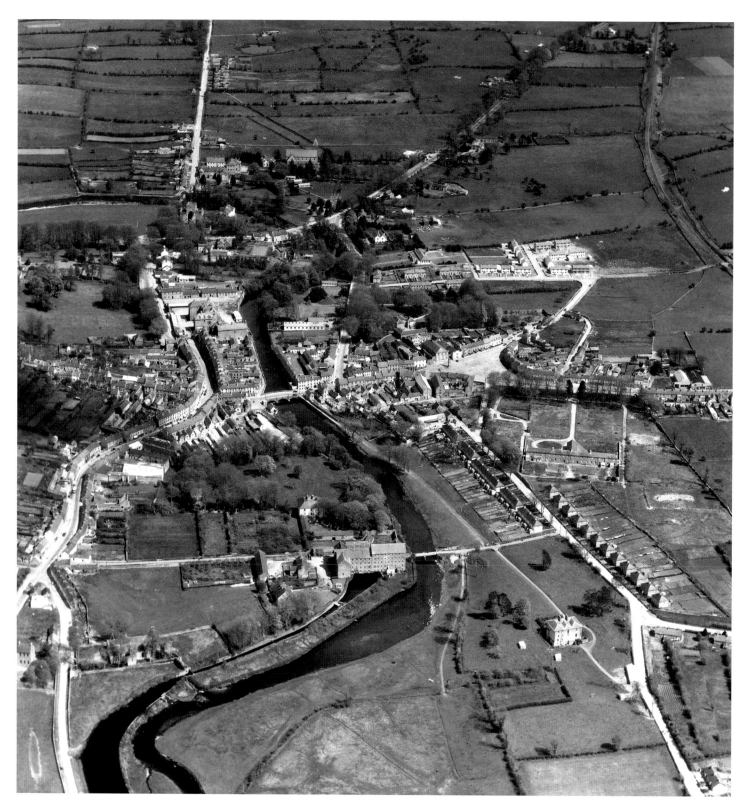

18 April 1952 Boyle, one of Roscommon's chief towns, through which passes the western highway to Sligo. The River Boyle winds through the town, on its way between Lough Gara and Lough Key. Towards the top left, by the river, is situated the renowned Boyle Abbey, the ruins of a Cistercian abbey, which was founded in the twelfth century and had associations with Mellifont Abbey, County Louth. **A70**

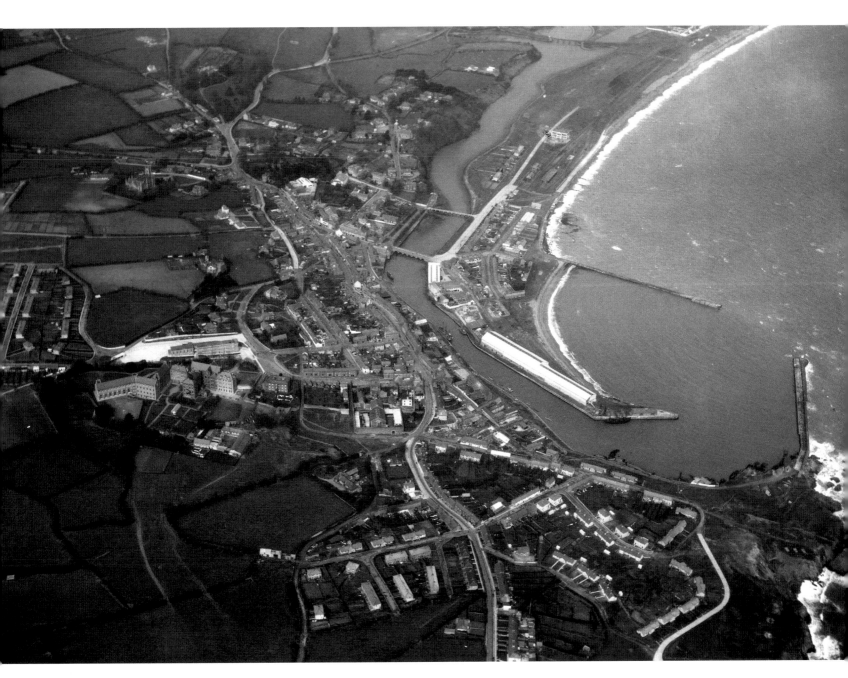

2 May 1952 Wicklow town. The narrow strip of land between the sweeping seafront and the mouth of the Vartry River carries the railway terminus. To the right of the harbour is the promontory leading to the famous Black Castle. The prominent group of buildings in the left foreground include the Dominican Convent and its secondary and national schools. **A447**

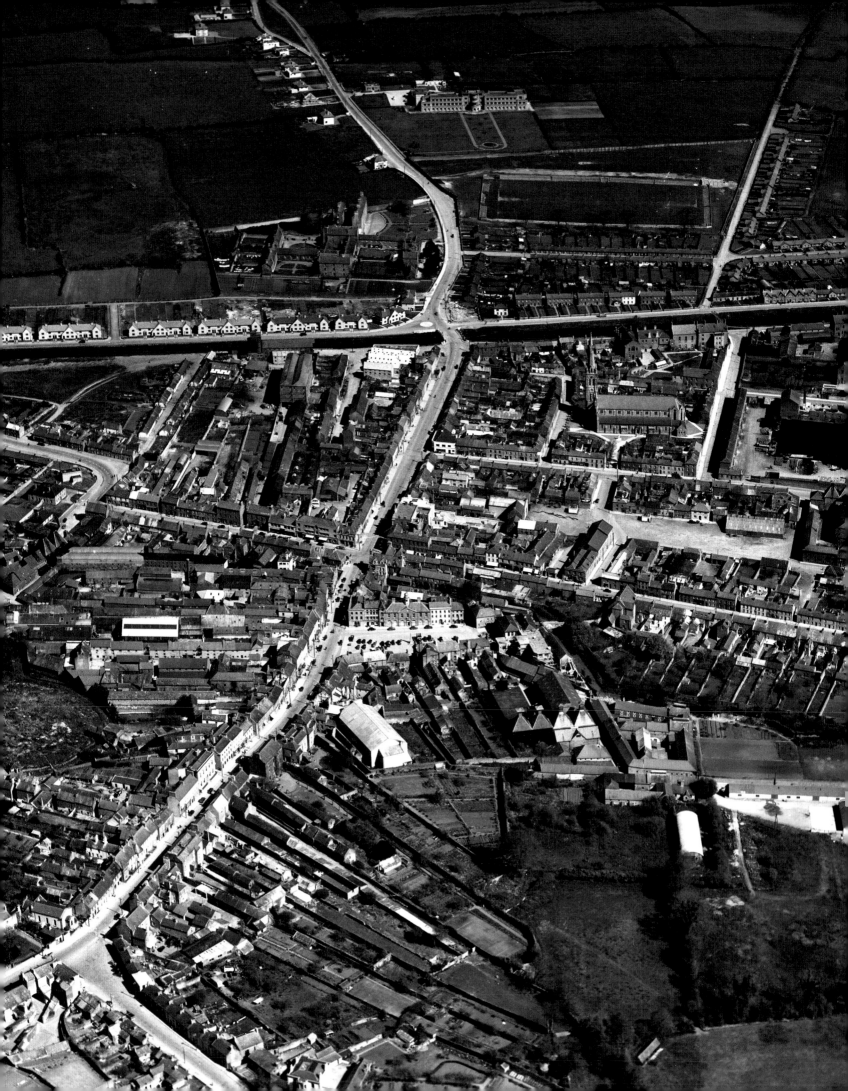

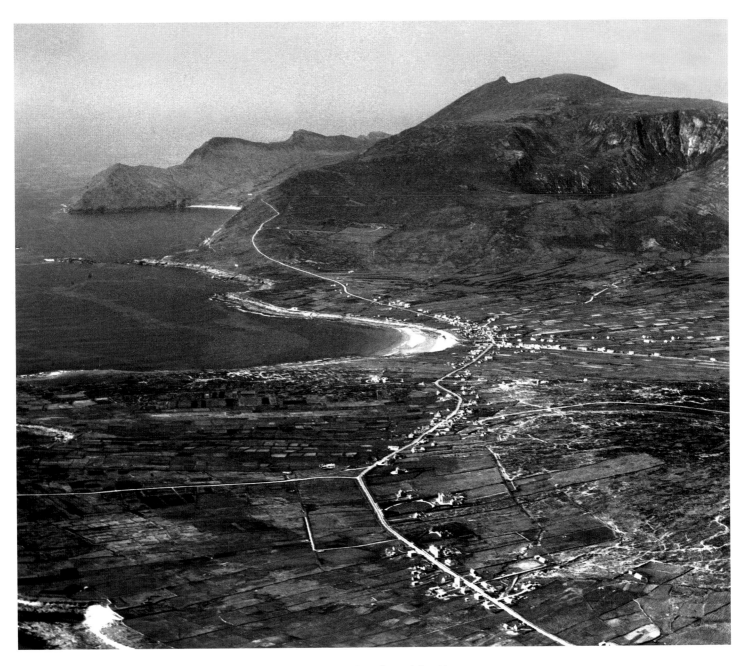

23 May 1952 Dooagh, the most westerly village on Achill Island, strung out along the road that skirts Croaghaun Hill and leads to Keem Bay, which is seen, partly hidden, in the distance. **A160**

9 May 1952 Tullamore, the chief town of Offaly, is a busy marketing and industrial centre. The Grand Canal cuts across the picture. The imposing Church of the Assumption is seen on the lower right. Tullamore has a fine county hall, and its disused jail is famous as the scene of William O'Brien's escape in the days of the land agitation. **A429**

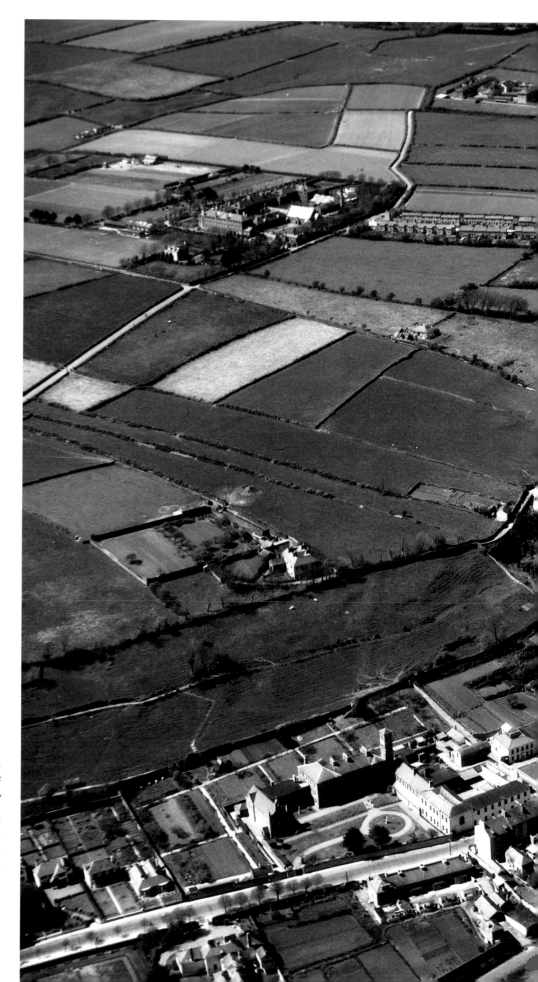

30 May 1952 Youghal – a favourite resort at the mouth of the Blackwater in Cork, with an unusual waterfront of a series of small harbours. The town claims many 'firsts' – Sir Walter Raleigh lived here, and introduced tobacco and potatoes to the country; South Abbey is said to have been the first Franciscan house in Ireland. Here was Cromwell's landing place. **A449**

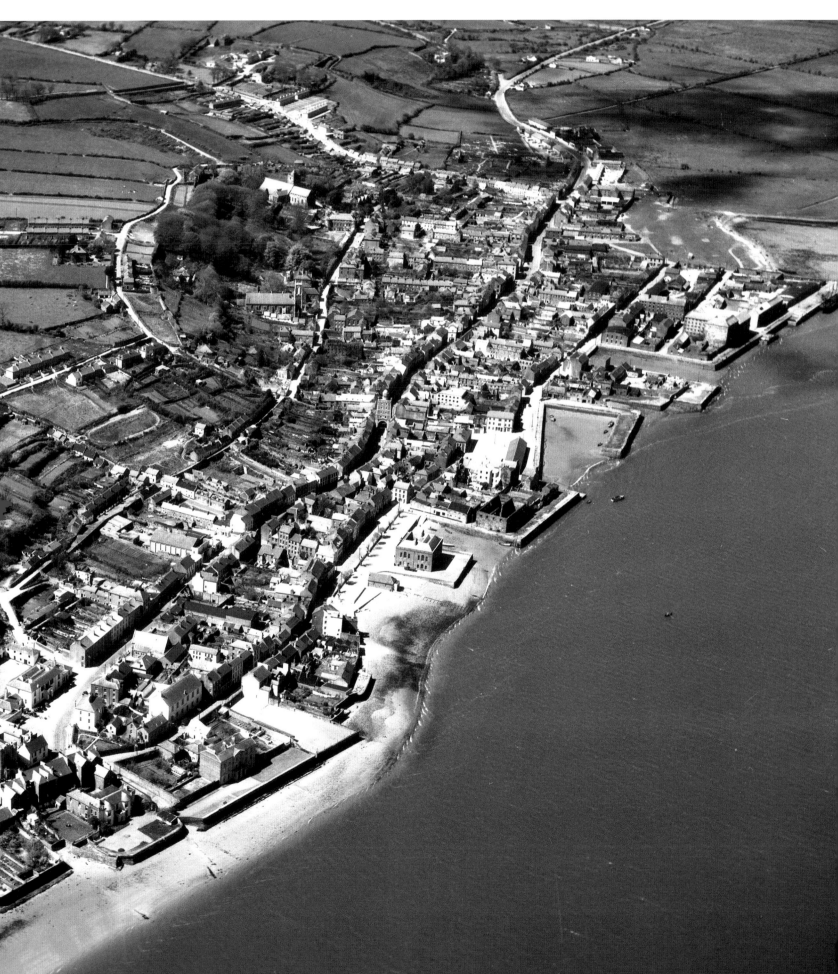

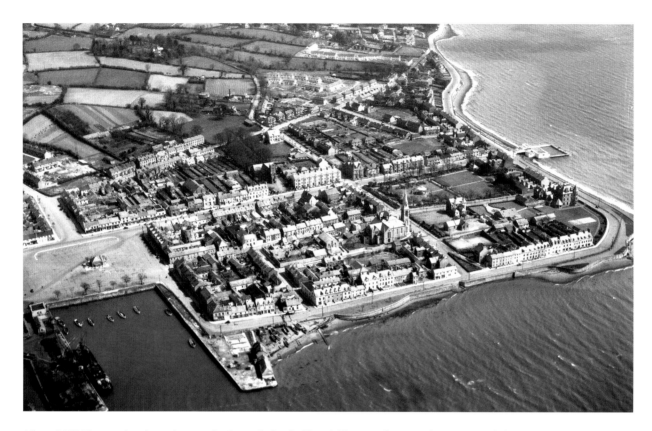

6 June 1952 Warrenpoint, situated on a projection on Carlingford Lough. This view shows to advantage its orderly layout with tidiness, enhanced by its spacious streets and promenade and well-surfaced coastal road. **A437**

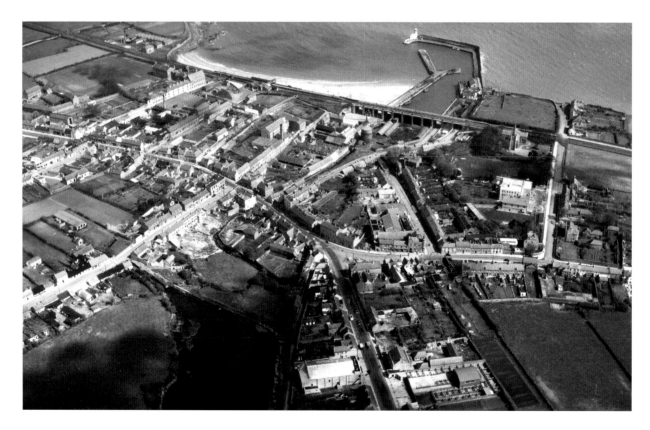

4 July 1952 Balbriggan, a north County Dublin coastal town, whose name is extensively linked with the hosiery and knitting industry. Its sheltered beach by the harbour is seen at the top of the picture. The prominent buildings to the top left are the Loreto Convent and schools; running in from the foreground is the busy highway from Dublin to Belfast. **A29**

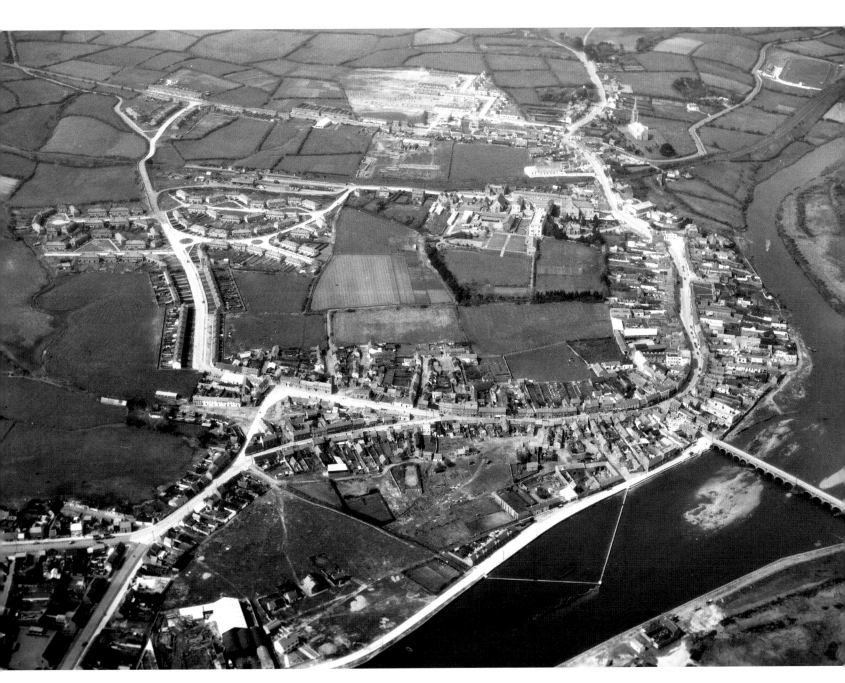

11 July 1952 Arklow, County Wicklow, on the Avoca River, bridged as it widens into the broad estuary which gives it its Irish name, *Inbhear Mór*. The town and districts are rich in historical associations, particularly with the 1798 Rebellion. **A18**

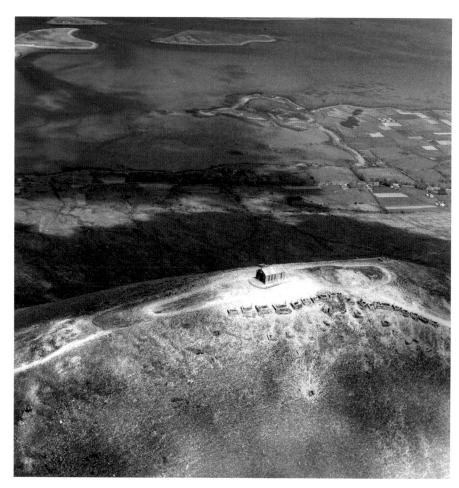

5 September 1952 Croagh Patrick, County Mayo. Usually viewed from the lower level, the little mountaintop oratory is here seen from a high angle. The boxlike row of stone shelters is also on the summit of 'The Reek'. Down at sea level Clew Bay stretches away to the top of the picture. **A141**

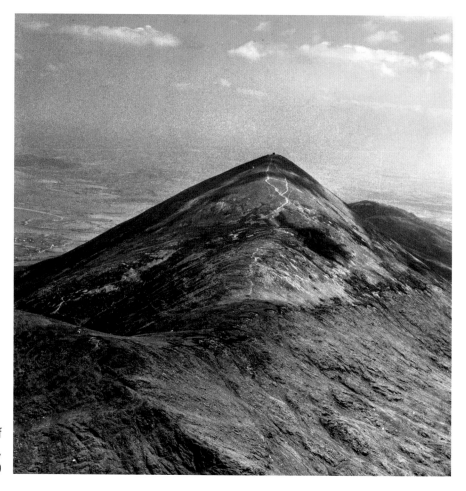

5 September 1952 An aerial view of Croagh Patrick, Ireland's sacred mountain, approaching from the west. **A140**

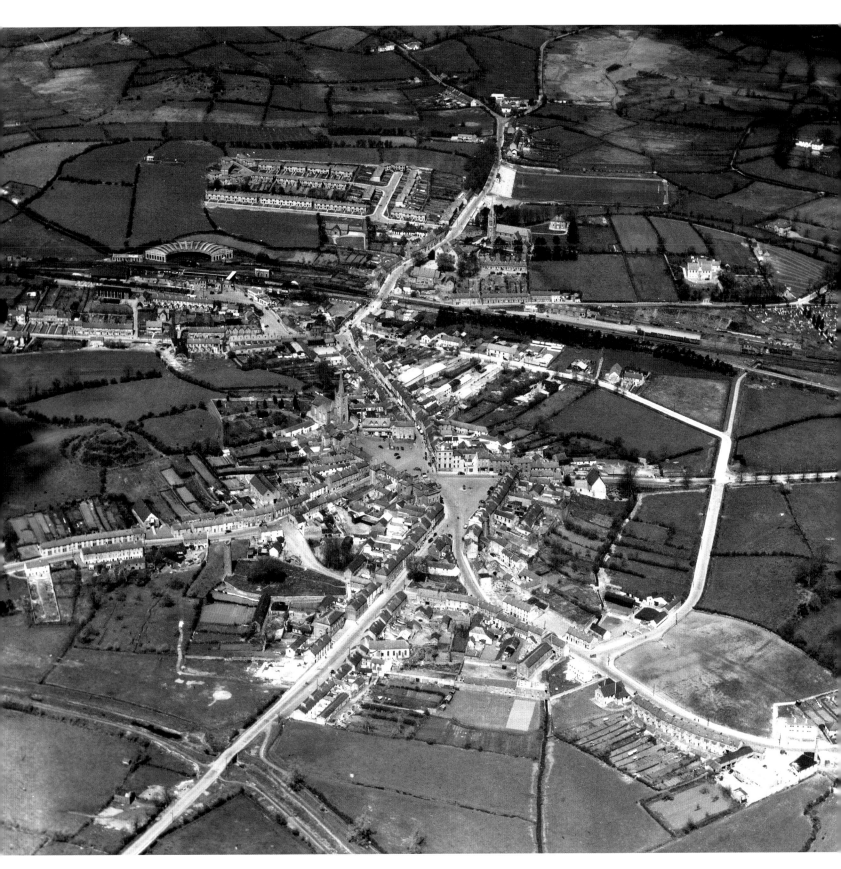

12 September 1952 The town of Clones in west Monaghan and close to the Fermanagh and Northern Ireland border. Its well-known landmark, The Diamond, is seen clearly as the picture's centrepiece. To the lower left stands the town's round tower in good preservation. **A119**

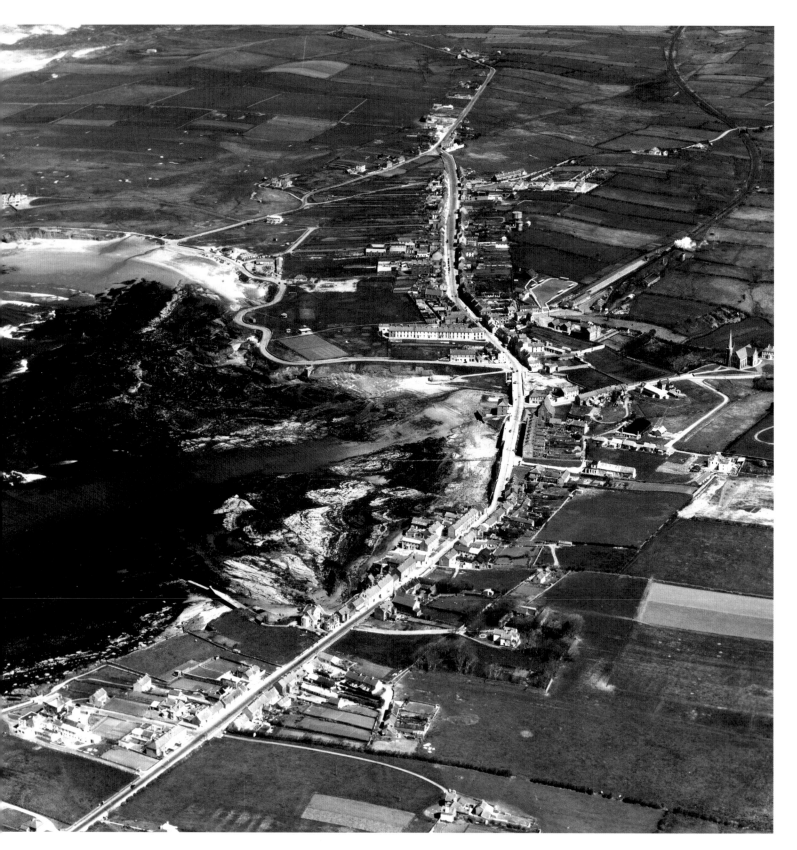

19 September 1952 Bundoran, Donegal Bay: backed by the Sligo–Leitrim mountains and facing the hills of Donegal to the north across the bay, Bundoran, with its fine sandy beach, has much to offer in the way of scenic beauty to the holidaymakers, who throng annually to this famous western resort. **A73**

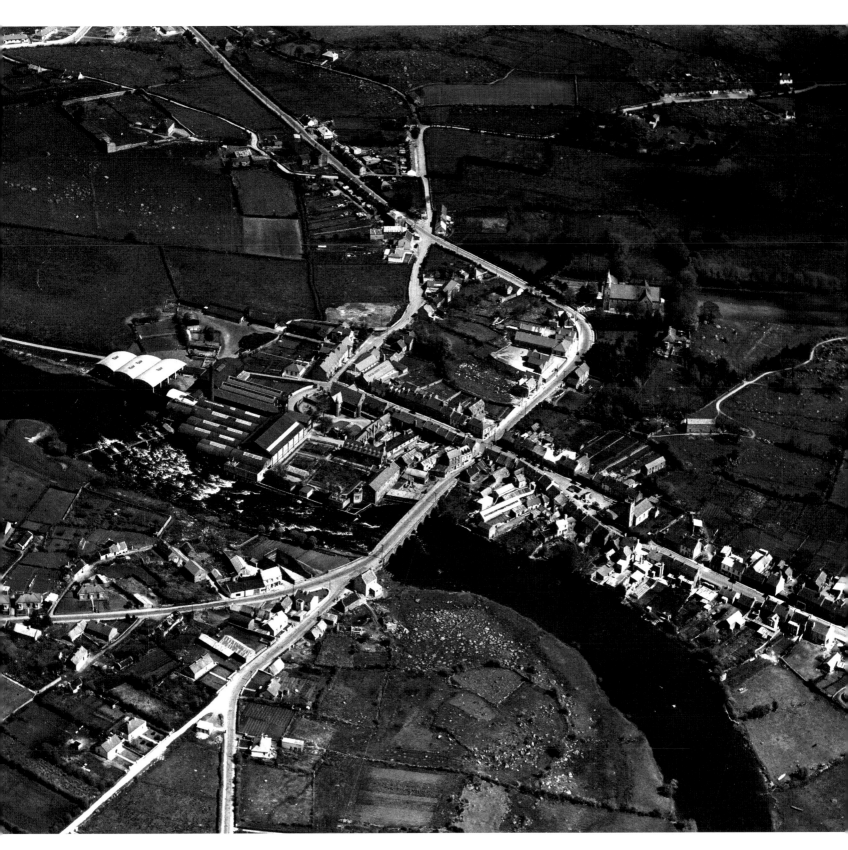

3 October 1952 About halfway between Ballina and Castlebar in County Mayo stands Foxford. This sizeable town, on the River Moy, is the centre of an important woollen industry. The river, its tributaries, and Loughs Callow and Muck to the east of the town provide excellent fishing. **A203**

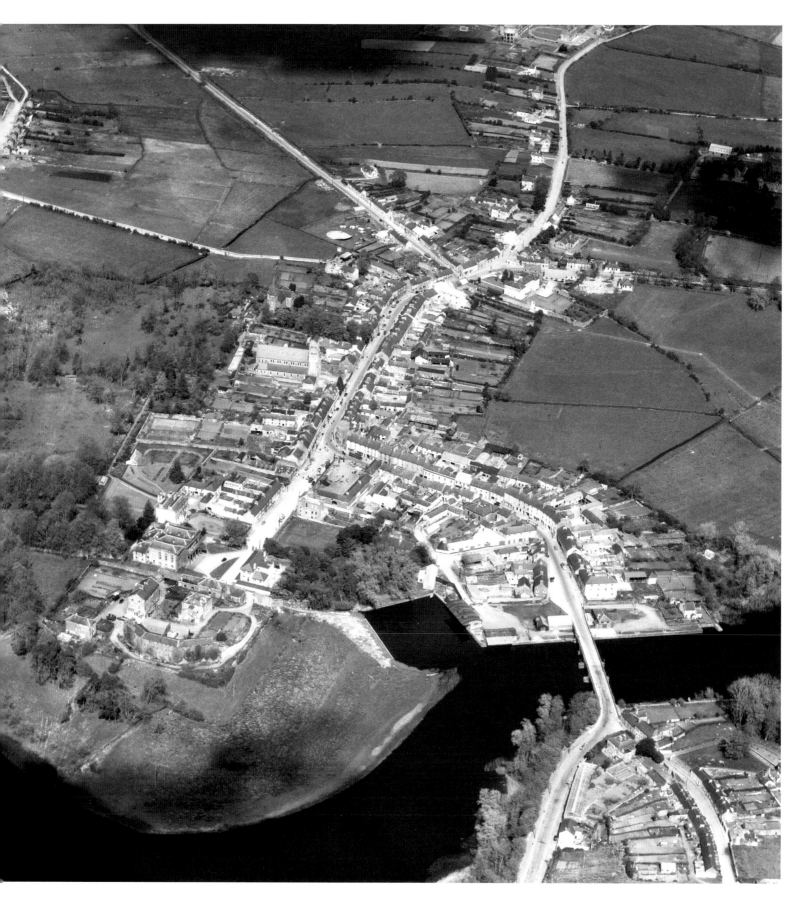

10 October 1952 Carrick-on-Shannon, county town and centre for the Leitrim lake district. The main Dublin–Sligo highway enters from the right of the picture, bearing left for the river bridge in the foreground. Beside the bridge is the harbour for the Royal Canal. **A89**

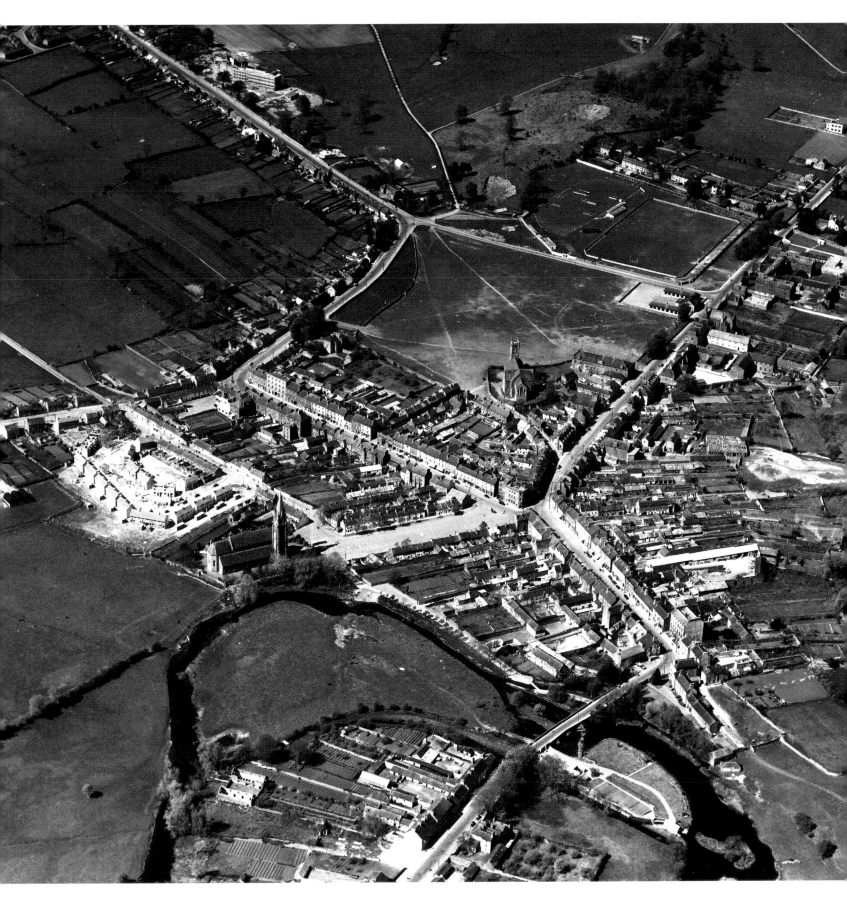

24 October 1952 Ballinasloe, first Connacht town on the way to Galway from Dublin, situated on the River Suck, at the provincial boundary of Leinster. It is famous for its great annual hostings of the October horse fair. **A34**

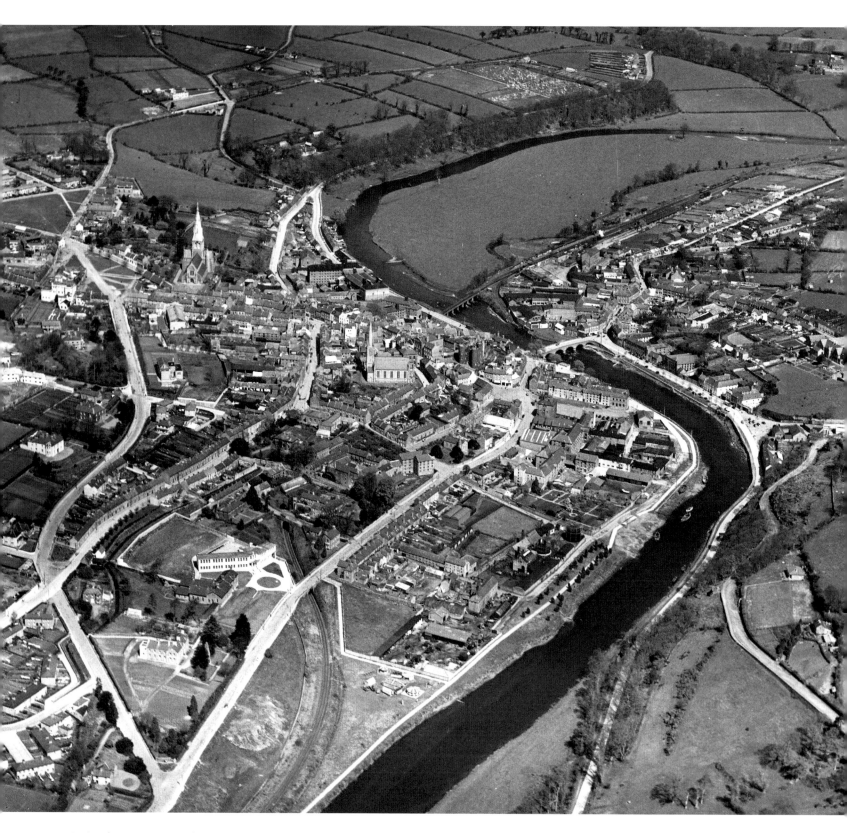

31 October 1952 Enniscorthy – Wexford's centre of 1798 history. Its winding, navigable river, spanned by impressive bridges, makes a graceful picture from the air. The Norman castle stands near the first bridge. **A195**

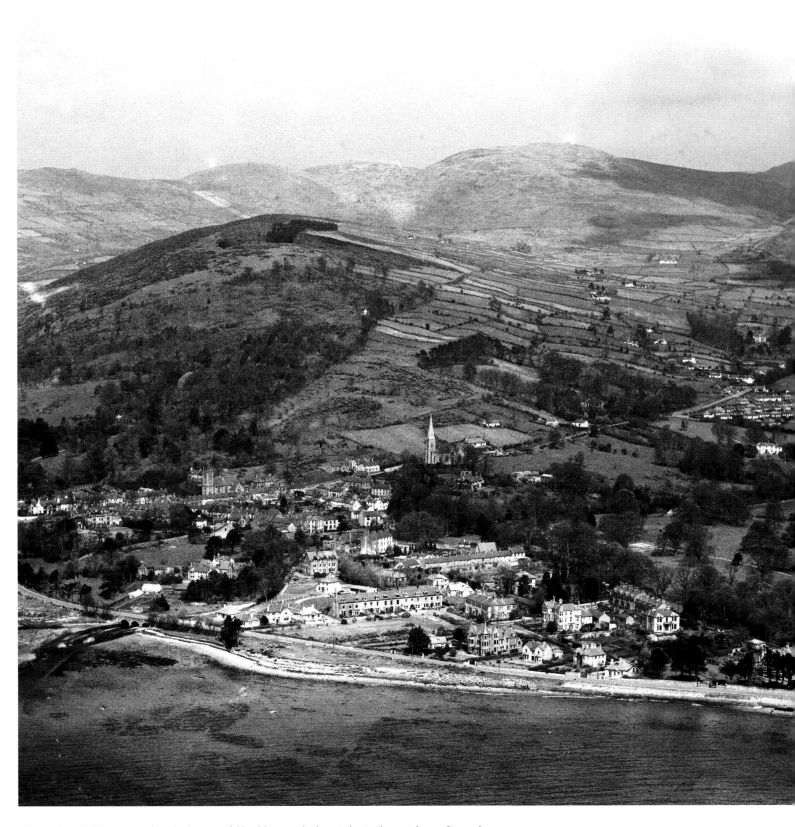

7 November 1952 Rostrevor, described as a restful health resort, looks just that in this aerial view. Situated on the shore of Carlingford Lough in County Down it has a background of wooded hills, sweeping up to the Mourne Mountains. **A354**

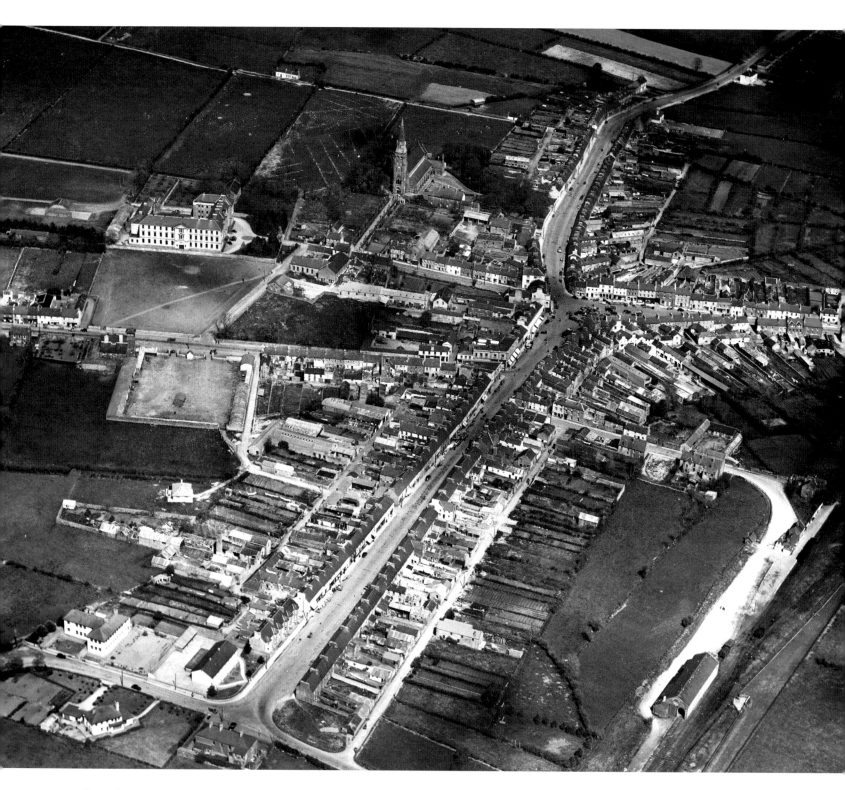

14 November 1952 Ballaghaderreen, County Roscommon, lies in the Lough Gara area. This is the cathedral town for the Diocese of Achonry. St Nathy's College and the cathedral stand prominently to the top left of the picture. **A31**

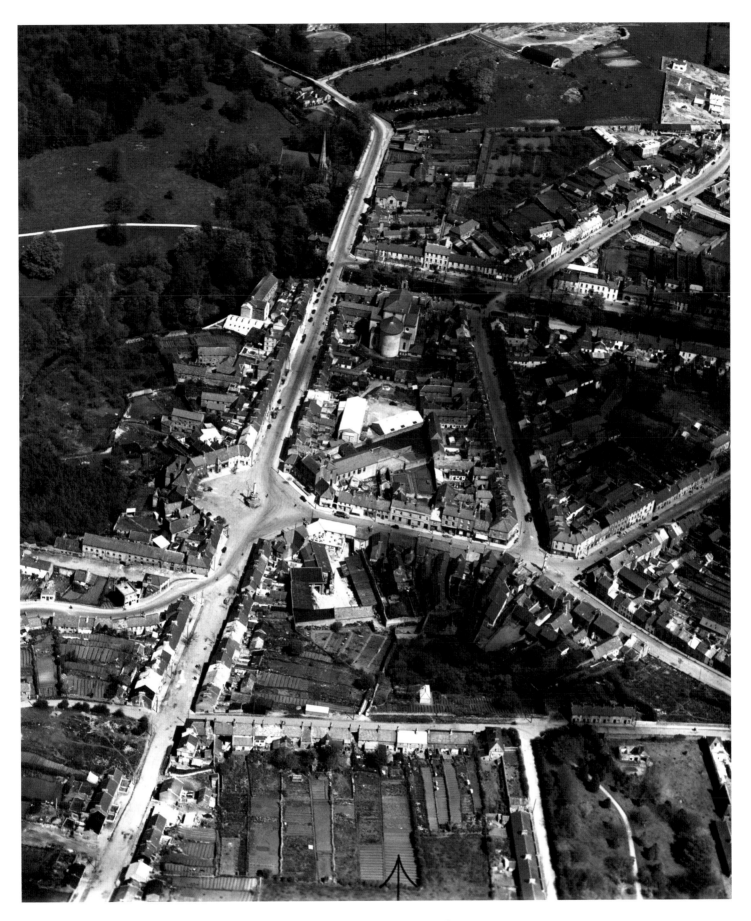

21 November 1952 Westport – the Mayo town, situated amidst trees which enhance its surroundings and even enter the town to grace the Mall on both sides of the river. The new Catholic church on the Mall is seen near the centre of the picture. **A444**

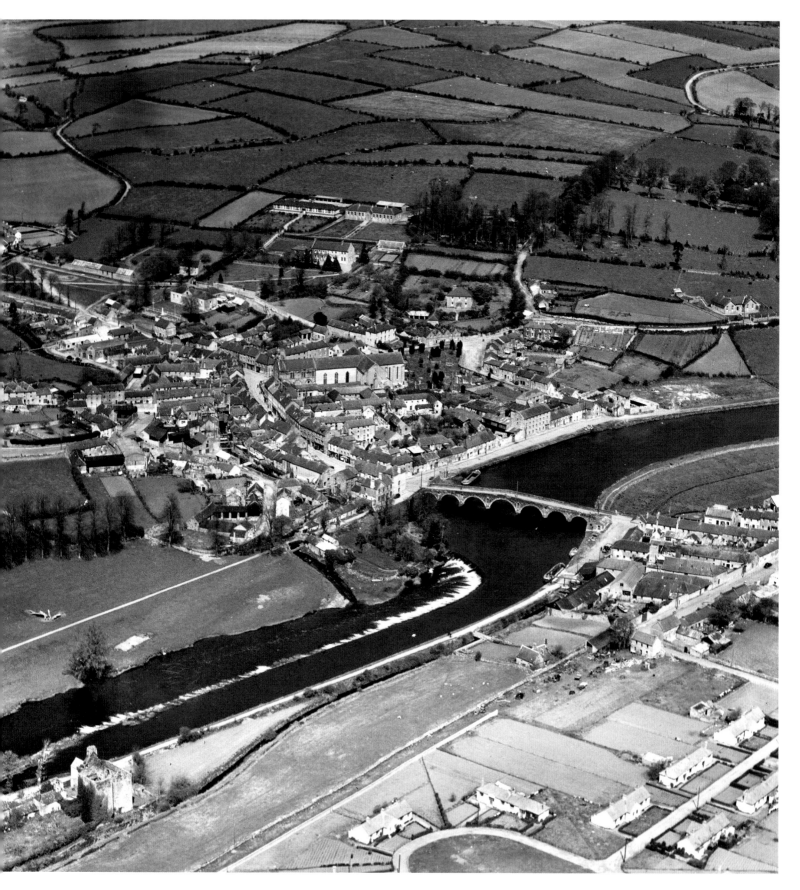

5 December 1952 Graiguenamanagh in County Kilkenny, a marketing centre, is picturesquely placed on the River Barrow. Its antiquity is vouched for in its name, which means 'Village of the Monks'. Of its local industries, the woollen mills are the mainstay. **A218**

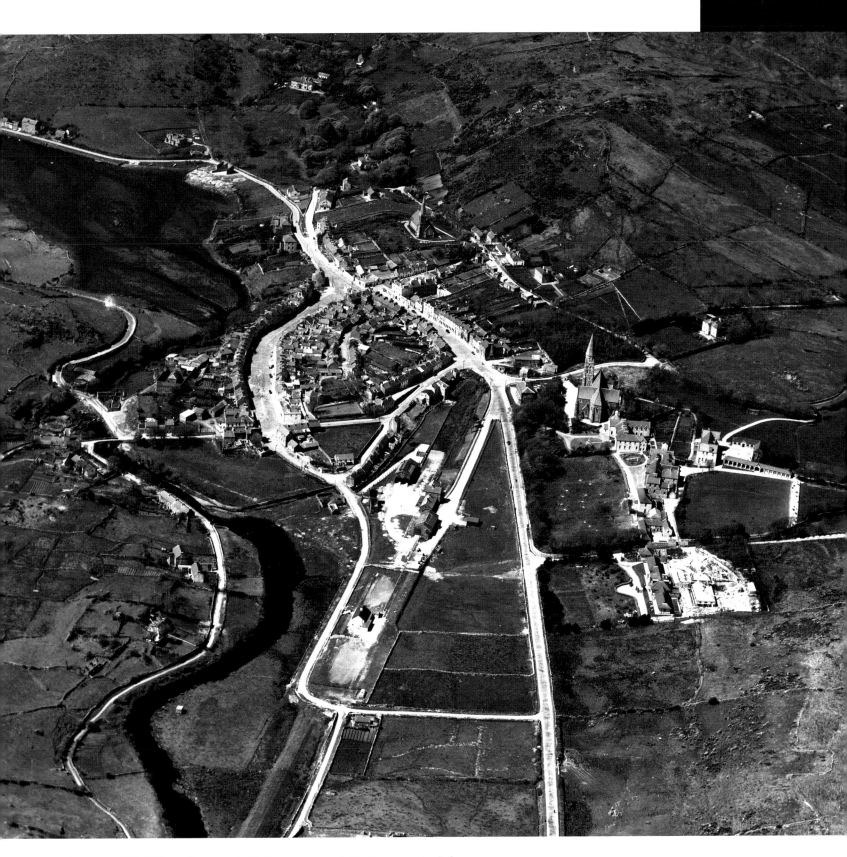

2 January 1953 Clifden – Connemara's chief town – surrounded by the treasure land of mountain, river and bog that makes it a favourite for sportsmen and artists alike. The winding roads indicate the rugged nature of the area in which it lies. **A114**

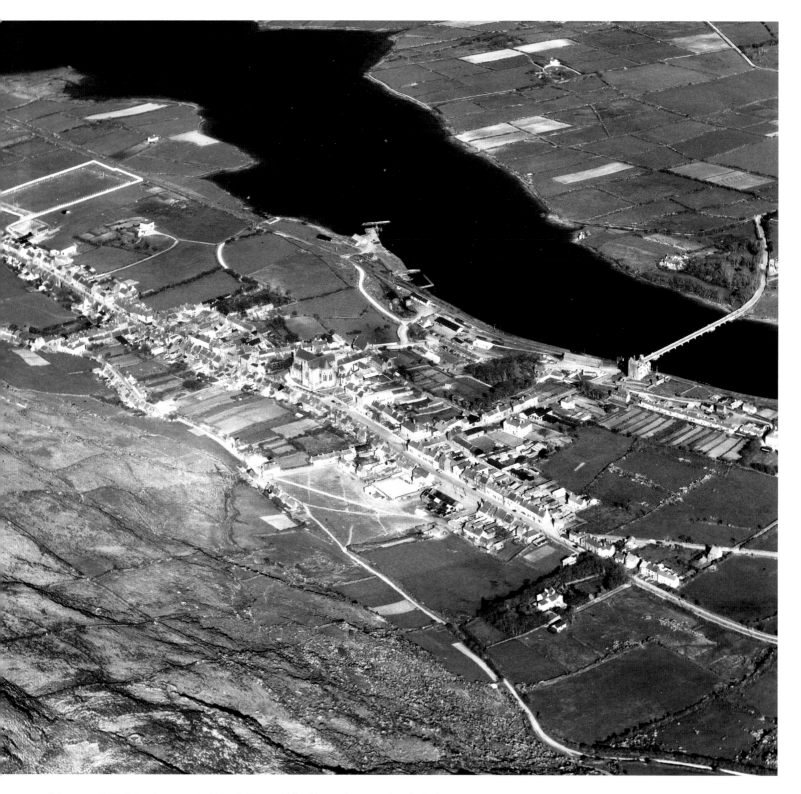

9 January 1953 Cahersiveen, on the Valentia River, which widens as it approaches the harbour. The impressive memorial church to Daniel O'Connell, in the heart of whose Kerry county the town stands, is seen in the centre of the picture. The parish priest of Cahersiveen, Very Rev. J. Canon Lane, is at present with the Most Rev. Dr D'Alton's party in Rome. **A78**

16 January 1953 St Patrick's Cathedral, Armagh, with the Diocesan College on the right and in between, Ara Coeli, the residence of the primate of All Ireland, his Eminence Cardinal D'Alton. **A21**

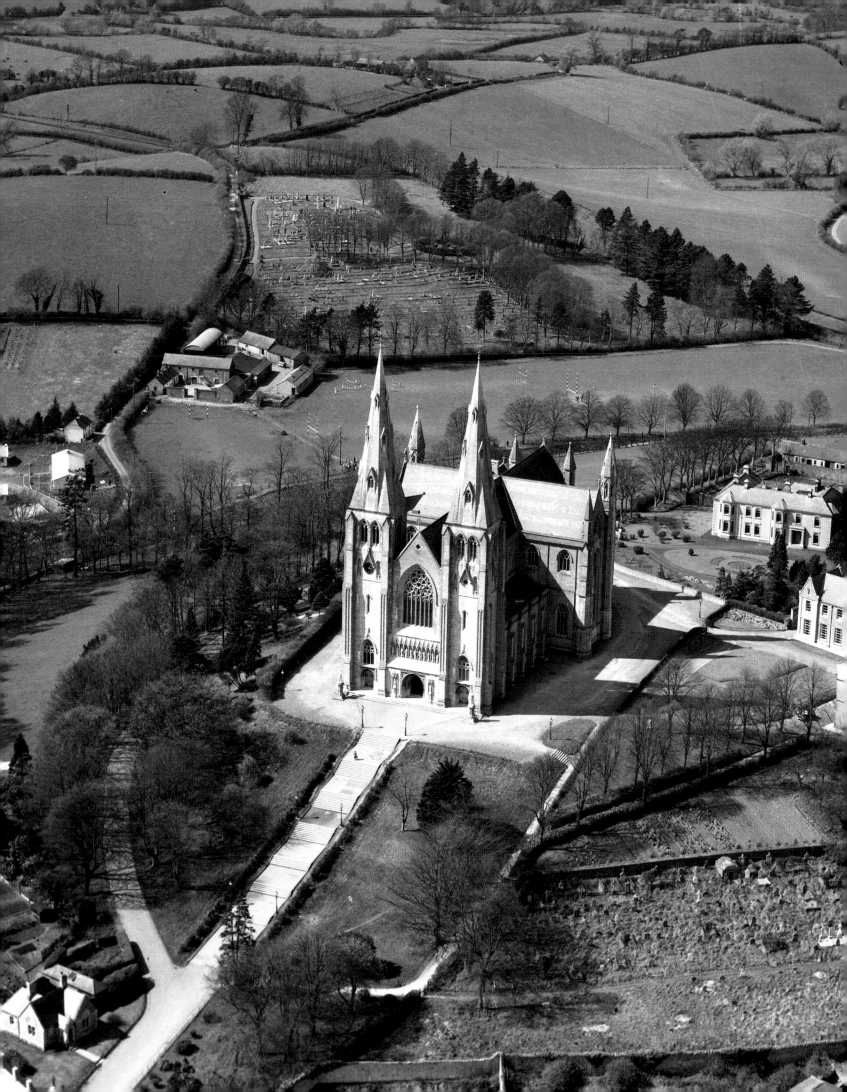

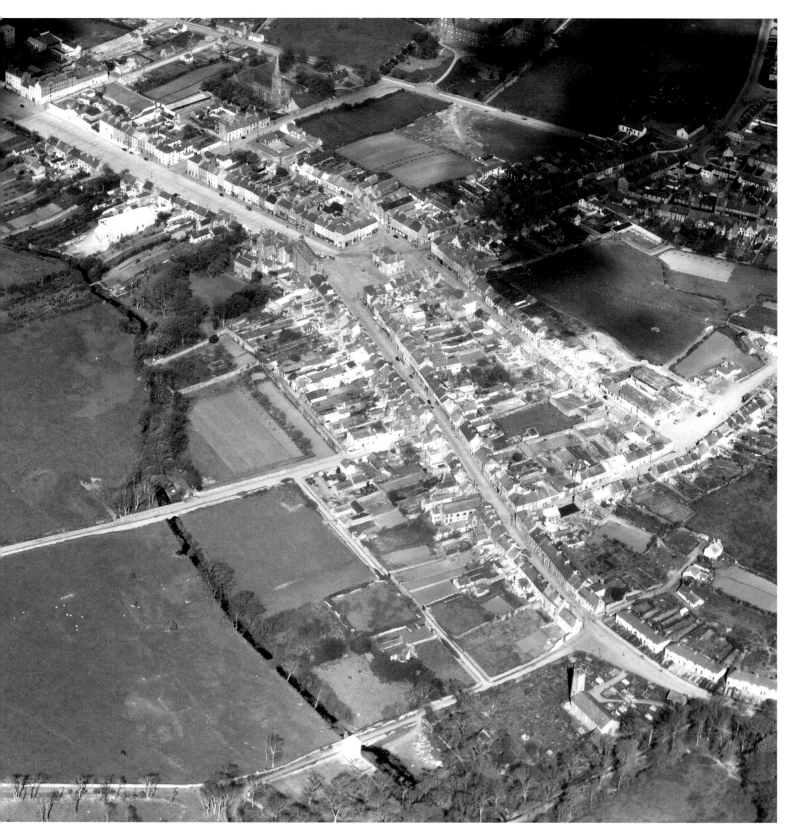

23 January 1953 Kilrush, second largest town in Clare and a keen marketing centre. Its open square and wide approach to it occupy the centre of the picture. **A246**

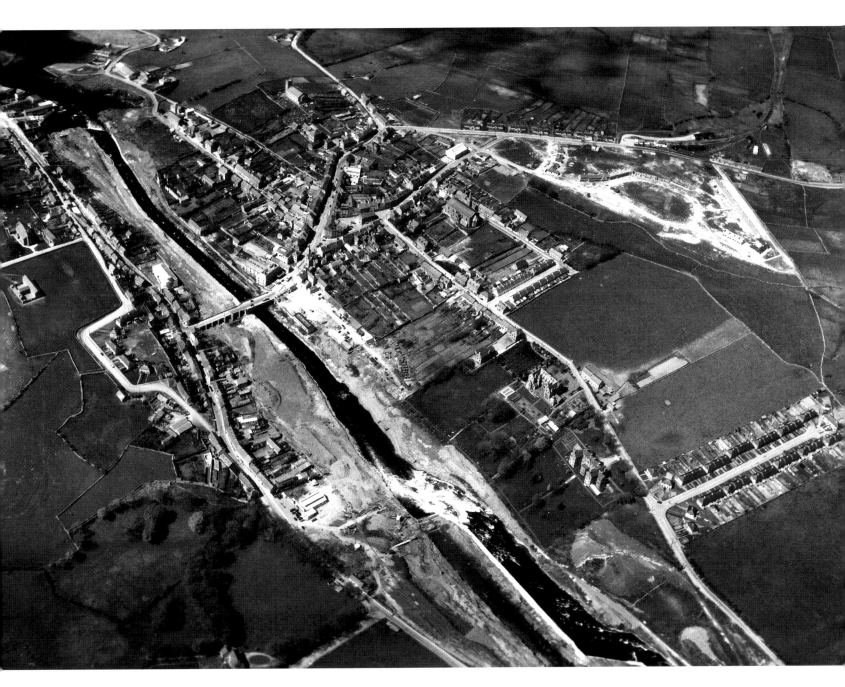

30 January 1953 Ballyshannon, a south Donegal town on the rising banks of the Erne River. The river cuts its way vigorously to the estuary over the falls, on the way from the great Lough Erne, which has been harnessed for hydroelectric purposes. **A45**

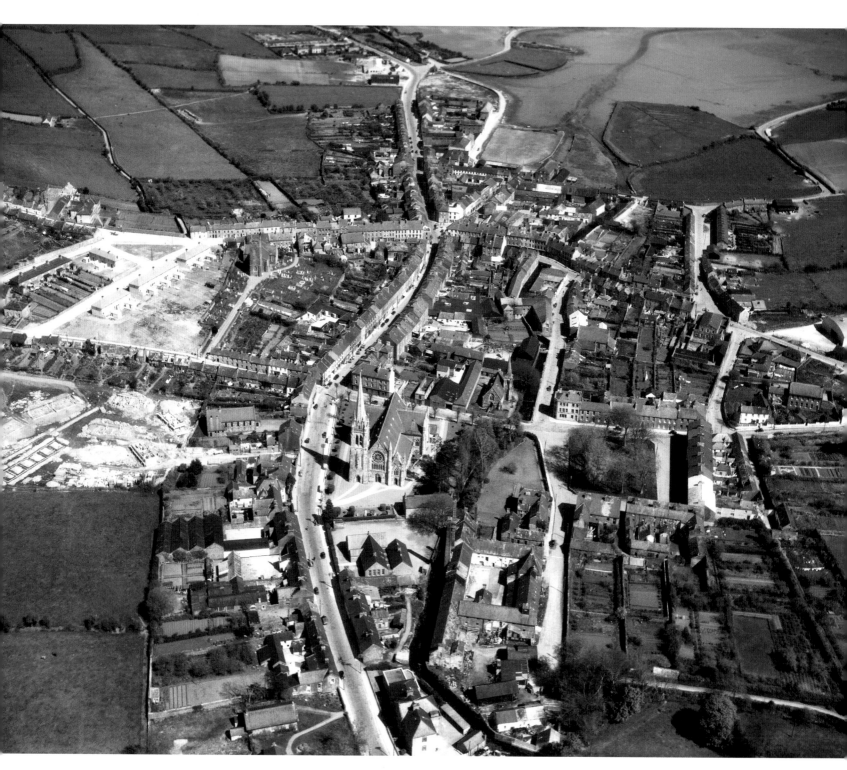

6 February 1953 Clonakilty, on the southern shores of County Cork, is an important town for the surrounding fertile agricultural district. It has a notable Gothic-style edifice for its Catholic church. **A117**

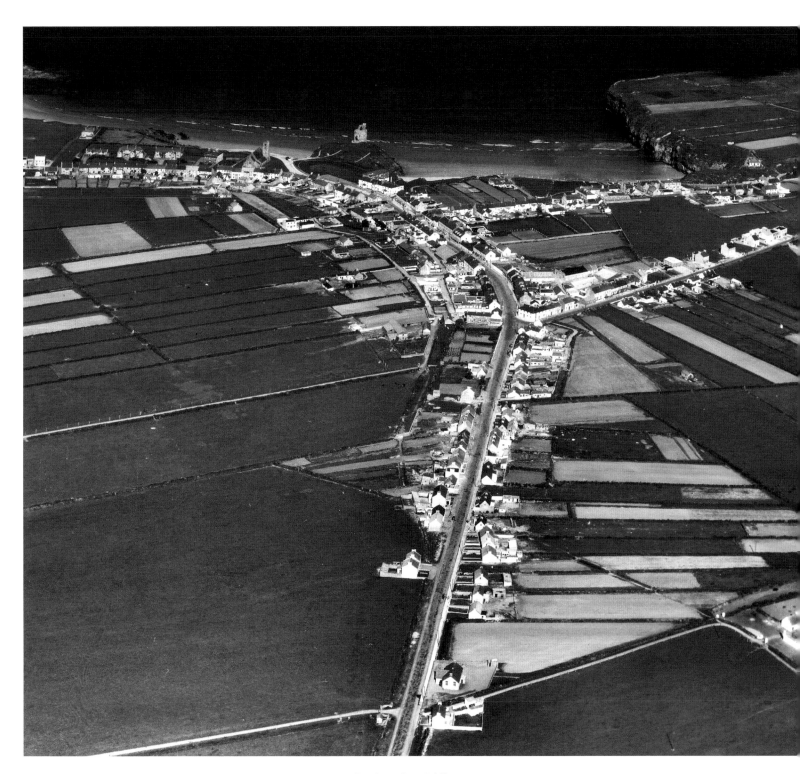

13 February 1953 Ballybunion, in north-west Kerry, with its sheltered strand and cave-bored cliffs, is a favourite holiday town. Its landmark, the castle ruin, overlooking the strand, stands out clearly. **A37**

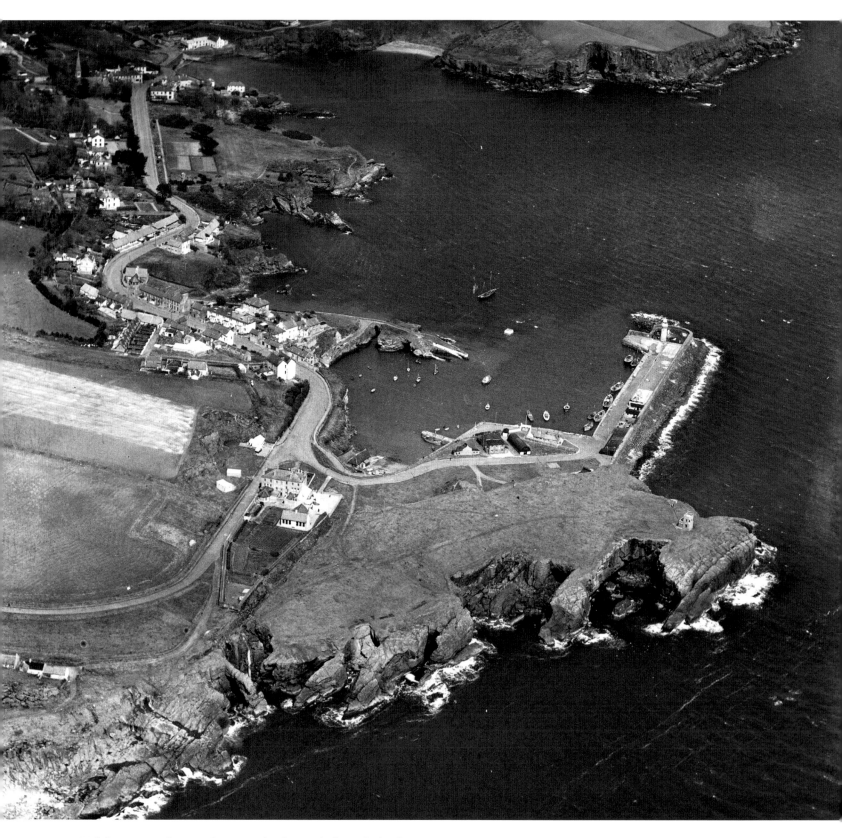

20 February 1953 Dunmore East, situated at the mouth of Waterford Harbour, nine miles from the city. Its many coves add to the charm of this picturesque seaside resort, noted for its sea fishing. **A187**

27 February 1953 Borris, County Carlow, in the picturesque Barrow Valley.
The Main Street skirts the lovely demesne of Borris House. **A69**

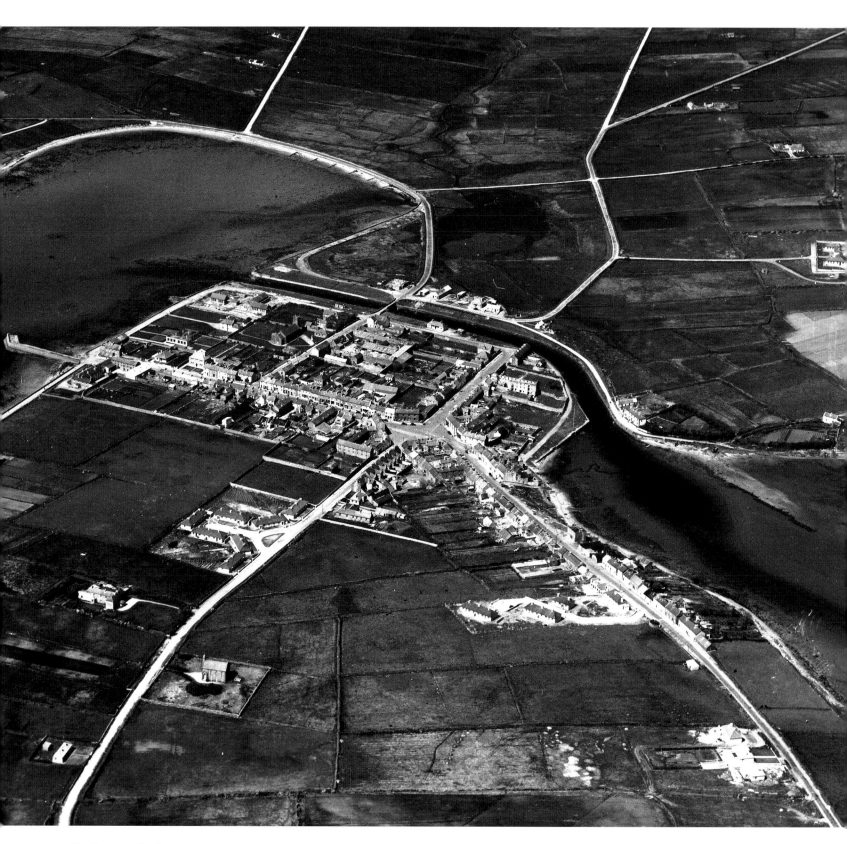

6 March 1953 Belmullet: gateway to the bleak Mullet Peninsula in north Mayo. Its several roads, extending through good bogland, show up prominently in the picture. They lead to outlying Atlantic points, like Erris Head and Blacksod Point. **A60**

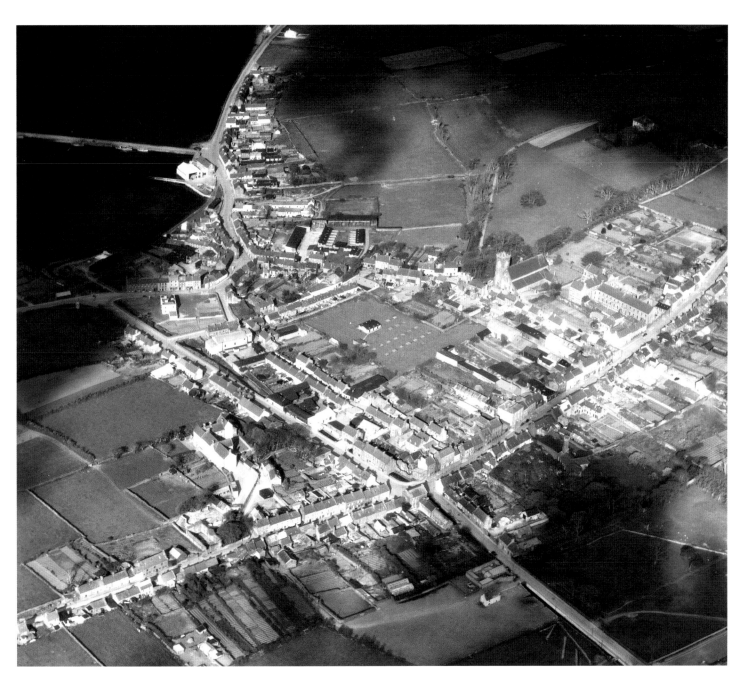

13 March 1953 Dingle. Out on the extreme west of Kerry, the town was once the chief port for the county, and had lively associations with the old Spanish trading days. In its vicinity lie many places of first-rate tourist interest. **A148**

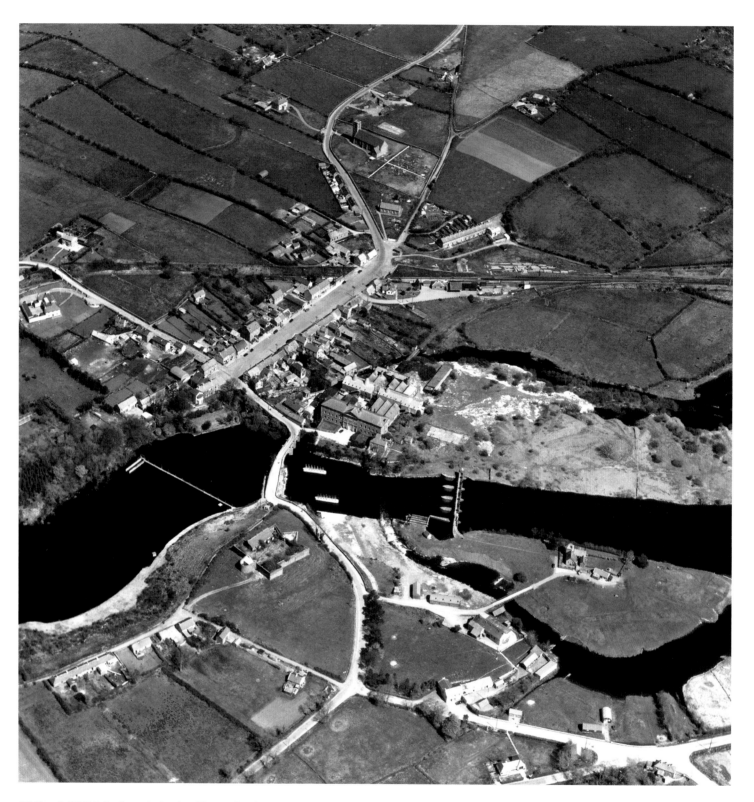

20 March 1953 Belleek, on the border of Donegal and Fermanagh, by the River Erne. The name of the town is famed far afield, having given its name to lustrous chinaware and pottery. **A59**

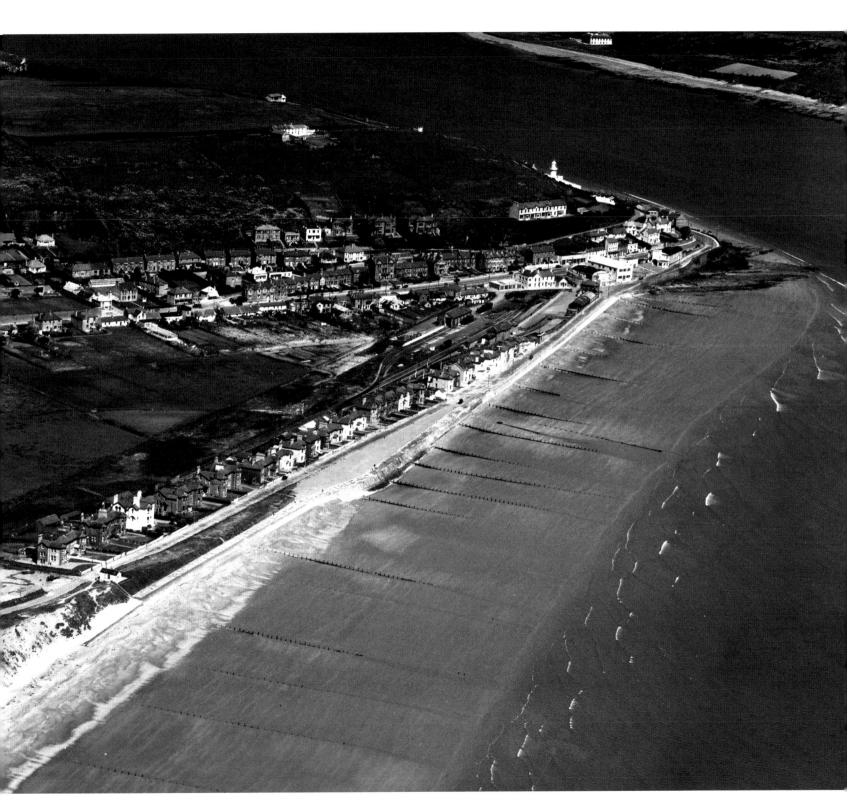

27 March 1953 Youghal Strand, at the mouth of the Blackwater River and in the shelter of Youghal Bay, is a favourite resort for those who like a pleasant strand and well-developed recreational amenities. **A450**

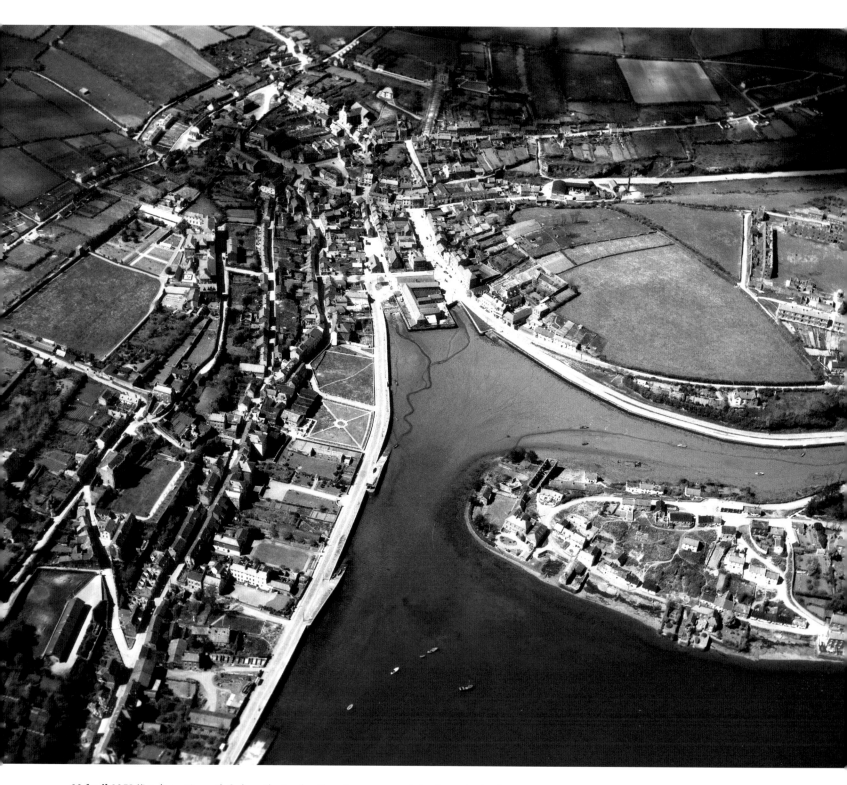

10 April 1953 Kinsale port in south Cork: on the Bandon River, its many ancient structures stand to its lively part in early Irish history, the outstanding event being the siege of 1602, which preceded the famous retreat by the men of O'Sullivan Beare. **A251**

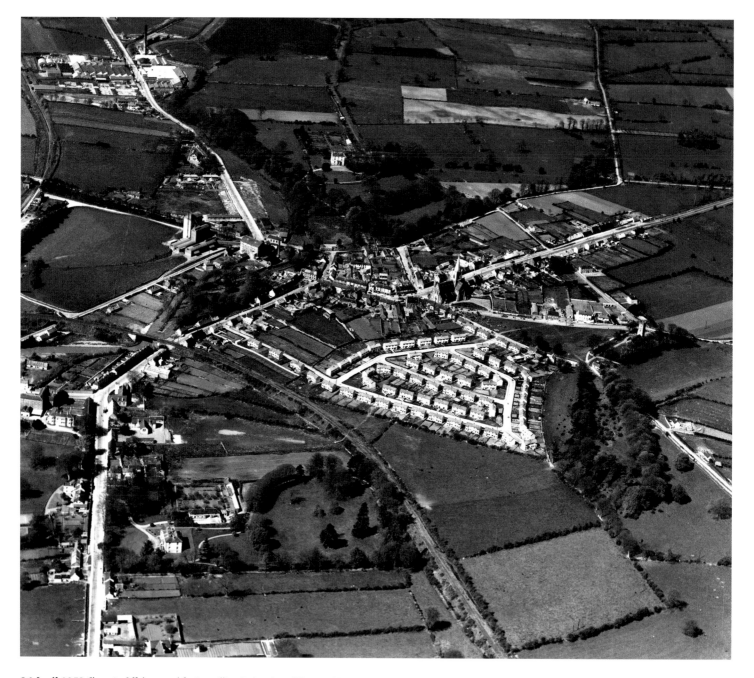

24 April 1953 Clara, in Offaly, noted for its milling industries of flour and jute, has its factories and homes placed in a rural setting. **A110**

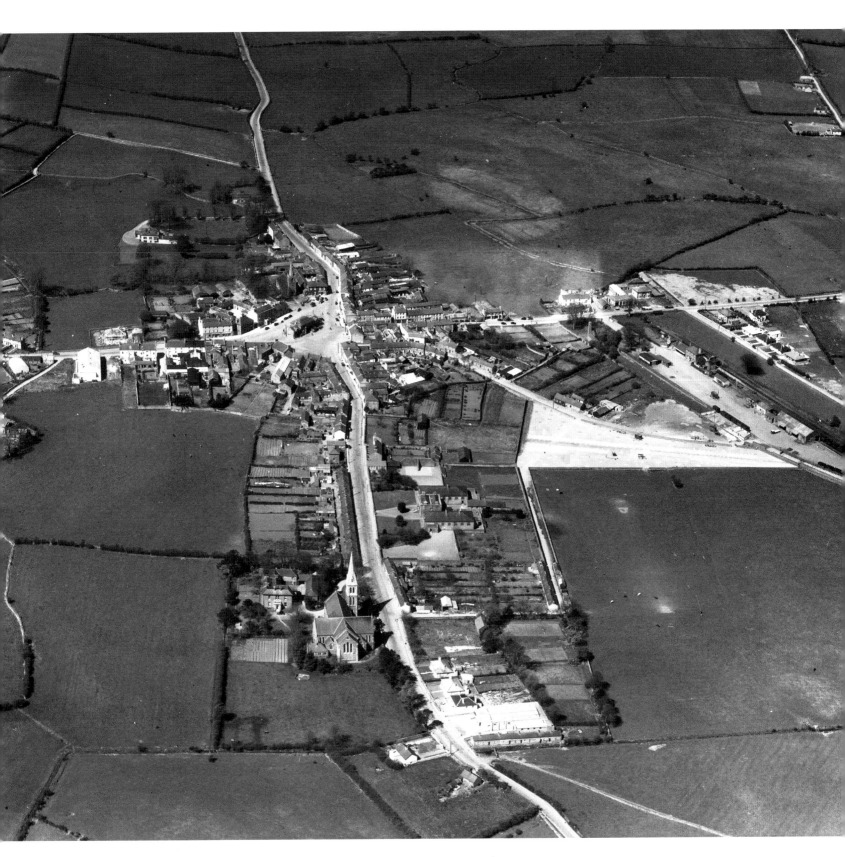

1 May 1953 Oldcastle, on the western boundary of Meath, is a centre for angling in the Cavan and Westmeath lake districts. In the vicinity of the town is Loughcrew, birthplace of Blessed Oliver Plunkett. **A338**

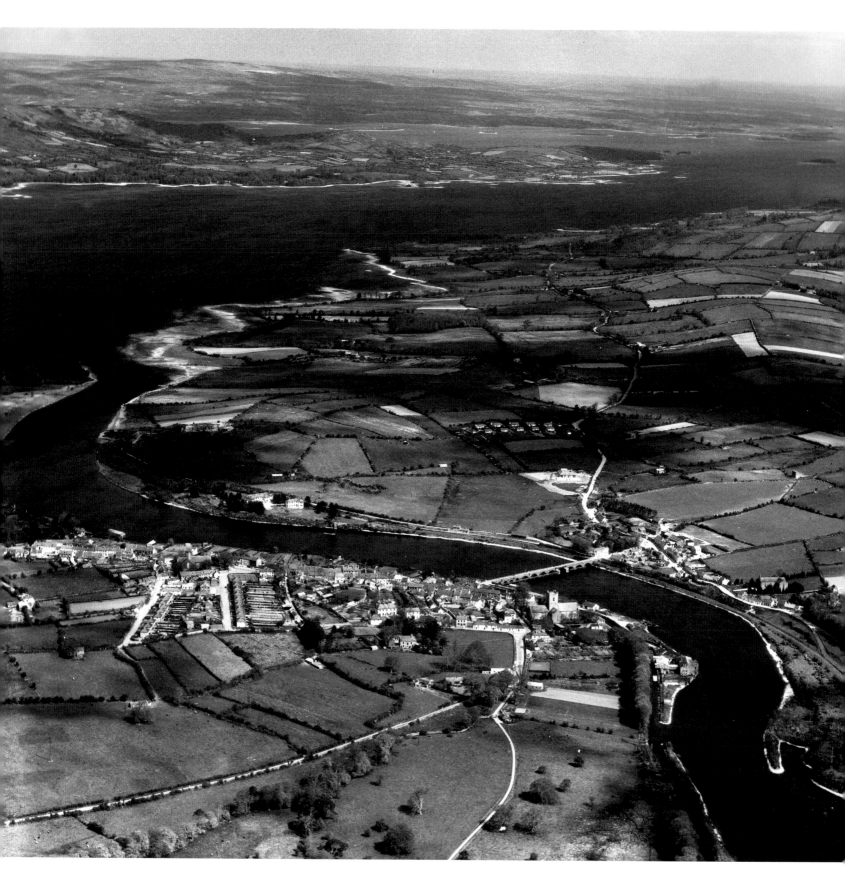

15 May 1953 Killaloe, County Clare, on the banks of the Shannon with Lough Derg in the background. The thirteen-arch bridge links the town with the village of Ballina in County Tipperary. The twelfth-century cathedral is discernable near the bridge. **A237**

22 May 1953 Rosscarbery, a compact little town in Cork, on the shore of the bay of the same name, where the bathing is good. The cathedral stands near the site still marked by a few remains of the sixth-century monastery of St Fachnan. **A350**

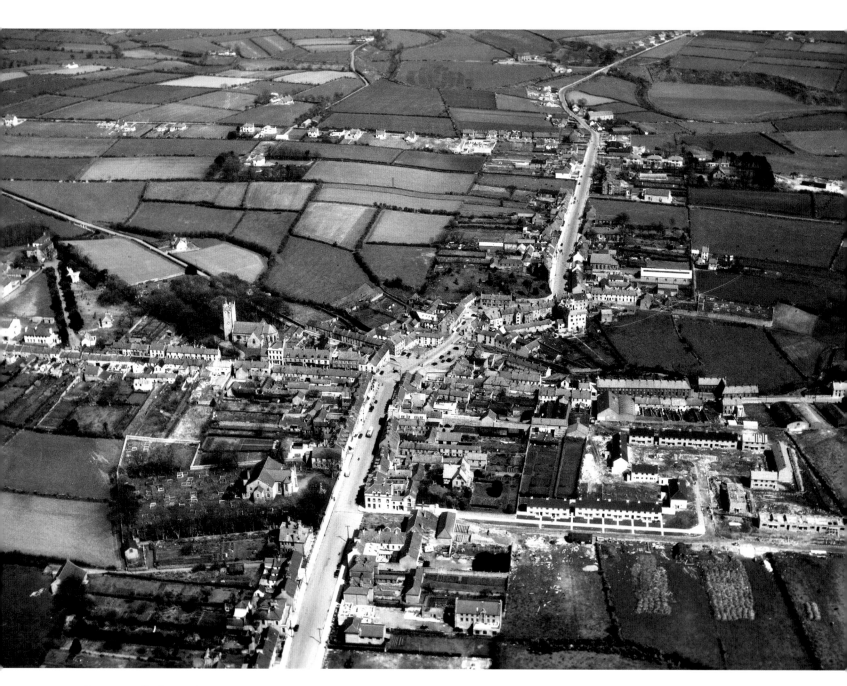

29 May 1953 Kilkeel, a trim little town with a good harbour in County Down, is the home port of a large fishing fleet. Good salmon and trout fishing also abound in the locality, and the town is an excellent centre for exploring the sheltering Mournes. **A233**

5 June 1953 Listowel, in north Kerry, on the main route between Limerick and Tralee.
An inland town on the River Feale, it has a racecourse of note. **A268**

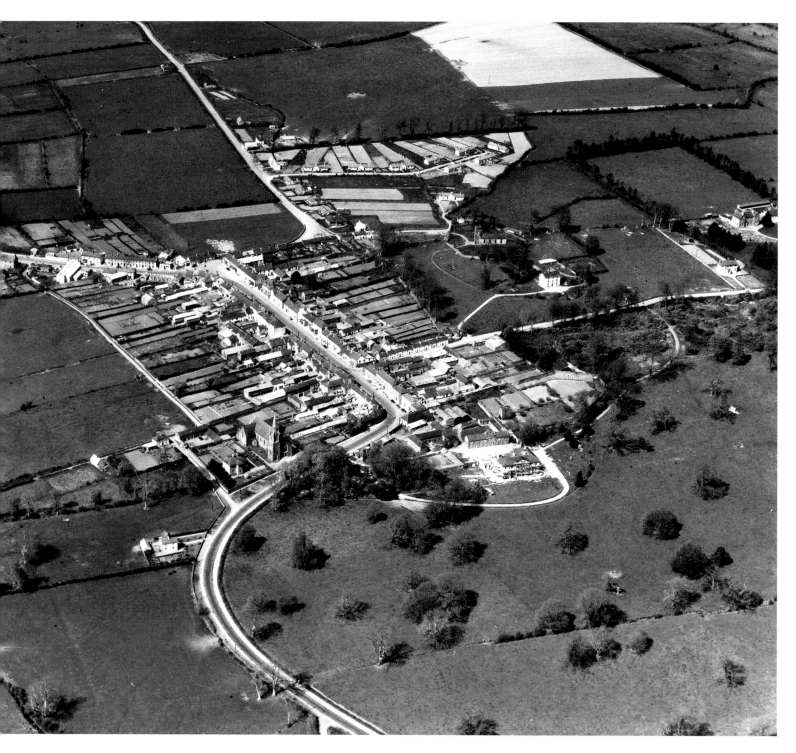

12 June 1953 Edgeworthstown, in County Longford, on the Dublin–Sligo highway. The town takes its name from the Edgeworth family, who settled here in the sixteenth century. Richard Lovell Edgeworth, inventor and educationalist, and his daughter, Marie Edgeworth, the novelist, are interred in the churchyard of St John's. **A192**

26 June 1953 Lisburn, a busy Antrim town with the River Lagan operating its linen mills. A Huguenot established the industry there in the seventeenth century. The cathedral spire dominates a clean-cut market place. **A266**

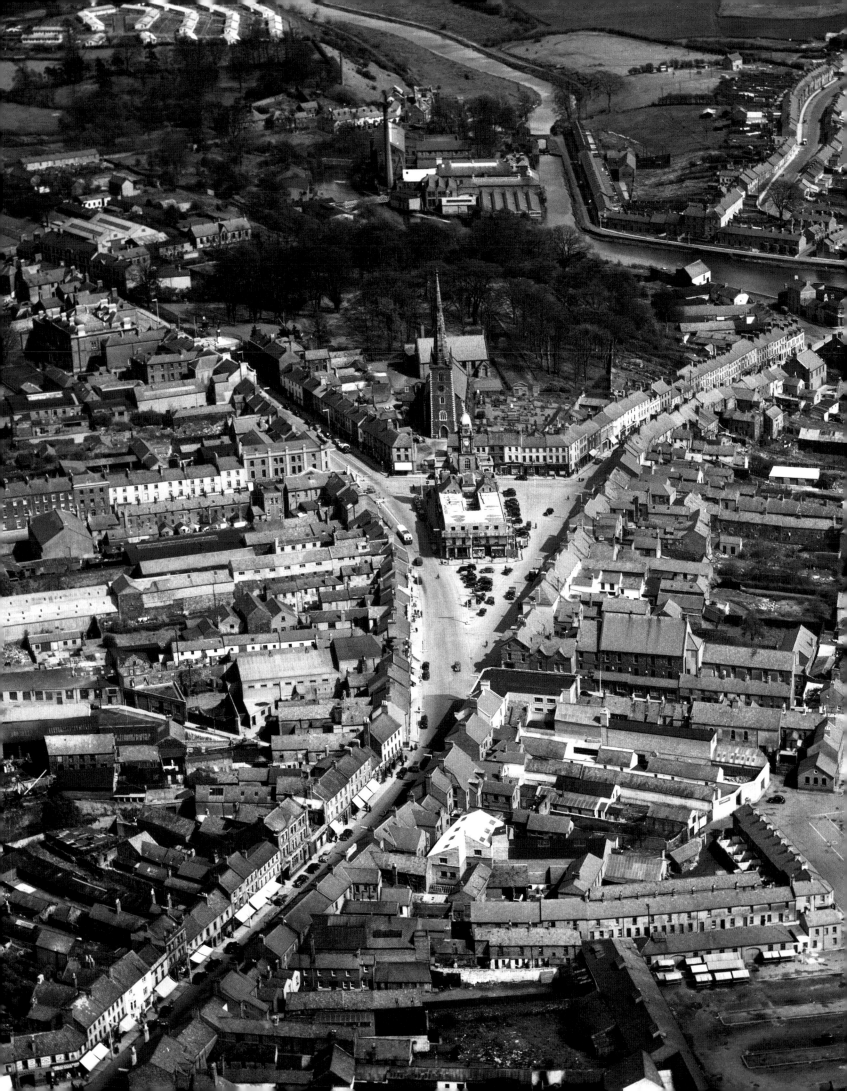

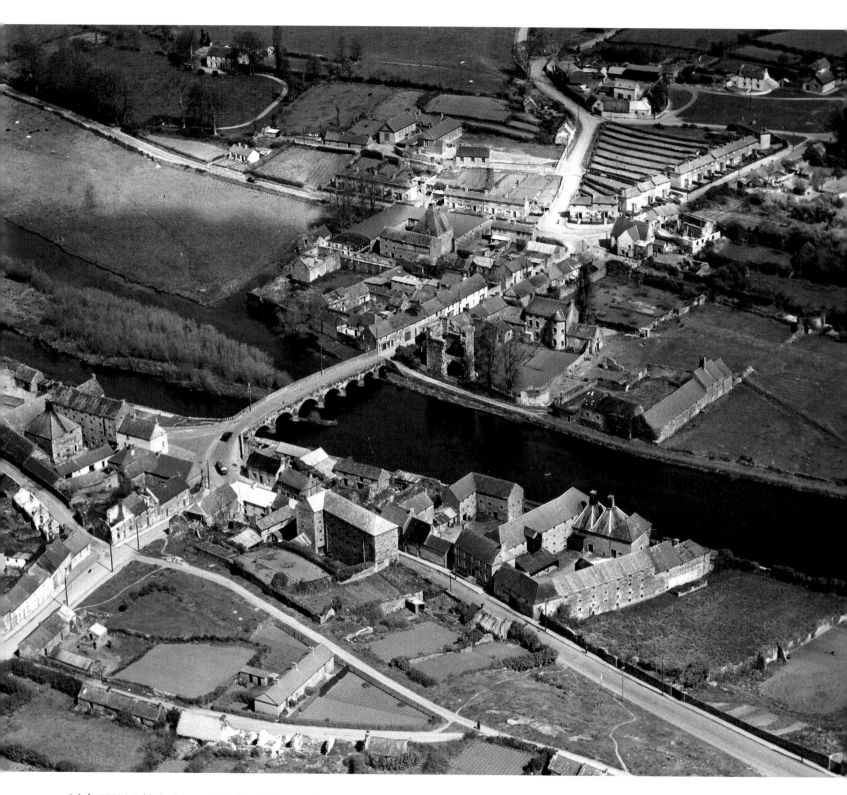

3 July 1953 Leighlinbridge, on the Carlow–Kilkenny road, which is carried over the River Barrow by the seven-arch bridge, beside which stands the ruin of the ancient Black Castle. **A254**

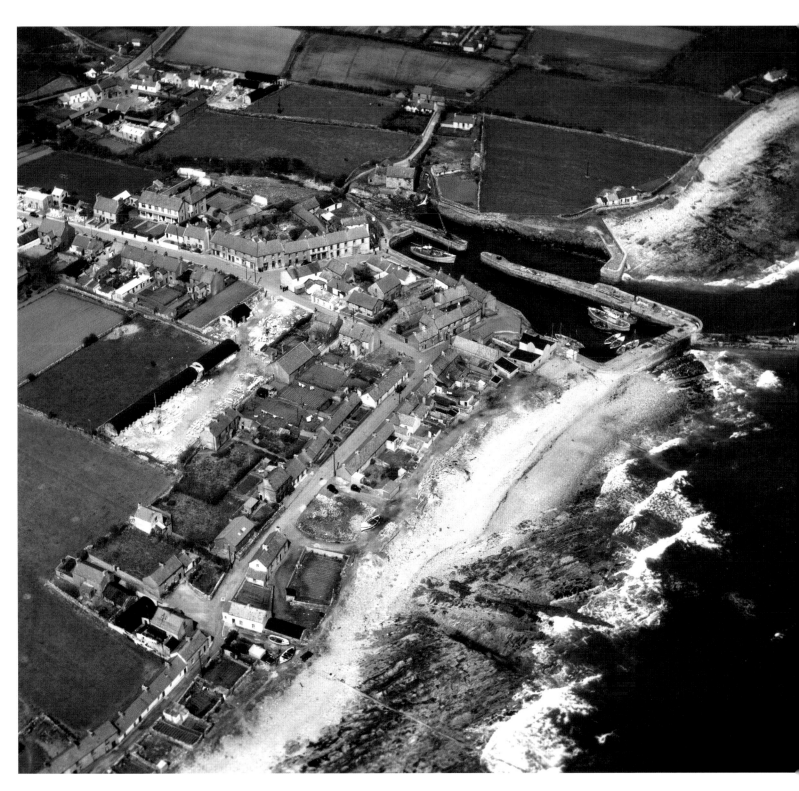

10 July 1953 Annalong. Rocks ruffle the sea at the approaches to this little
sheltered harbour on the County Down coast. The villagers, in addition to fishing,
dress granite for export. **A9**

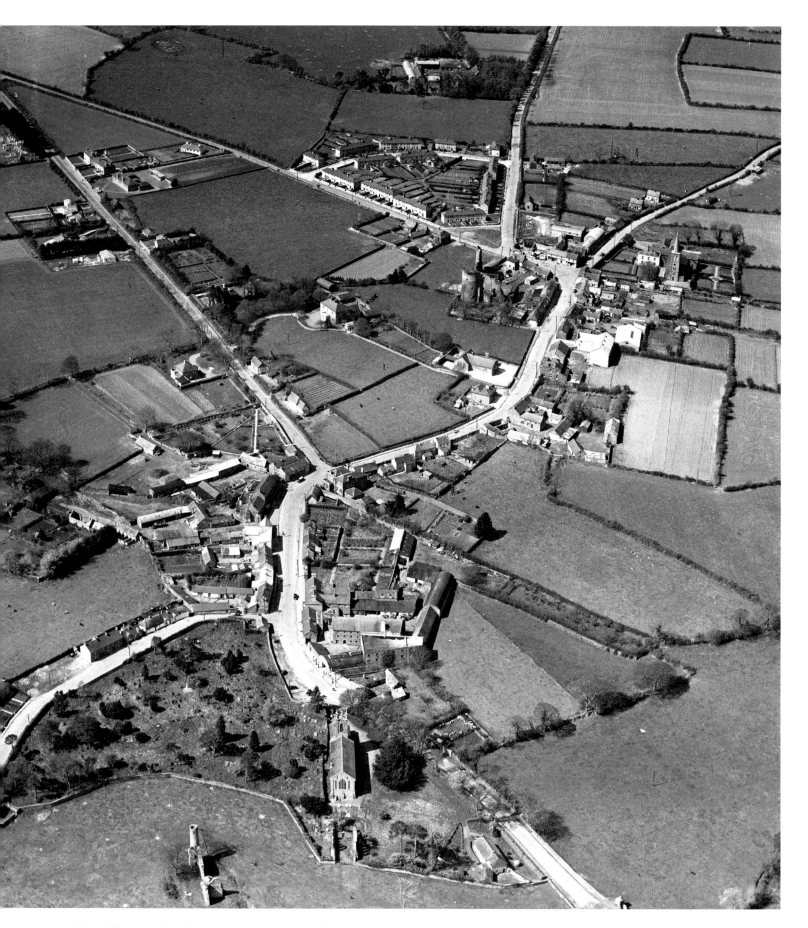

17 July 1953 Ferns. The cathedral and abbey ruins in the little Wexford town point to its former
importance as the centre of the Episcopal See. At one time it was the capital of Leinster. **A200**

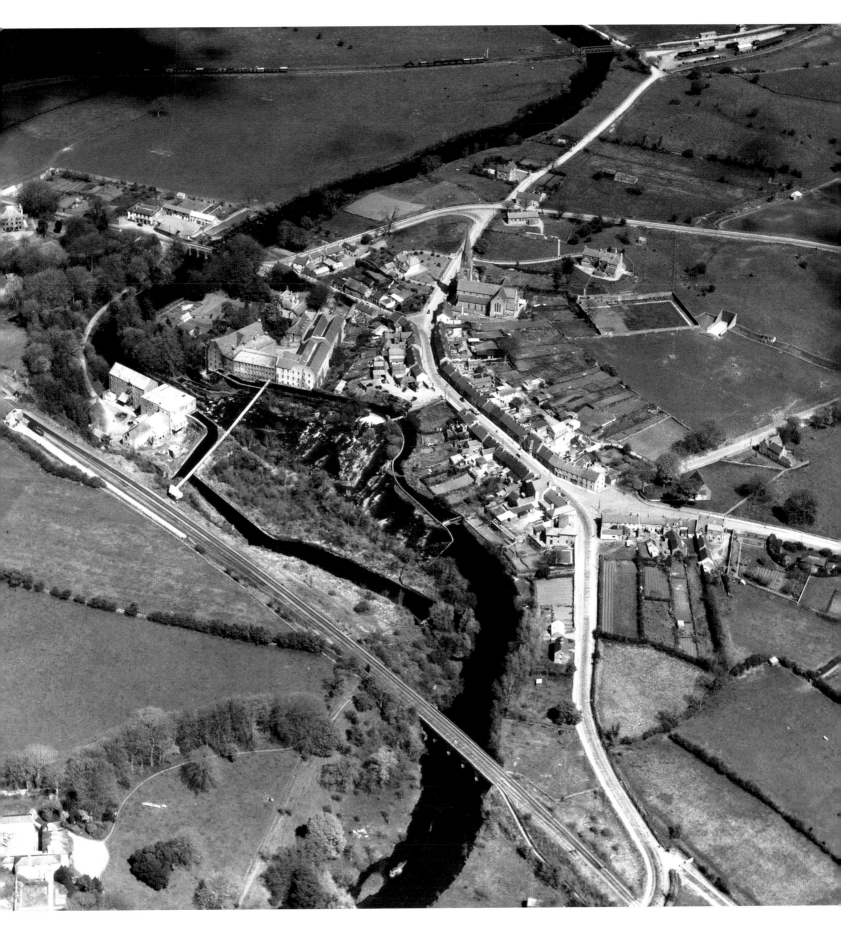

31 July 1953 Collooney in County Sligo, with its Owenmore River and the road to Sligo town (seven miles away). This neighbourhood has figured prominently in Irish military history since the sixteenth century. **A125**

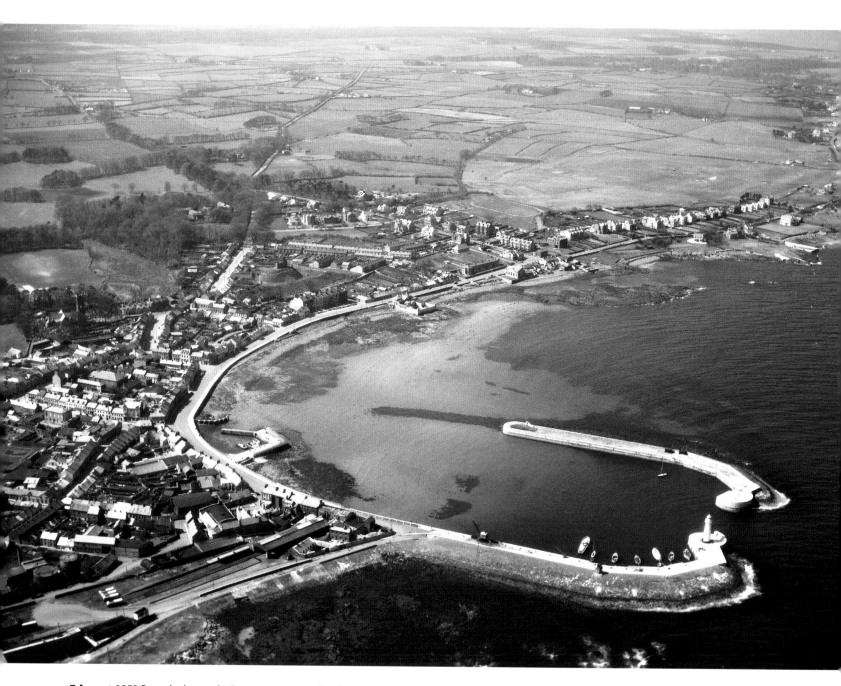

7 August 1953 Donaghadee, on the Down coast, near Belfast Lough. Its harbour, beach and pools make it attractive for swimmers. 'The Rath' mound, a prominent landmark, can be seen near the centre of the picture. **A154**

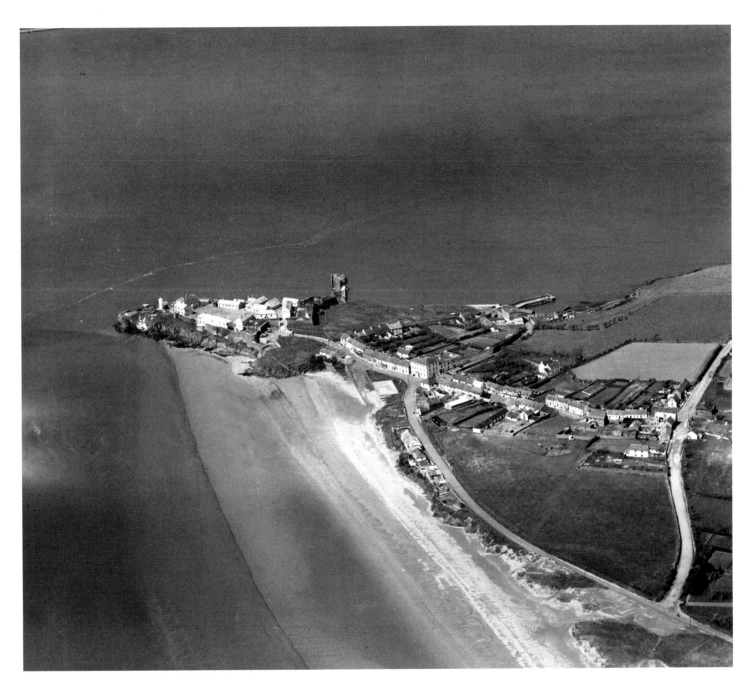

14 August 1953 Duncannon, County Wexford, projecting into Waterford Harbour. The old fort on the headland at one time guarded the approach to the estuary. **A176**

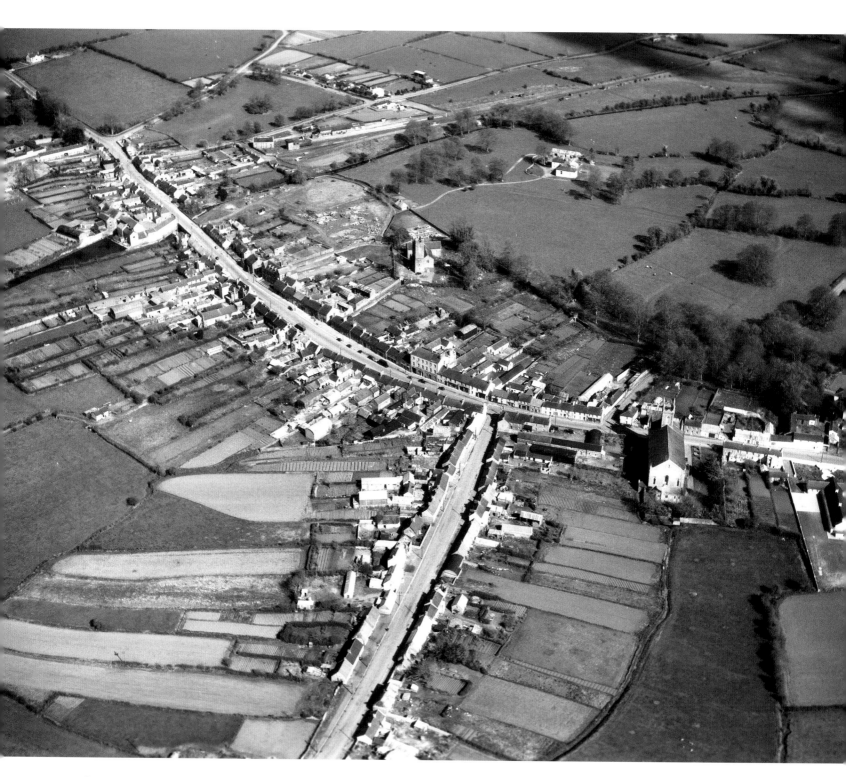

21 August 1953 Athboy, in Meath, near the Westmeath border, is on the Athboy River, a tributary of the Boyne. As a stronghold of the Pale, it saw lively days in medieval times. **A23**

4 September 1953 Rosslare Harbour, with the Fishguard boat berthed at the pier. This point in south Wexford is the landing place for many visitors to Ireland. The ferrying of tourists' motor cars to Rosslare has been notably heavy this season. **A351**

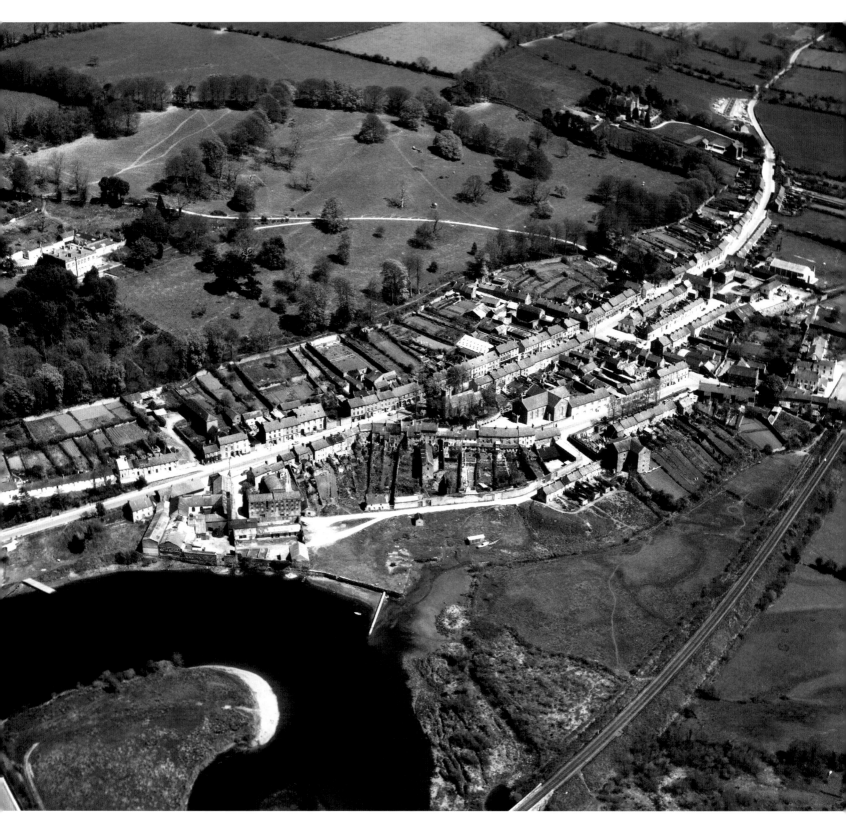

11 September 1953 Cappoquin. This quiet Waterford town is best known as the railway stop for the renowned Mount Melleray Abbey, which lies four miles up the Knockmealdown Mountains from here. The Blackwater River is seen on the left, as it wheels south for the sea at Youghal Harbour. **A81**

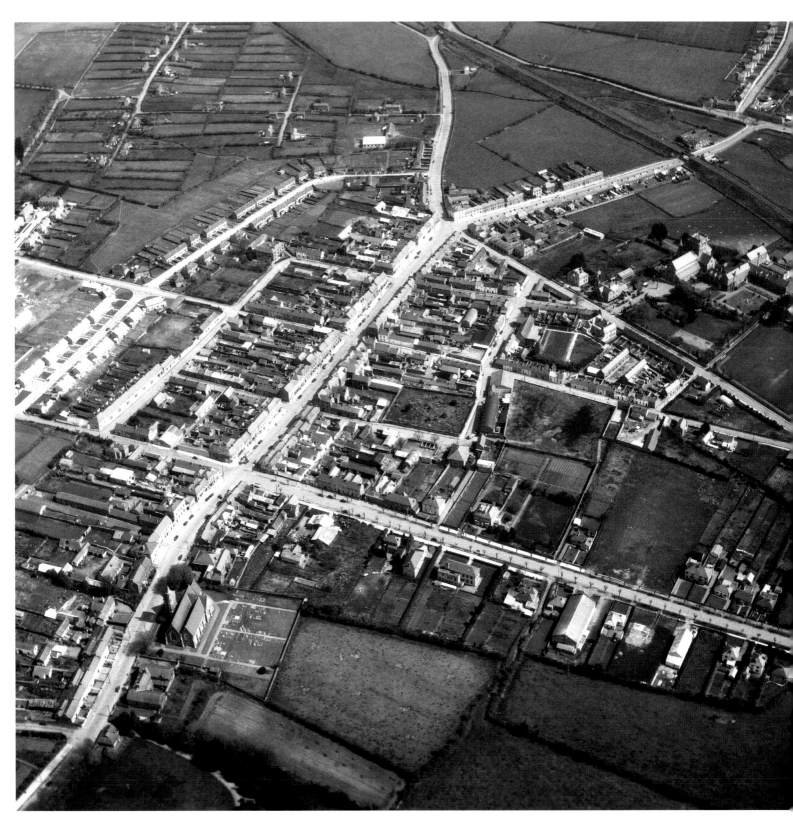

18 September 1953 Gorey, a well-planned town in County Wexford, with surroundings of
pleasantly wooded and undulating country, is deeply associated with the 1798 Rebellion. **A213**

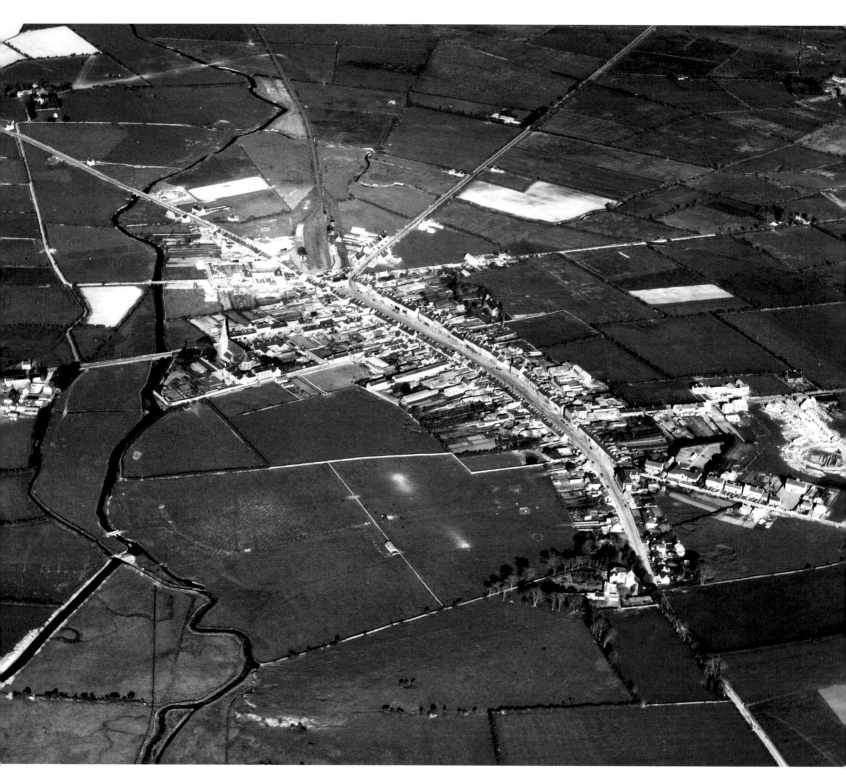

2 October 1953 Castleisland, a pretty town south-east of Tralee in County Kerry, is on the headwaters of the River Maine. The brown trout fishing in the district is good, and will repay a visit from the angler. **A96**

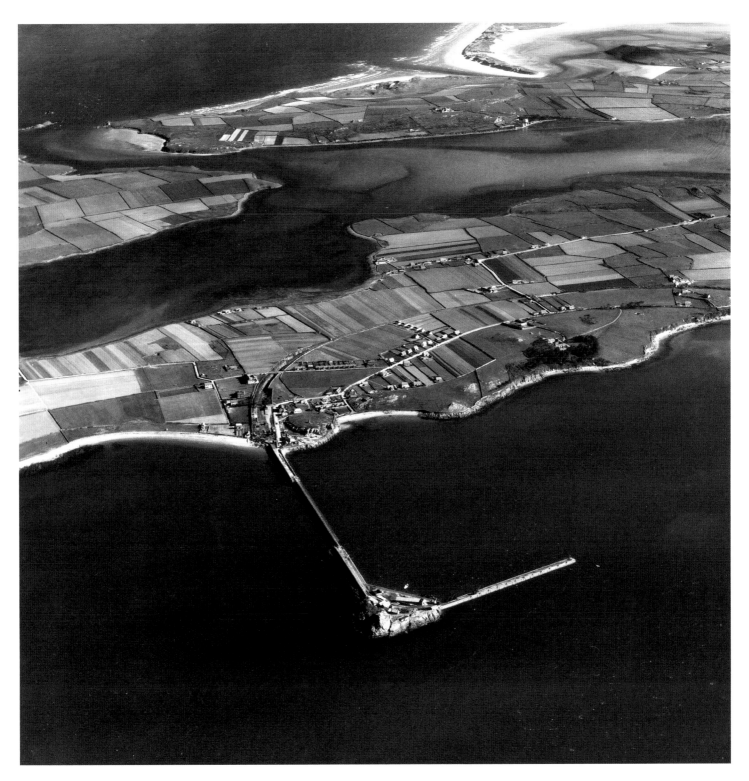

9 October 1953 Fenit, a village and harbour on Tralee Bay in County Kerry, with Barrow Harbour, and beyond, the commencement of a stretch of strand on which, two miles up the coast, at Banna, Sir Roger Casement landed from the *Aud* the day prior to his capture in 1916. In the neighbourhood of Fenit, St Brendan, the Navigator, was born. **A199**

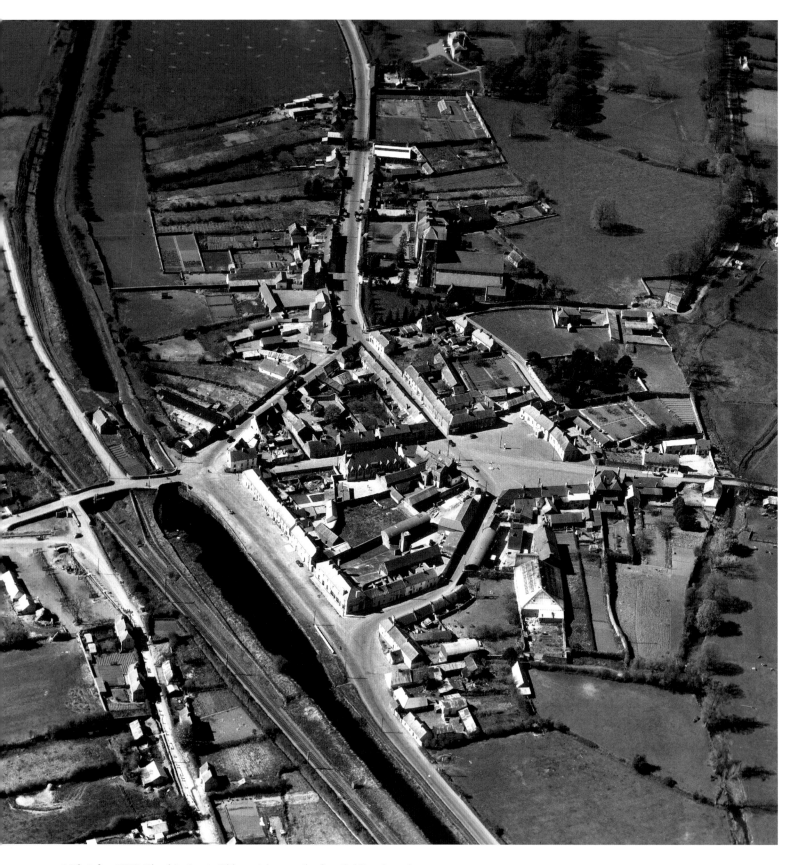

16 October 1953 Kilcock in County Kildare, eighteen miles from Dublin, where the
road, rail and canal run side by side on the way to the west of Ireland. **A229**

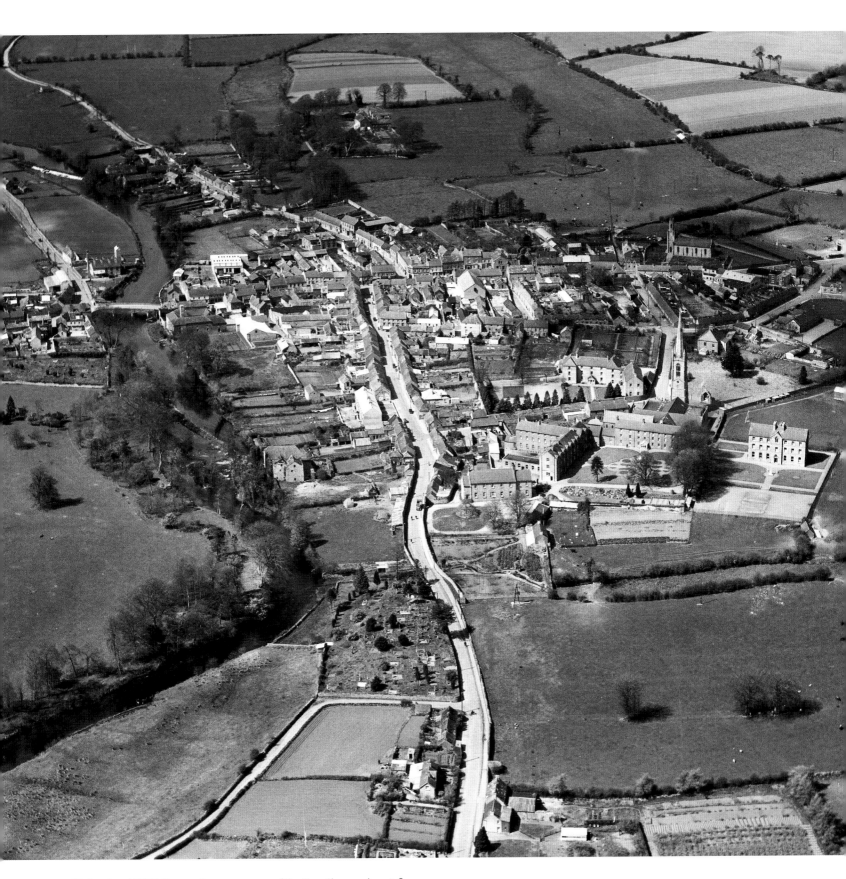

23 October 1953 Tullow, on the upper course of the River Slaney, where it flows
through Carlow on its long journey to Wexford Harbour. A noted centre for angler
fishing in several nearby rivers. **A430**

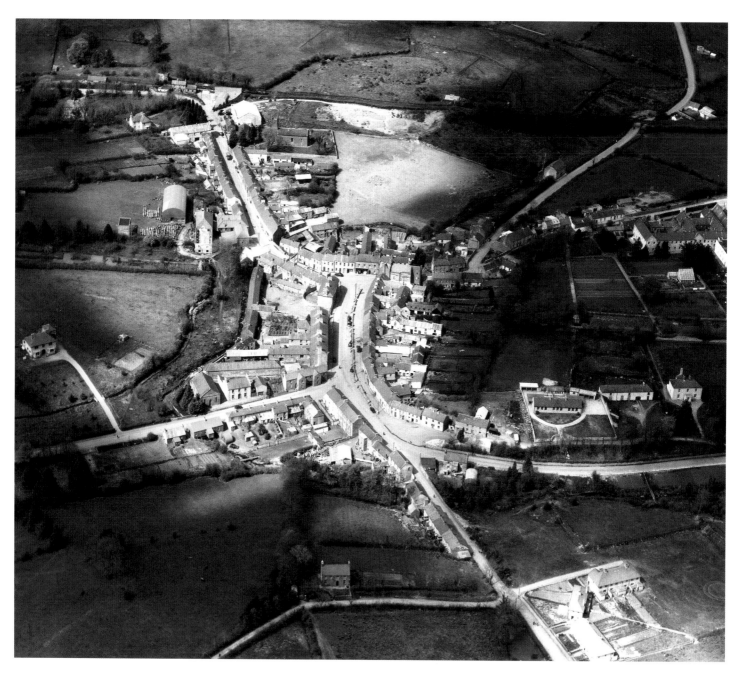

30 October 1953 Drumshanbo, County Leitrim. On the southern end of Lough Allen, it is a favourite resort for anglers interested in the surrounding Shannon lakes. **A169**

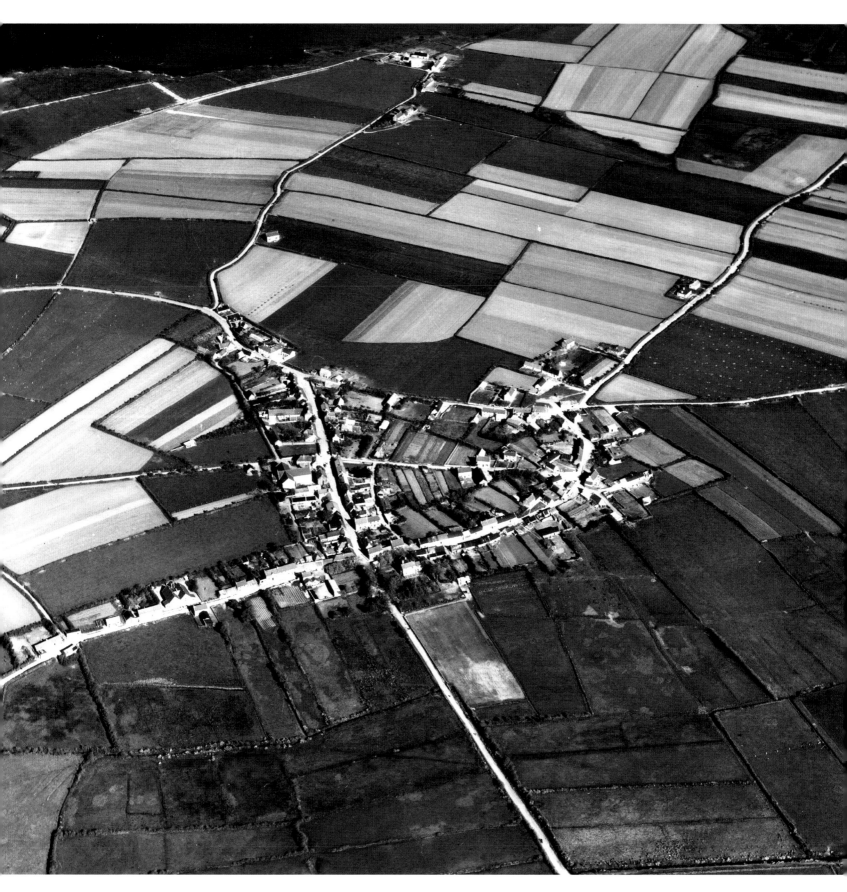

6 November 1953 Castlegregory, on Tralee Bay in County Kerry, with its intensively tilled surrounds, has in recent times, like the adjacent Magharees district, made a reputation for early and specialised vegetable growing. **A95**

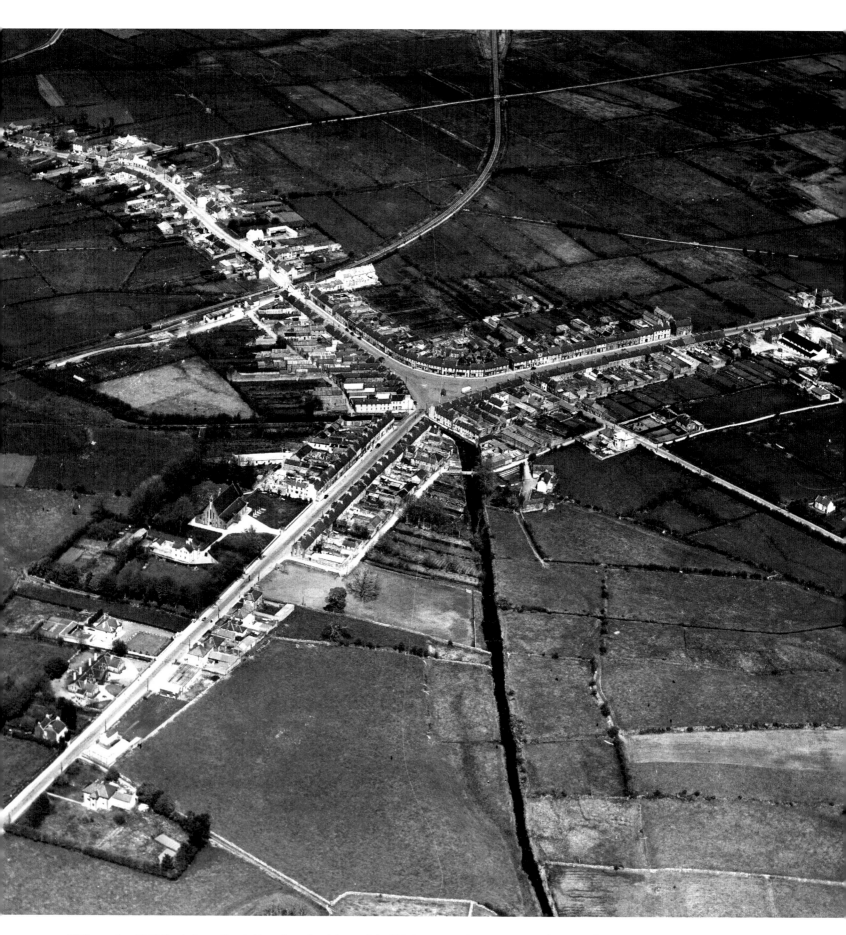

20 November 1953 Charlestown, County Mayo. From the air it reveals itself, in layout, as a three-way town with a triangular centrepiece. The Claremorris–Sligo railway line can be seen to the top left. **A109**

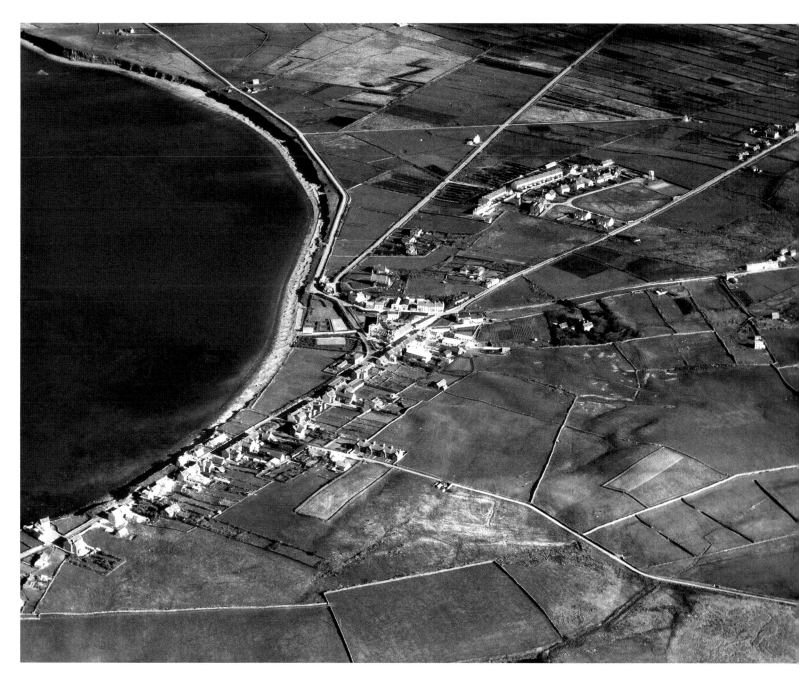

27 November 1953 Waterville, on Ballinskelligs Bay in County Kerry, an angling centre with a deservedly famous reputation. Like tentacles, its roads shoot forth to the Kerry wonderland of mountain and lake. **A443**

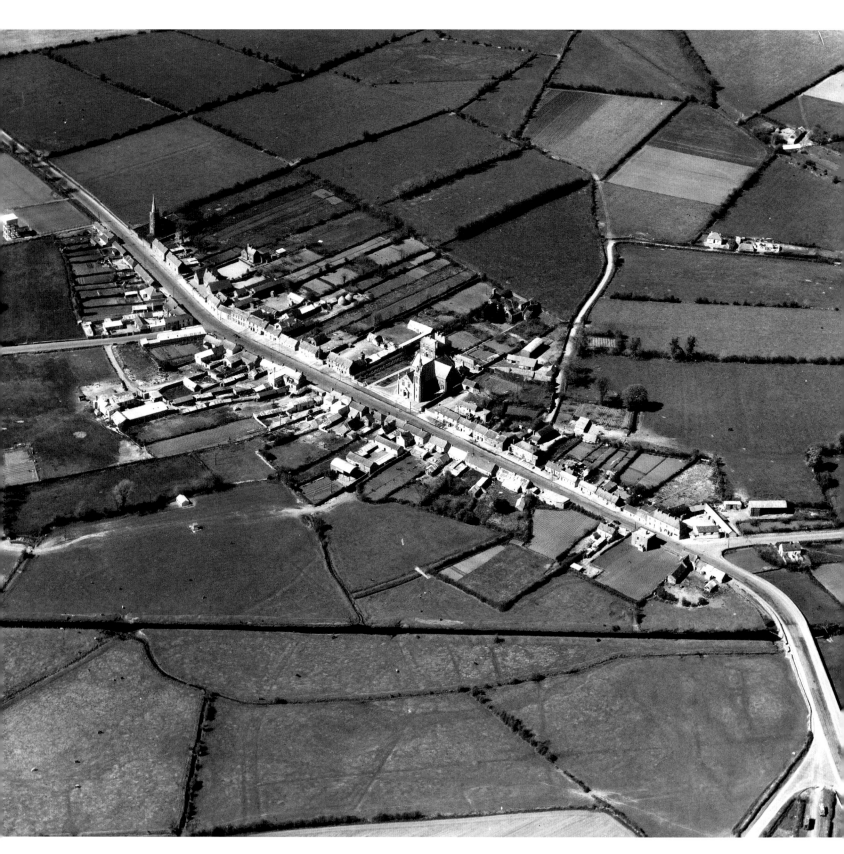

4 December 1953 Kinnegad, County Westmeath. Thirty-nine miles from Dublin on the western highway, it marks the point of parting of the Sligo and Galway roads. In the impressive church, halfway through the village, there is a fine altar attributed to Willie Pearse. **A248**

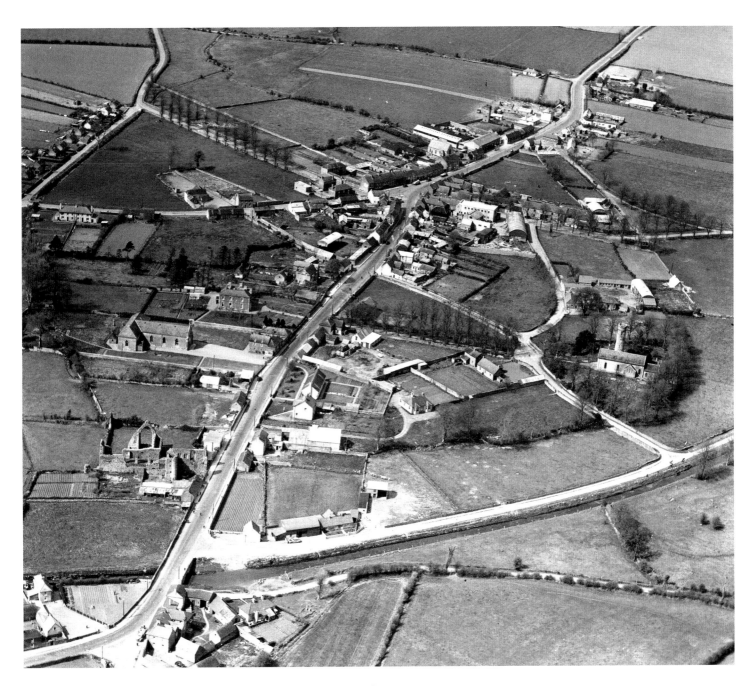

11 December 1953 Castledermot, in South Kildare, is noted as the birthplace of St Laurence O'Toole, Patron of the Archdiocese of Dublin. There is an interesting group of ecclesiastical ruins here, including a round tower (to the centre right) and a Franciscan friary (to the bottom left). The Marquis of Kildare resides in the neighbouring Kilkea Castle. **A94**

1954

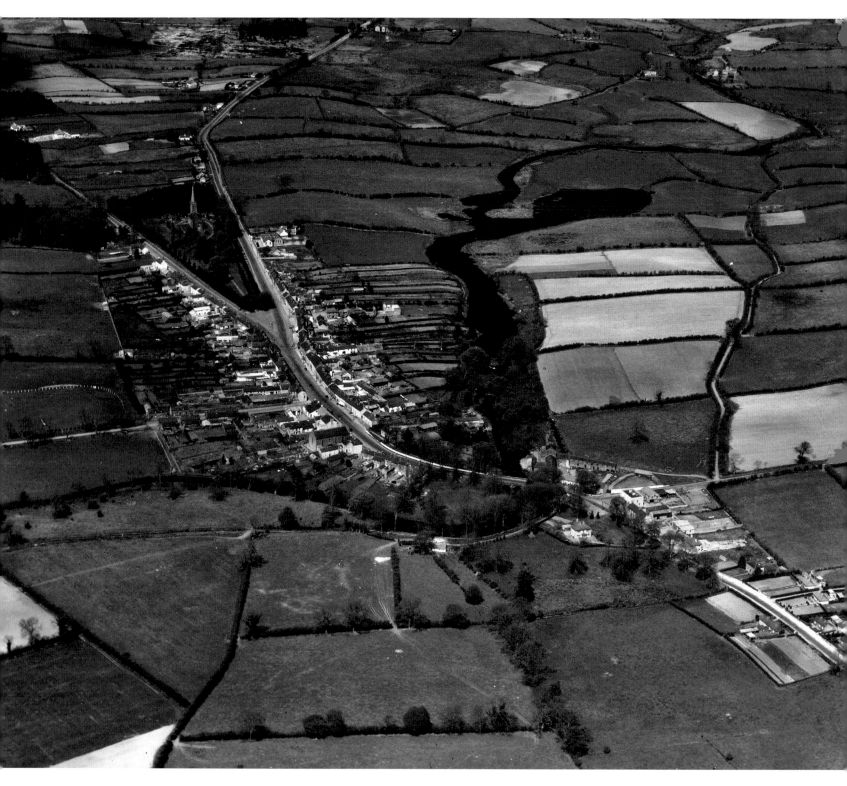

1 January 1954 Virginia, a charming County Cavan town whose attraction is the great adjoining Lough Ramor (not in the picture) whose many inlets and sandy, wooded shores offer good fishing, rowing and bathing. **A436**

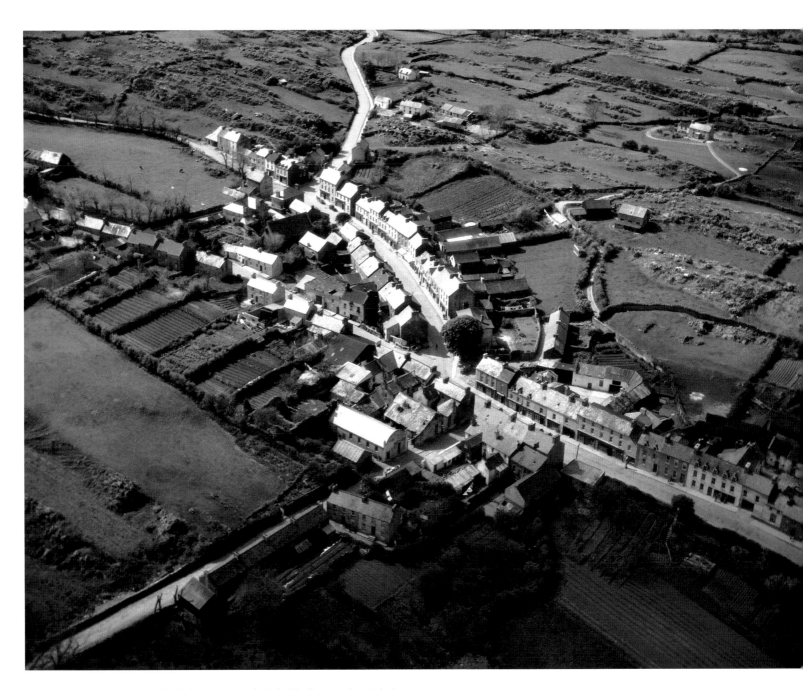

15 January 1954 Ballydehob, the little town in south Cork. A brilliant sun has picked out its abundance of two- and three-storey buildings. **A38**

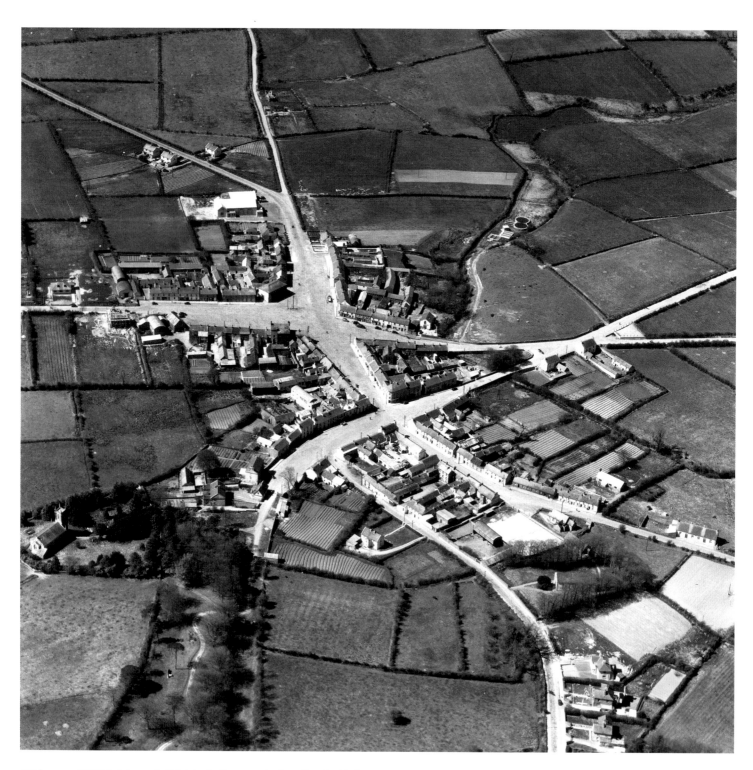

22 January 1954 Ballyjamesduff. Celebrated in a song by Percy French, this Cavan
town has, because of it, gained a worldwide renown. **A40**

5 February 1954 On rising ground overlooking an inlet of the bay lies the charming County Waterford resort of Ardmore. There is a smooth bathing beach, but the sightseer will be chiefly interested in the group of ecclesiastical remains, consisting of a round tower, St Declan's Oratory and Cathedral, Teampail Deisceart ('Church of the South') and St Declan's Holy Well and stone. **A14**

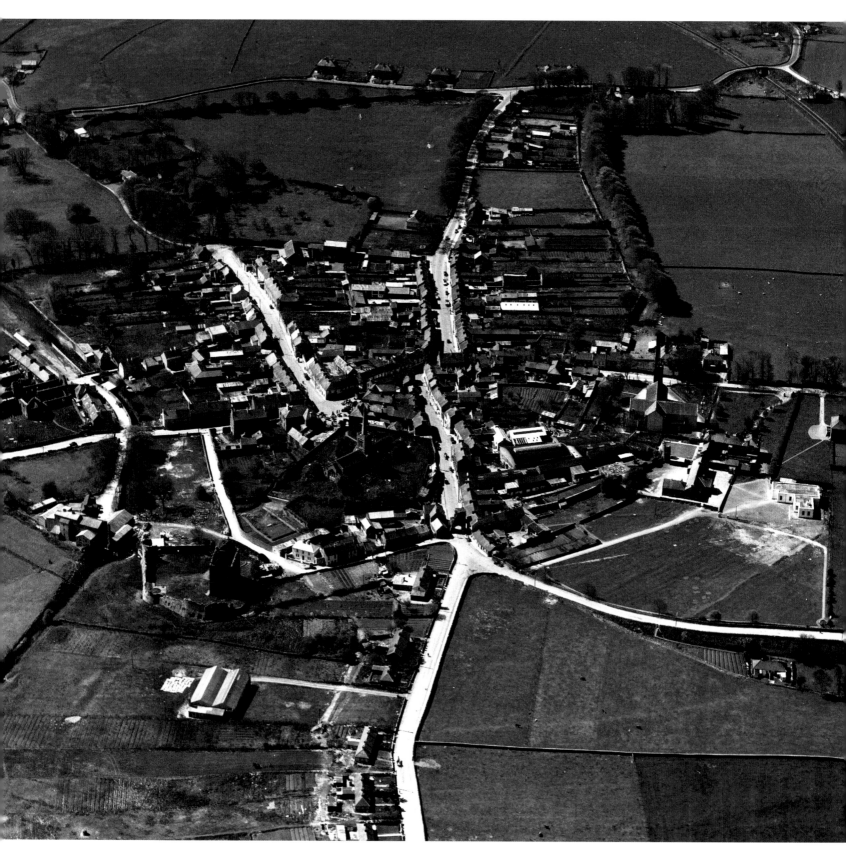

26 February 1954 Athenry, County Galway, well known as the railway junction of the Galway and Limerick lines. The Dominican Priory ruins, destroyed by Cromwell, still bear features telling of its architectural grandeur in times when it held university rank. **A24**

5 March 1954 Clear Island, lying in the Atlantic off the south-west Cork coast. Today, the Feast of St Ciaran, is a day of special devotion on the island. The festival commenced with a vigil last night at the North Harbour, in the foreground of the picture. **A112**

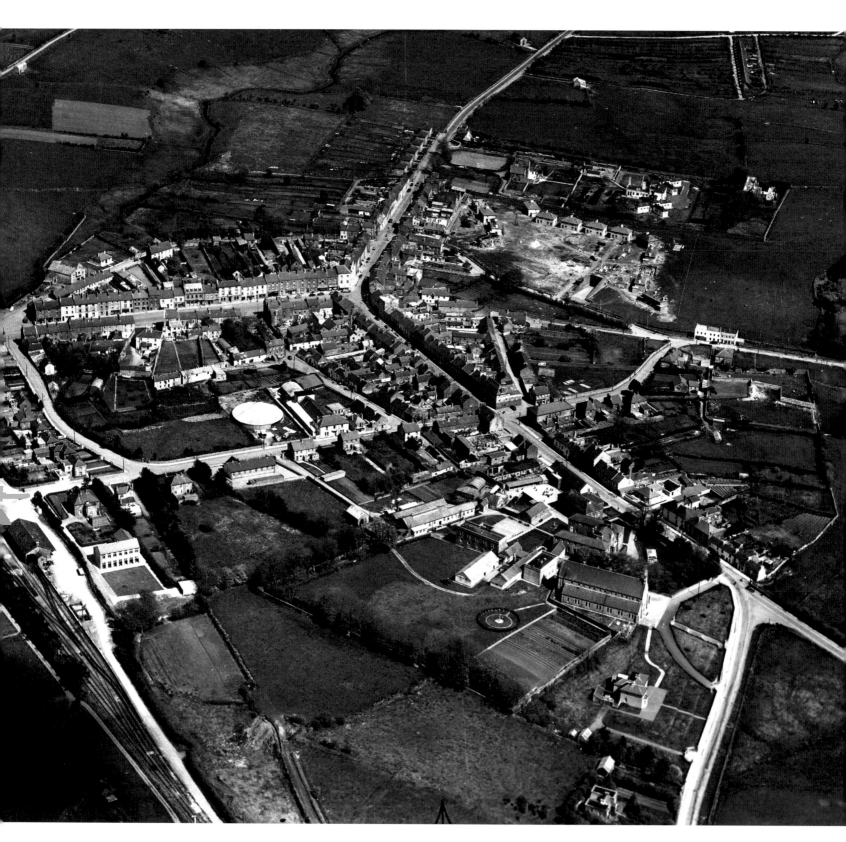

12 March 1954 Swinford, County Mayo. Situated near the River moy, it is a market town on the Claremorris–Sligo rail route. **A414**

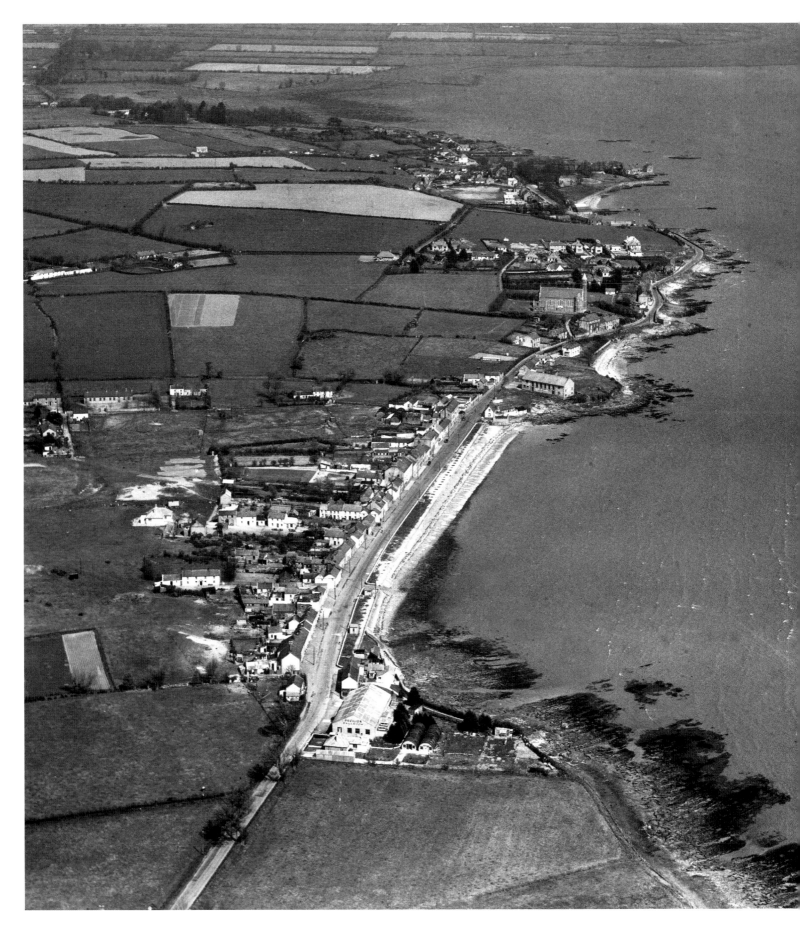

19 March 1954 A view from south of Blackrock, the popular seaside spot near Dundalk, County Louth. **A63**

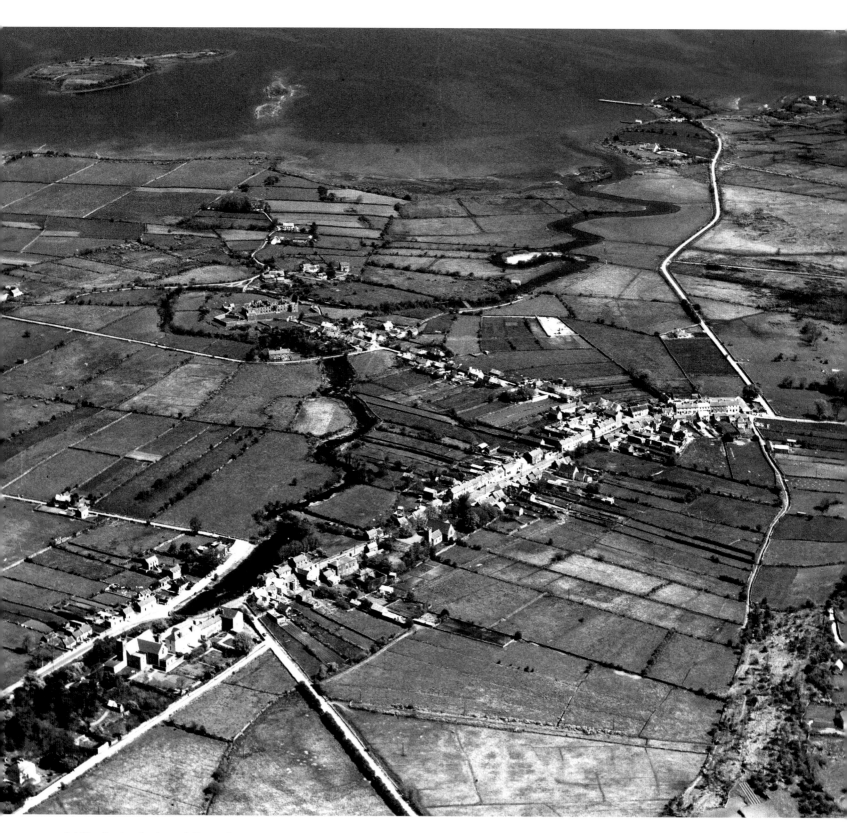

26 March 1954 Oughterard. The anglers' paradise, Lough Corrib, lies above
Oughterard, which is sixteen miles from Galway city. **A341**

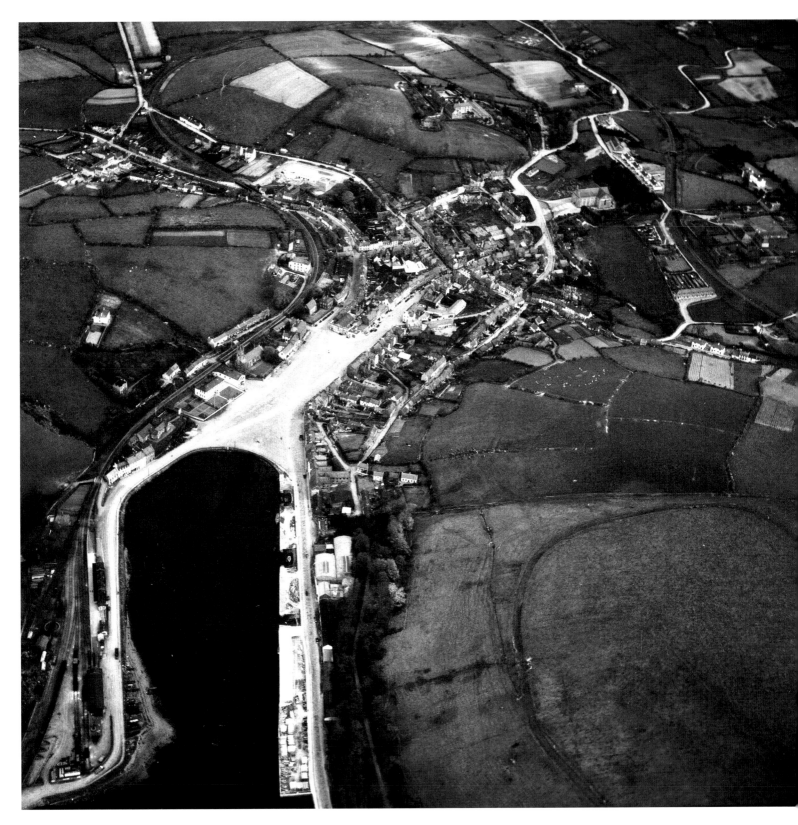

9 April 1954 Bantry, one of Cork's principal towns in the south-west. It is memorable as having seen two of history's naval invasions, in the bay, in 1689 and 1796. It was the birthplace, in 1855, of the late T. M. Healy, first Governor-General of the Irish Free State. **A51**

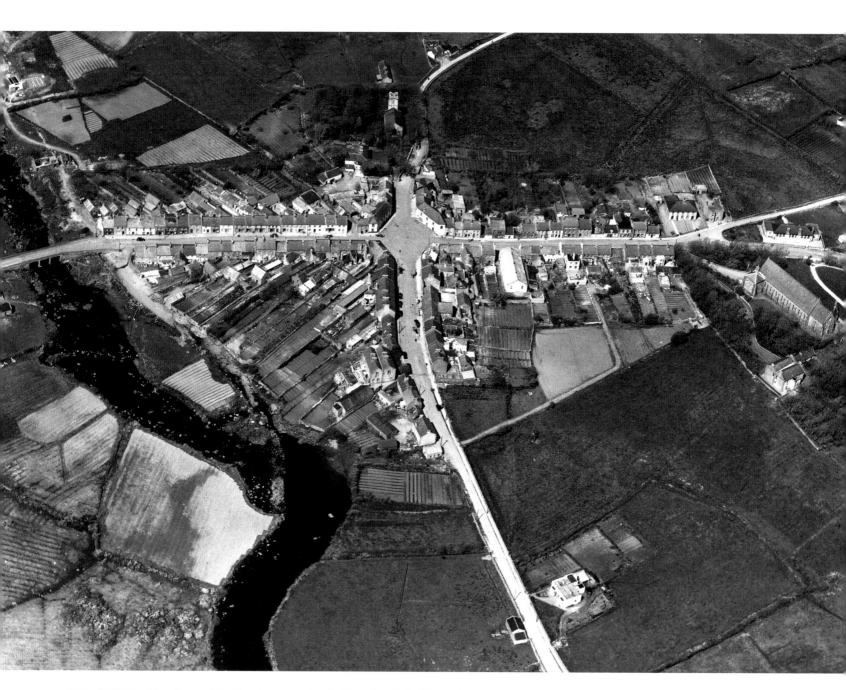

23 April 1954 Louisburgh, one of the Mayo towns associated with the Croagh Patrick area. Its proximity to the Murrisk lakes and Clew Bay make it a favourite with the angler. **A280**

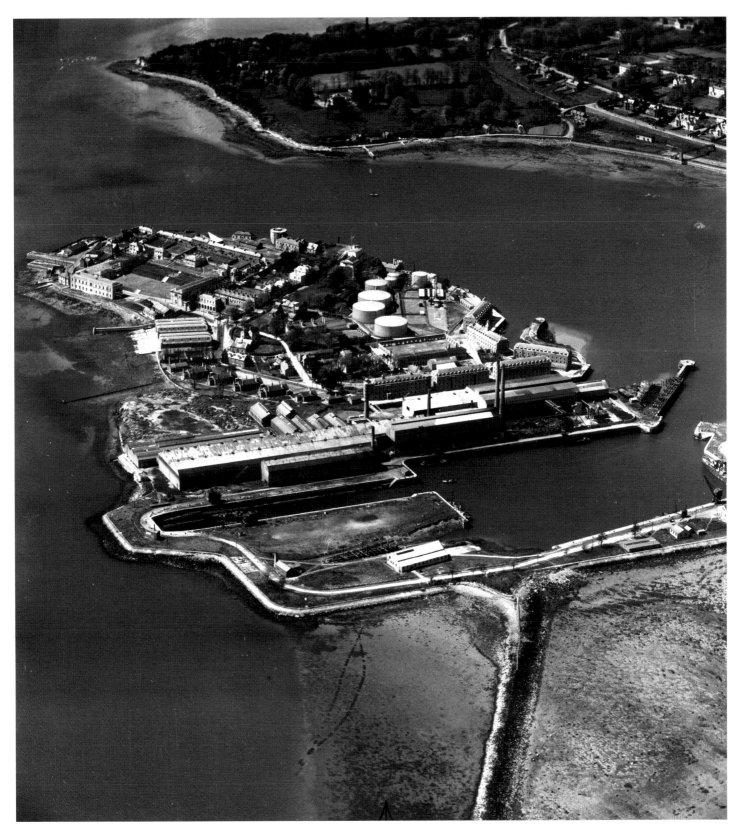

30 April 1954 Haulbowline, an island off Cobh in County Cork with its own harbour
and covered to capacity with dockyard, industrial and naval buildings. **A220**

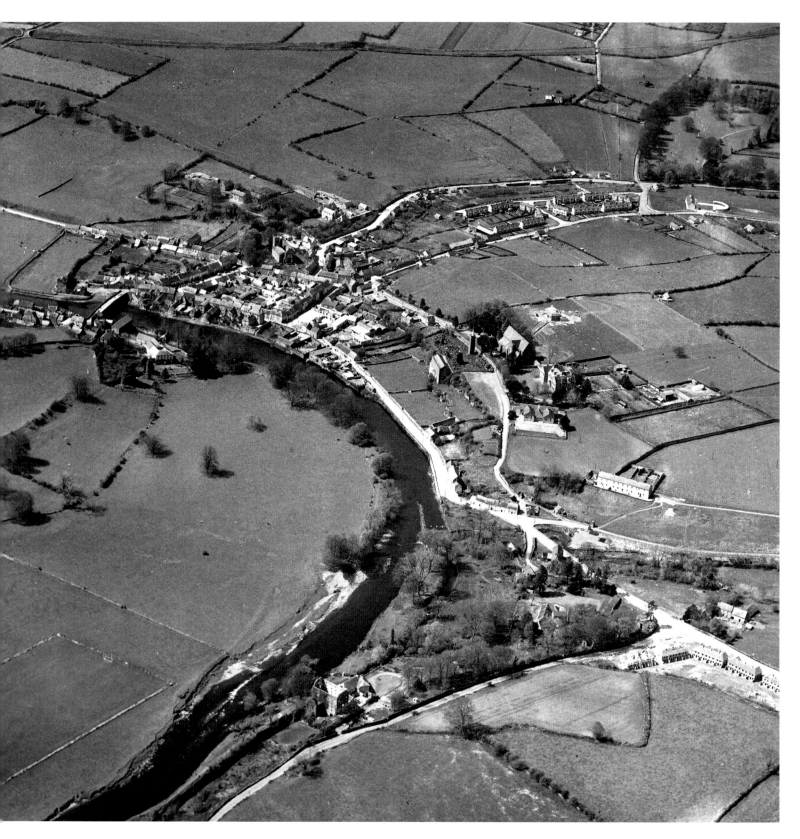

7 May 1954 Thomastown, a Kilkenny town founded by Thomas FitzAnthony Walsh, 700 years ago. It is situated in the beautiful Nore Valley, and is the headquarters of the Kilkenny Hunt. **A418**

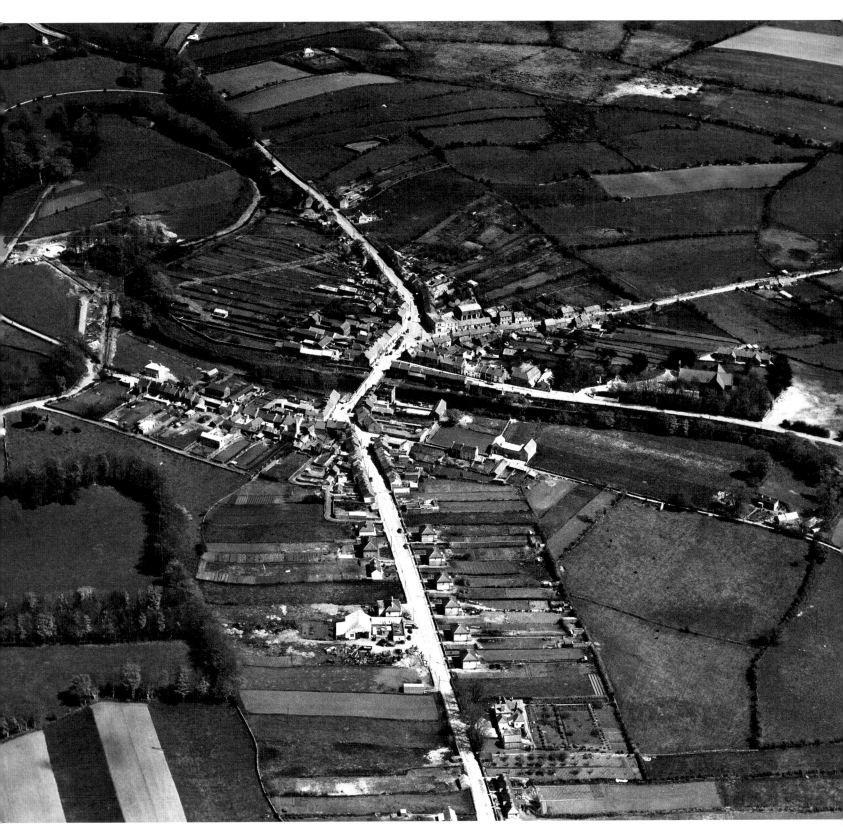

14 May 1954 Crossmolina, County Mayo, a well-built town bridging the River Deel.
Near Lough Conn, it is a good centre for the famous fishing lake. **A143**

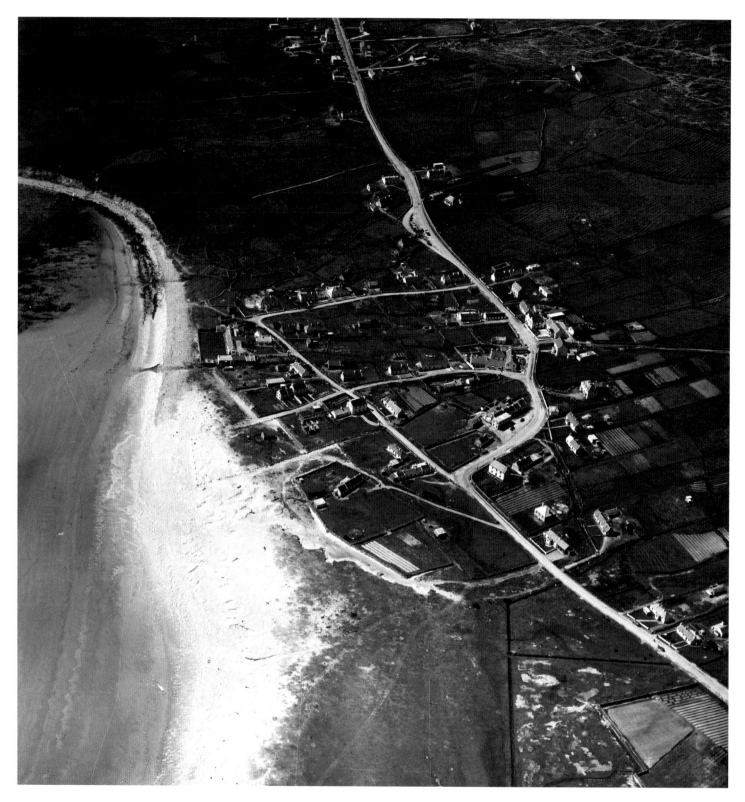

21 May 1954 Keel, a delightful resort on Achill Island, showing part of its famed sandy
beach. The village is sheltered by the Slievemore Mountains to the north. **A225**

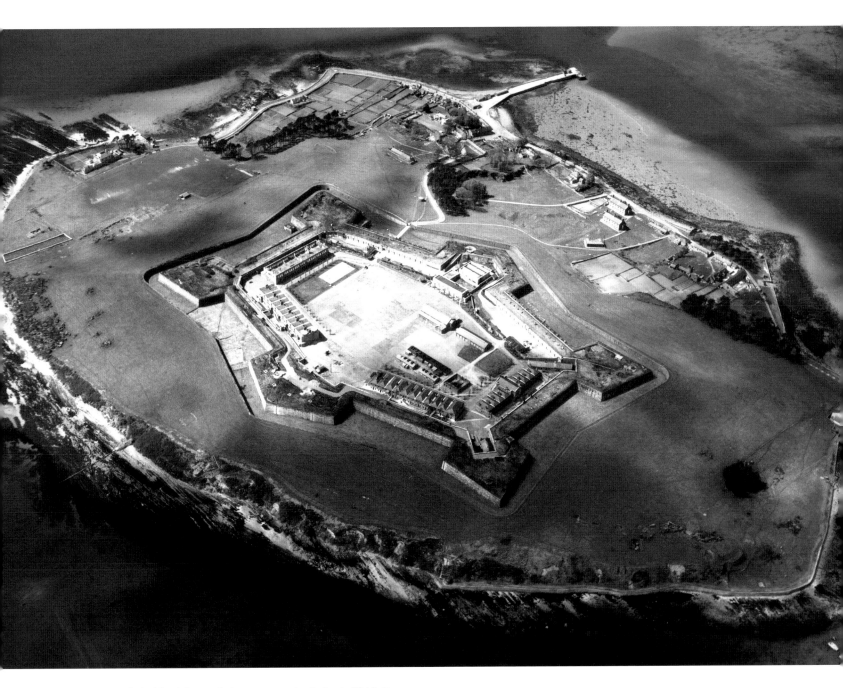

28 May 1954 Spike Island, County Cork, an army station in front of Cobh. It was formerly a British military post and earlier a convict prison of sinister memory. Many patriotic Irishmen were held here before transportation to Botany Bay, Sydney, Australia. **A409**

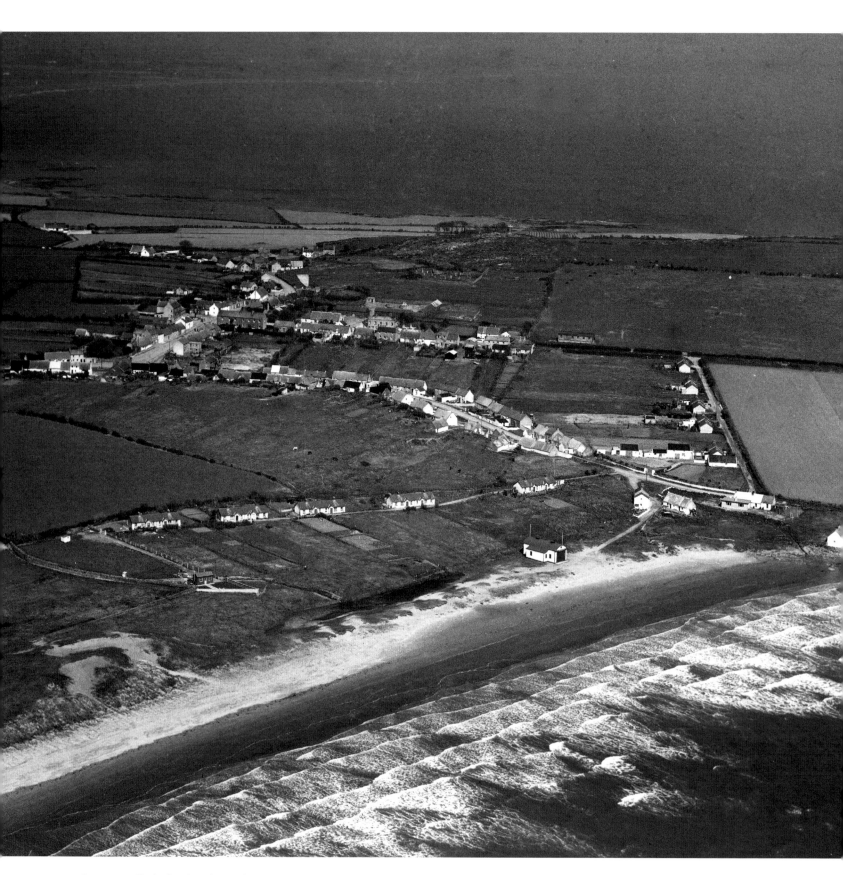

11 June 1954 Clogherhead, on the Louth coast, near Drogheda. It has all the characteristics of a model fishing village with headland, harbour and pier. Its setting has attracted film-makers seeking a location. **A116**

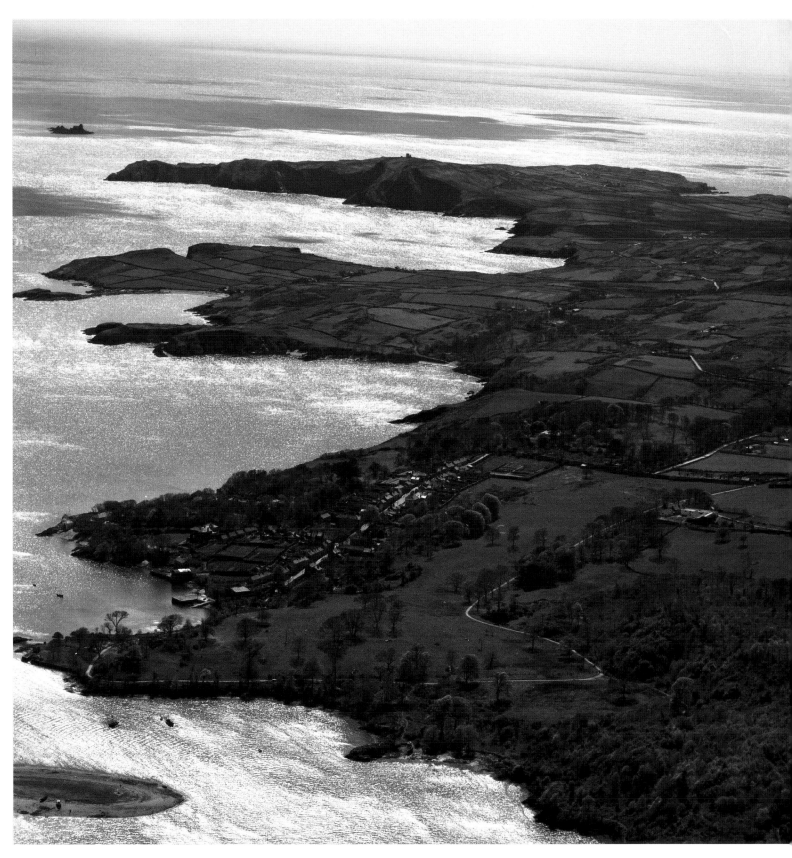

18 June 1954 Castletownshend, a village on the southern coast of Cork (in the foreground) with the Atlantic sparkling beneath a midday sun, throwing into high relief the jagged coast of Toe Head. **A101**

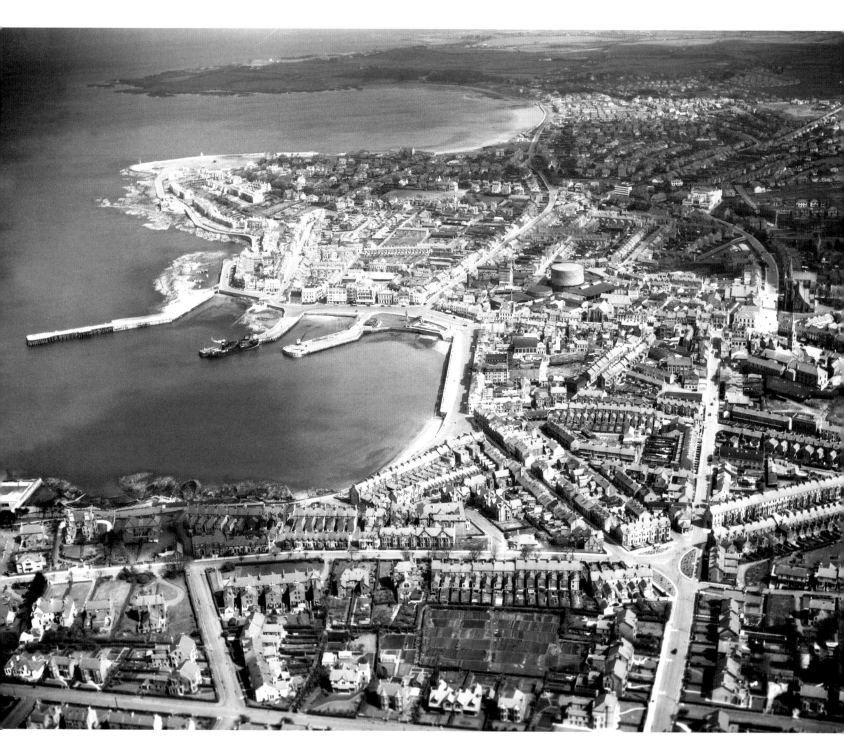

25 June 1954 Bangor, County Down, one of the largest and best-equipped seaside resorts in Ireland.
Built near the entrance to Belfast Lough, it is a favourite watering place for the northern capital. **A48**

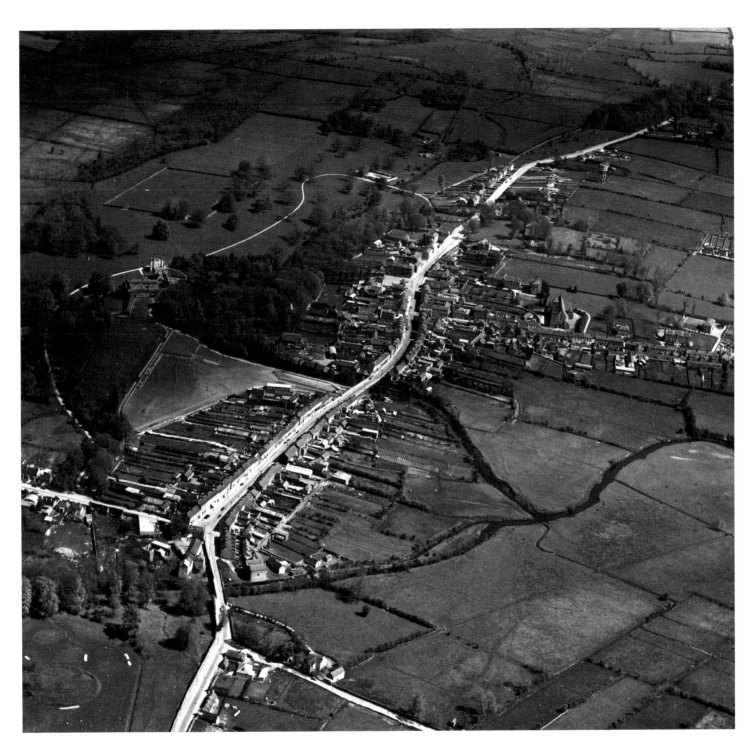

9 July 1954 Castlerea, on a wooded reach of the River Suck in County Roscommon.
It has a fine People's Park, with sports ground and swimming pool. **A100**

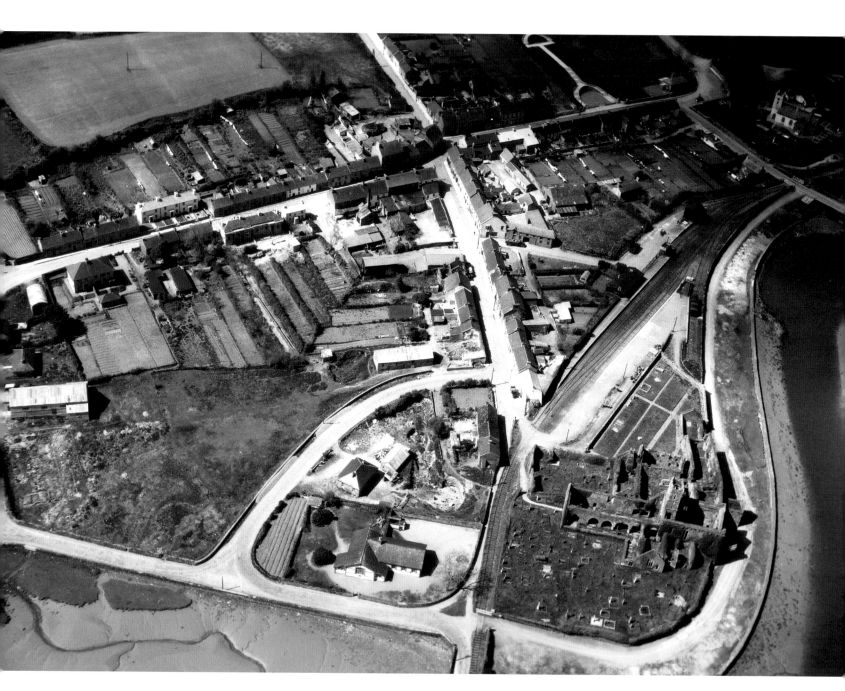

16 July 1954 Timoleague, on the estuary of the Argideen River at its approach to Courtmacsherry Bay in County Cork. Its abbey, once one of the most important houses in Ireland, stood on the same site now marked by the ruins of the fourteenth-century Franciscan friary. **A422**

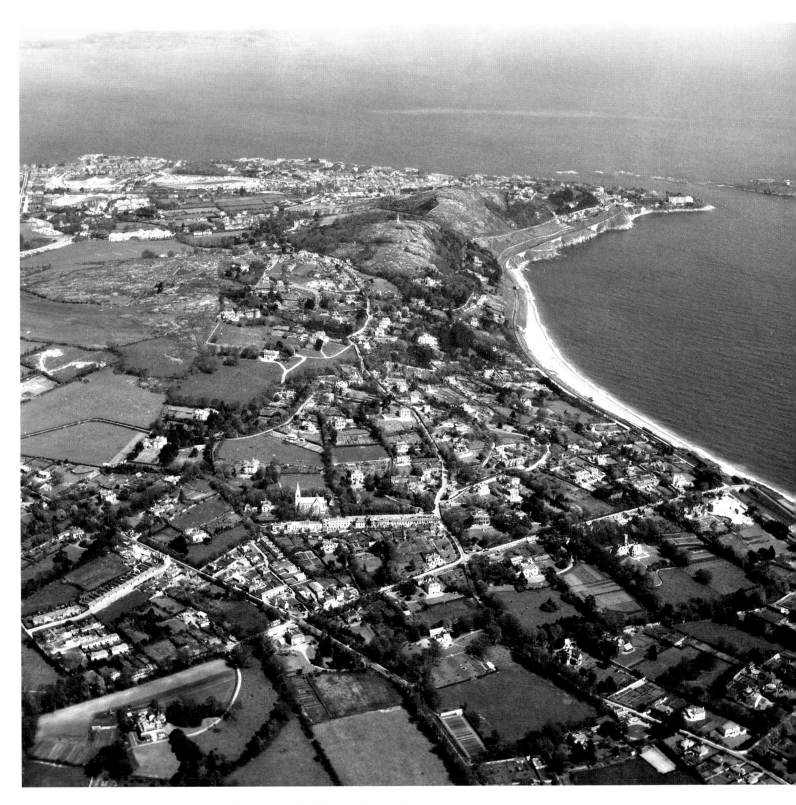

23 July 1954 Killiney Strand, County Dublin, with the coast road and railway above it going to
Dalkey. In the centre of the picture lies Killiney village with Ballybrack towards the foreground. **A242**

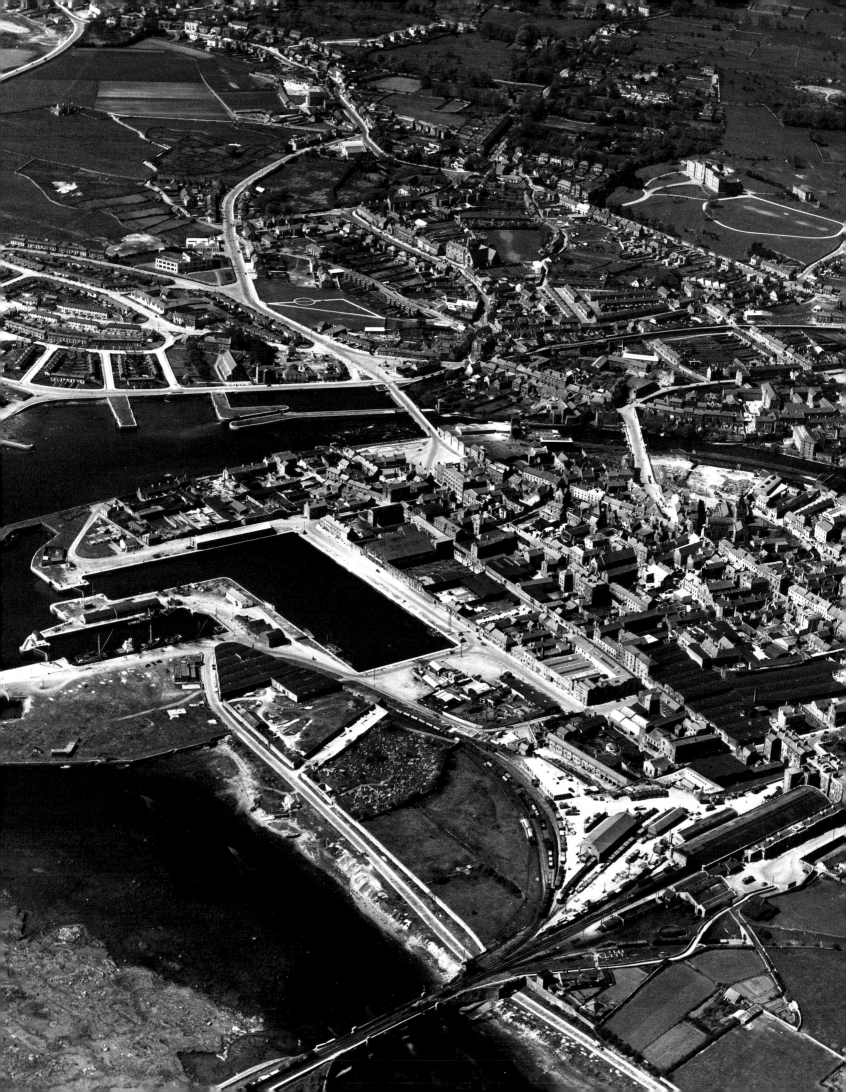

13 August 1954 Whiddy Island, lying at the head of Bantry Bay in County Cork, still has remains of the fortifications of O'Sullivan Beare. On the opposite side is the Glengarriff coastline. **A49**

30 July 1954 Galway: Connacht's city showing on the left its docks, from where the steamer service to the Aran Islands sails. The course of the River Corrib is traced through the centre of the picture. Eyre Square is at the lower right. **A209**

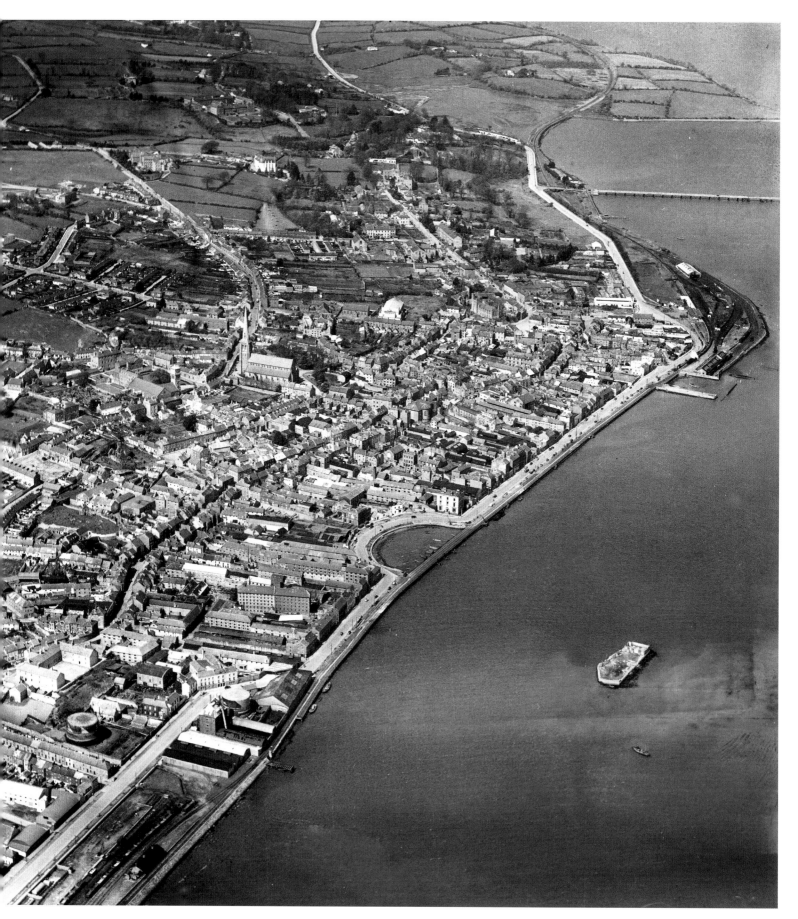

27 August 1954 Wexford, on the wide River Slaney, with its houses scarcely separated by the narrow streets for which the town is noted. **A446**

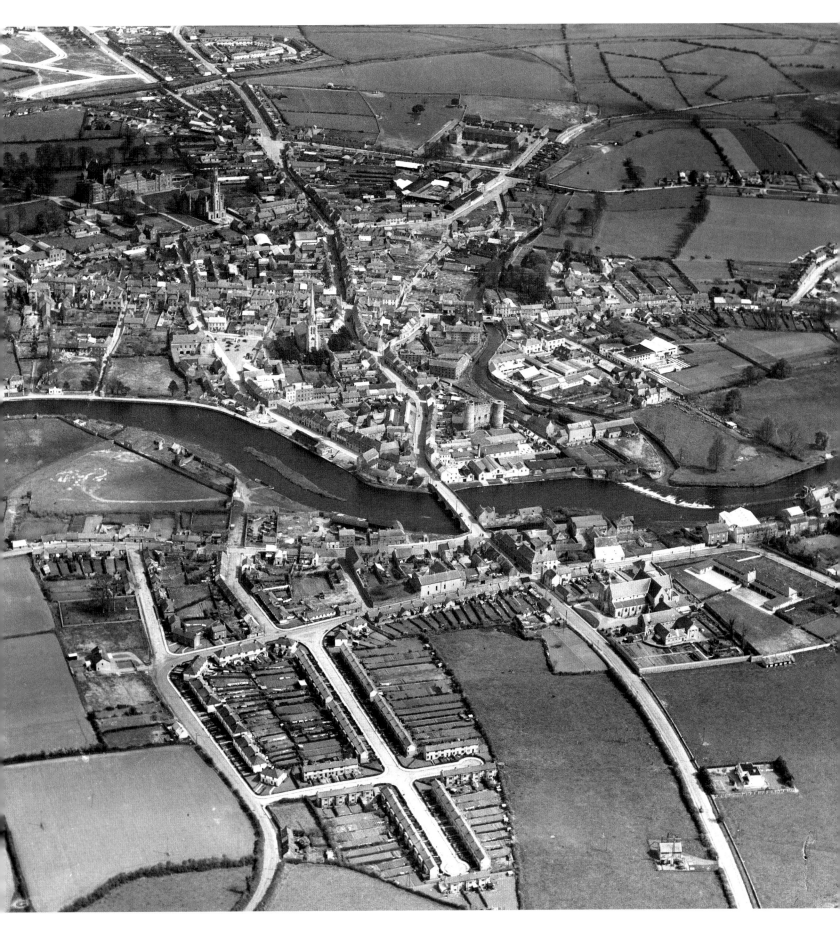

3 September 1954 Carlow. Its old Norman castle remains, with two round towers, are seen near the bridge.
To the top left, the Lantern tower marks the Cathedral of the Assumption and St Patrick's College. **A84**

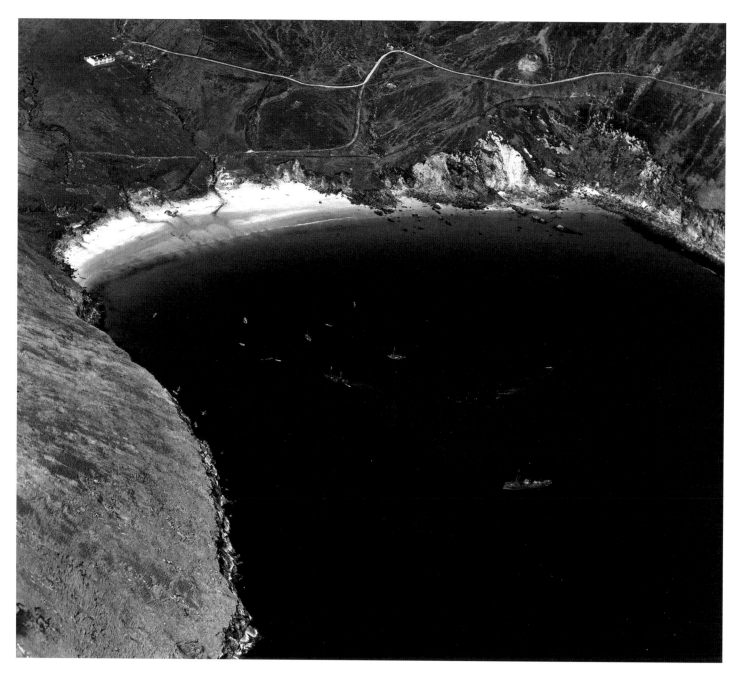

1 October 1954 Keem Bay, at the extreme west of Achill Island, County Mayo where a sheltered quiet is interrupted only by the morning activities of some lobstermen or of fishermen in quest of the basking shark. The old coastguard station stands by the cliff walk that goes by Dooagh. **A226**

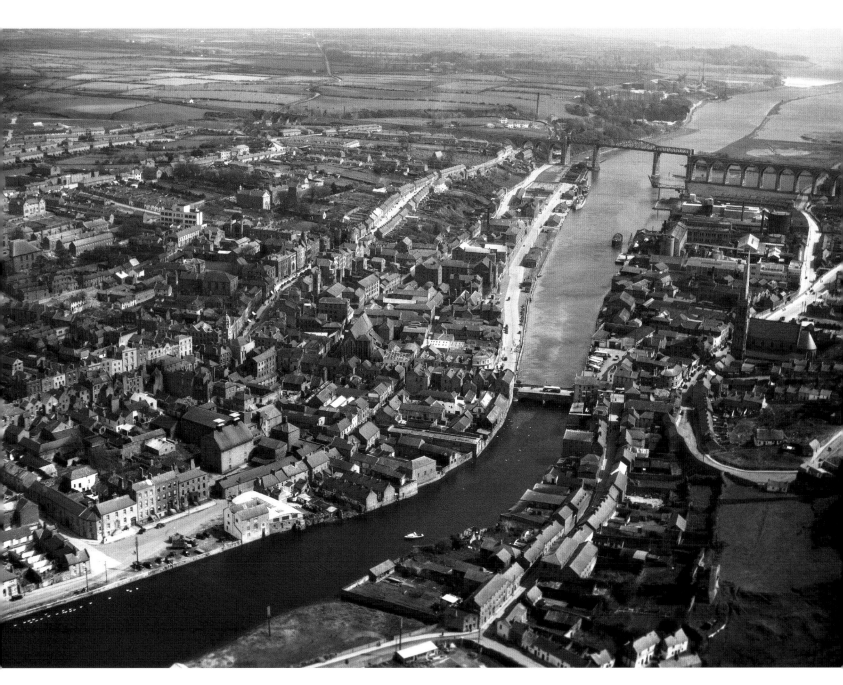

8 October 1954 Drogheda, a County Louth seaport and industrial town. As well as being on the Louth–Meath border, the River Boyne, passing through, also divides the town between the dioceses of Armagh to the left and Meath to the right of the picture. The viaduct carrying the Great Northern Railway line to Belfast is seen in the distance. **A166**

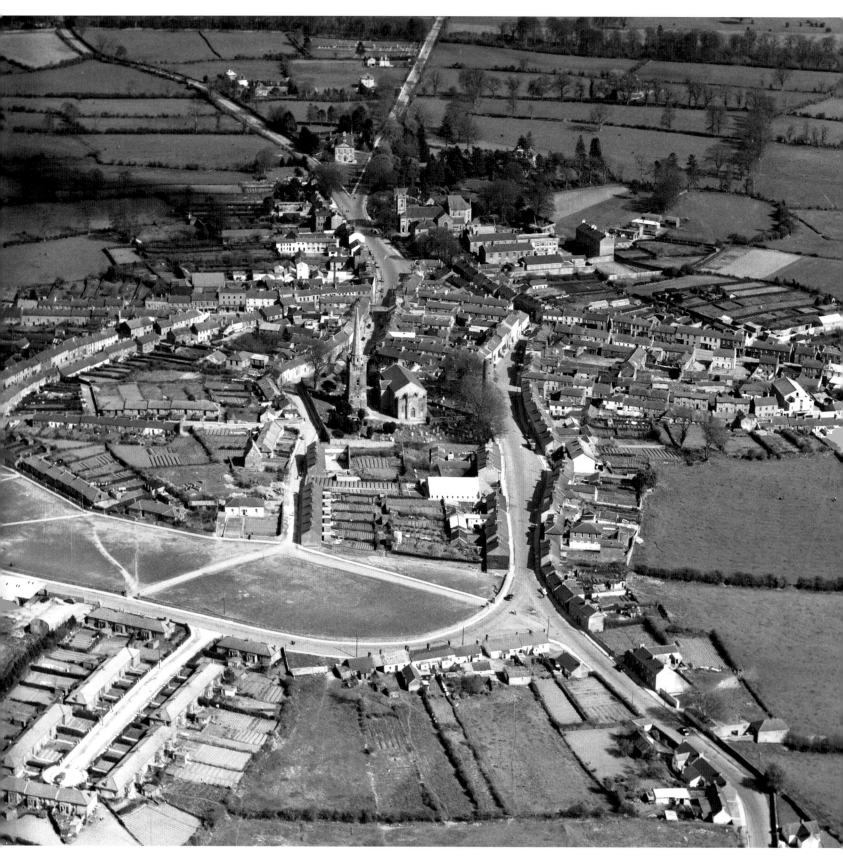

15 October 1954 *Ceanannas Mór* – the 'great residence' of County Meath, St Colmcille's House, a high-roofed stone building, still stands here as testimony to the town's importance as a monastic foundation of the sixth century. Other relics of its great days are a round tower, several stone crosses and the famous Book of Kells. **A104**

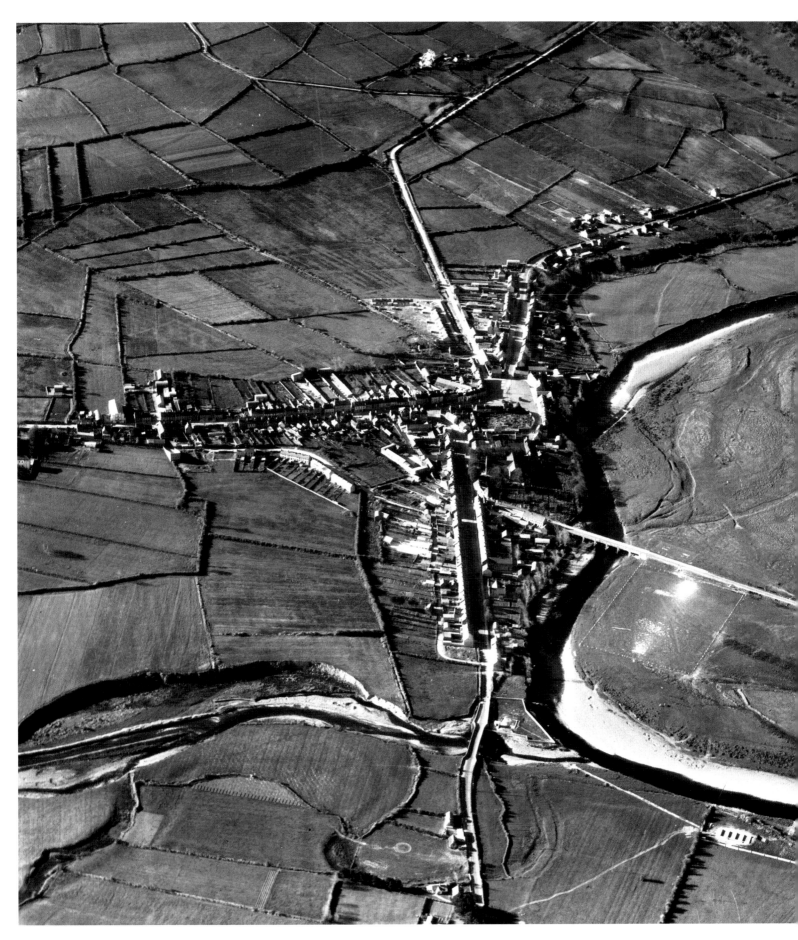

22 October 1954 Abbeyfeale takes its name from a twelfth-century abbey on the banks of the River Feale. The town is on the Limerick–Kerry border. **A3**

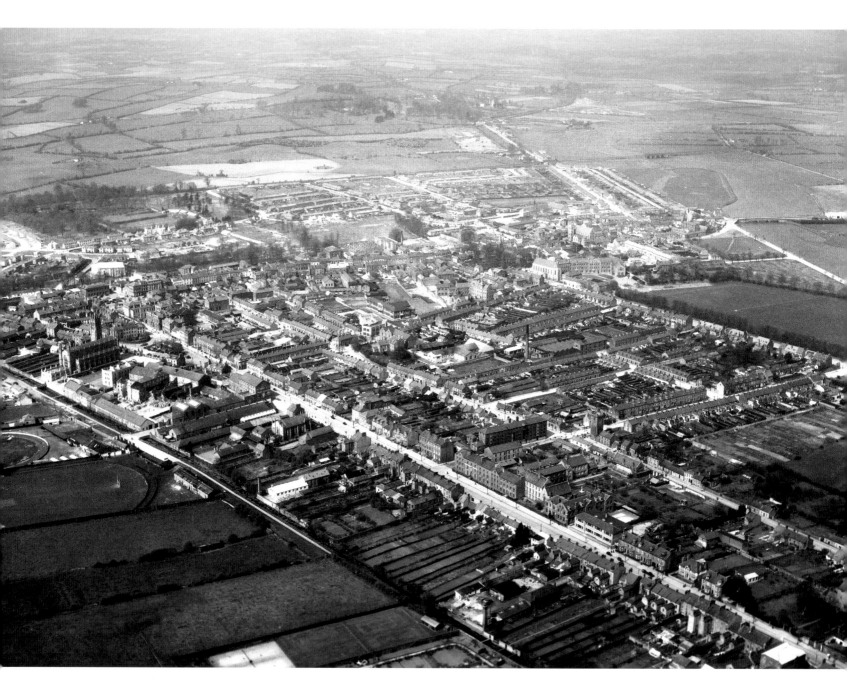

29 October 1954 Dundalk, the administrative centre of County Louth at the head of Dundalk Bay. A frontier town of the English Pale from the fourteenth to the seventeenth century, it is now the Republic's first town south of the Border. **A178**

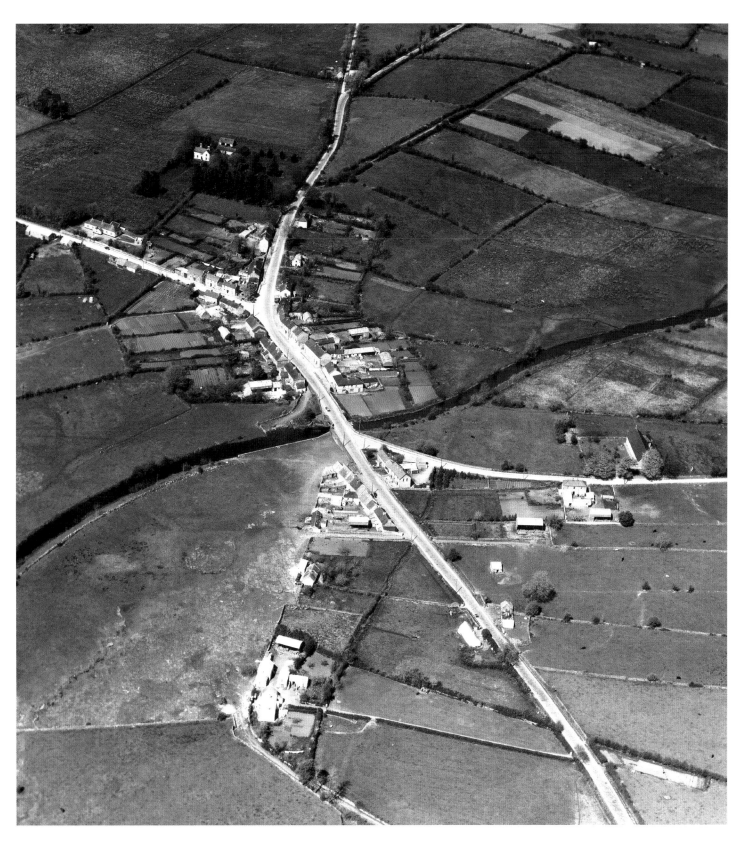

5 November 1954 Leitrim, a village north of Carrick-on-Shannon, which gives its name
to the county. The bridge over the little Shannon tributary is where the great retreat of
O'Sullivan Beare concluded after the historic march from Berehaven in Cork. The forked roads
lead left to Sligo and right into the Shannon Valley and Leitrim's lake district. **A255**

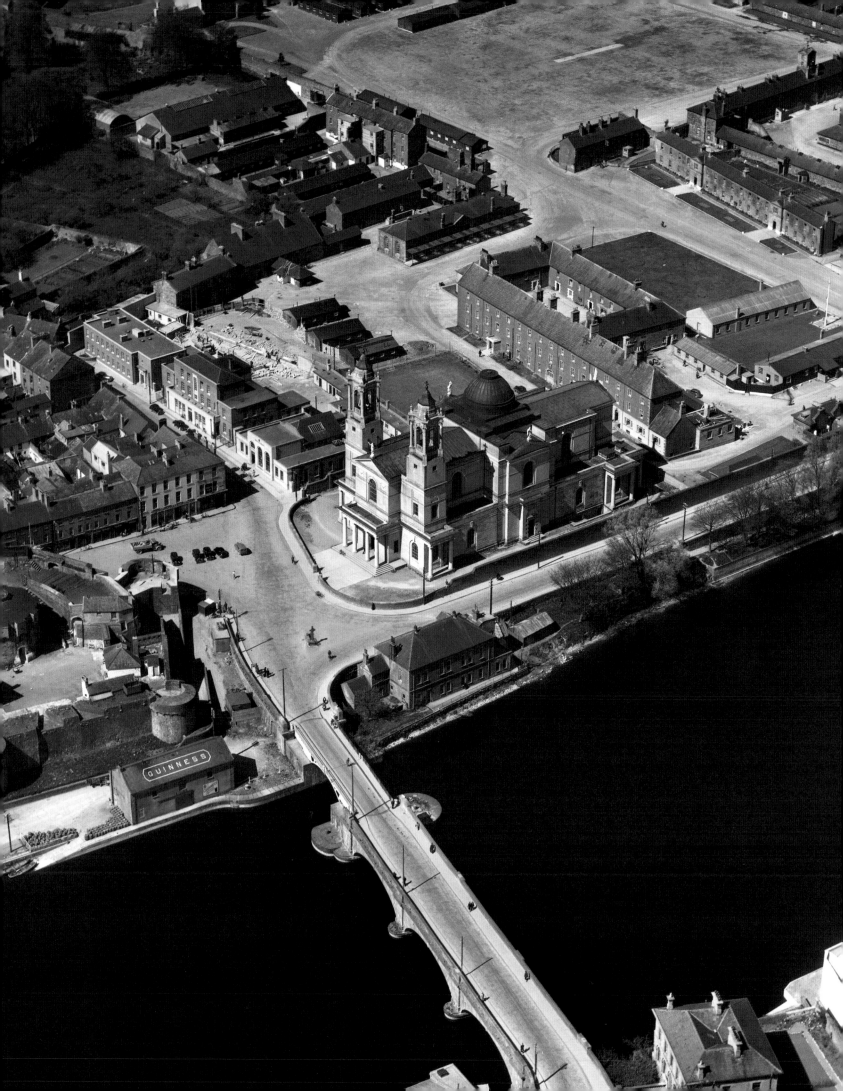

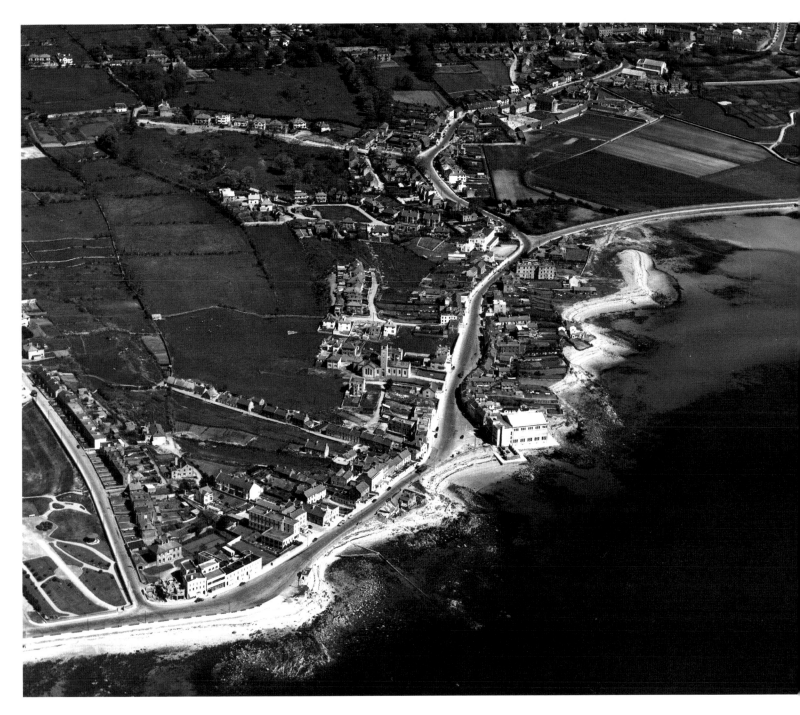

19 November 1954 Salthill, a popular Connacht seaside resort, stretching west from Galway city with up-to-date amusement amenities that have made it a leading Irish holiday centre. **A394**

12 November 1954 Athlone. The present-day bridge, successor to the old one of historic memory, crosses the Shannon from Leinster into Connacht. In the centre is the Church of SS Peter and Paul, with King John's Castle opposite. **A25**

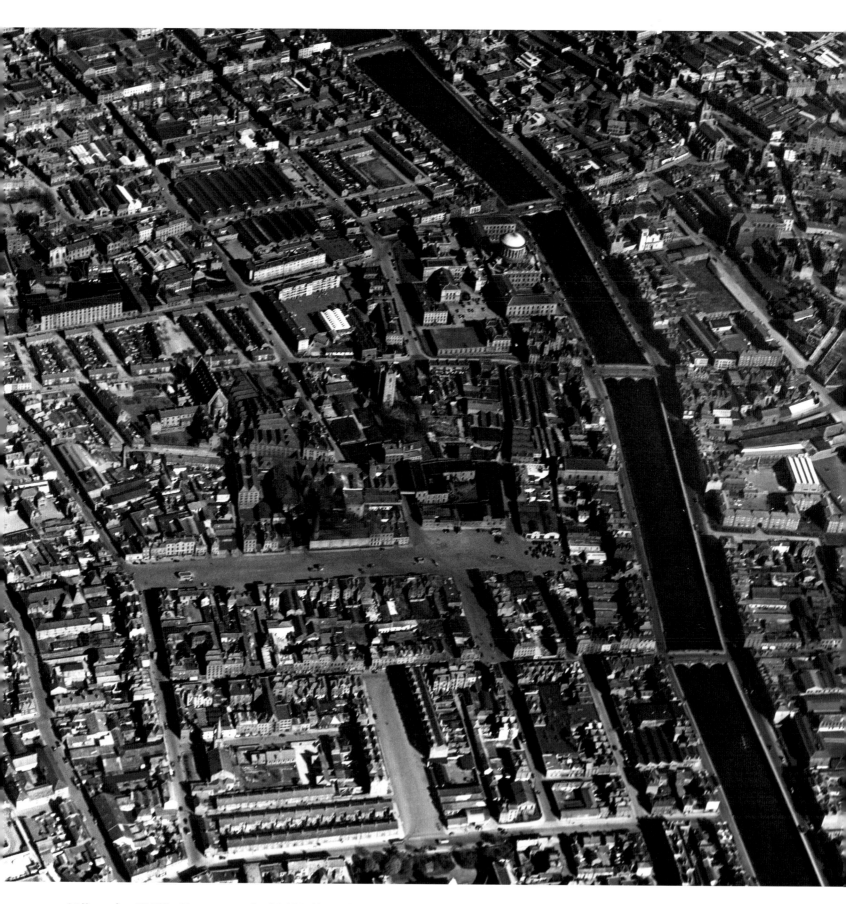

26 November 1954 The 66-acre space at Smithfield, Dublin, in the centre of this picture, was inspected by Dublin Corporation Town Planning Committee, who had been discussing a £1,700,000 scheme to develop the area. Landmarks readily identified are St Michan's Church and the Capuchin Friary in Church Street, with the Four Courts and St Paul's Church on Arran Quay. **A407**

3 December 1954 Belfast, looking over the Albert Bridge. Belfast Central Station is now located where the factory is on the left of the picture. **A53**

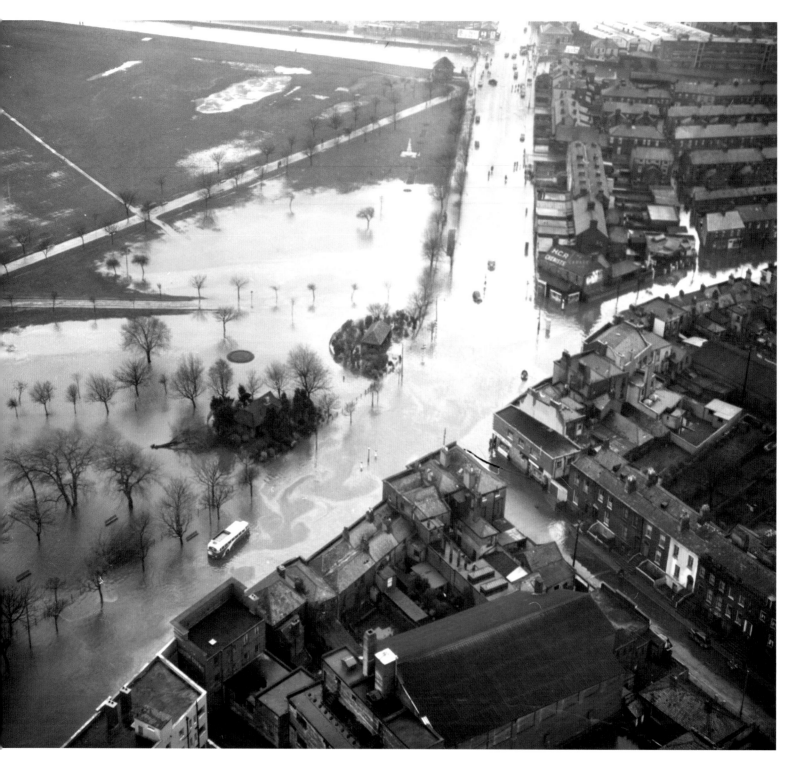

10 December 1954 Flooding at Fairview Strand, Dublin, yesterday, showing the waters' encroachment on Fairview Park. The Tolka River and the Annesley Bridge are at the top of the picture. **A426**

17 December 1954 Trim, a County Meath town on the River Boyne. Prominent landmarks seen here are the castle, St Patrick's Church, and the hospital under the care of the Sisters of Mercy. **A427**

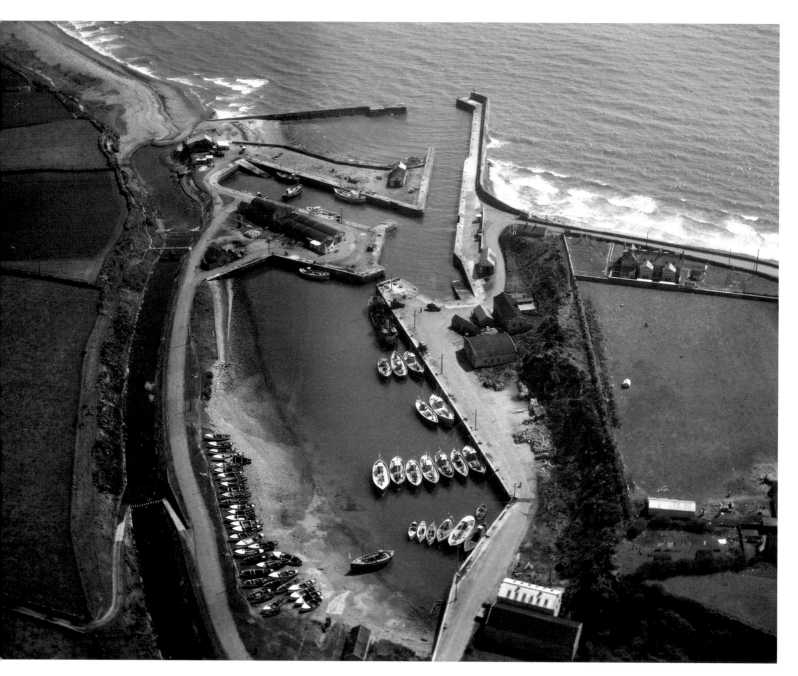

31 December 1954 Kilkeel, County Down: the fishing fleet at rest, with everything in order and accounted for, is symbolic of men's minds today, awaiting the morrow for greater efforts and new resolves. **A232**

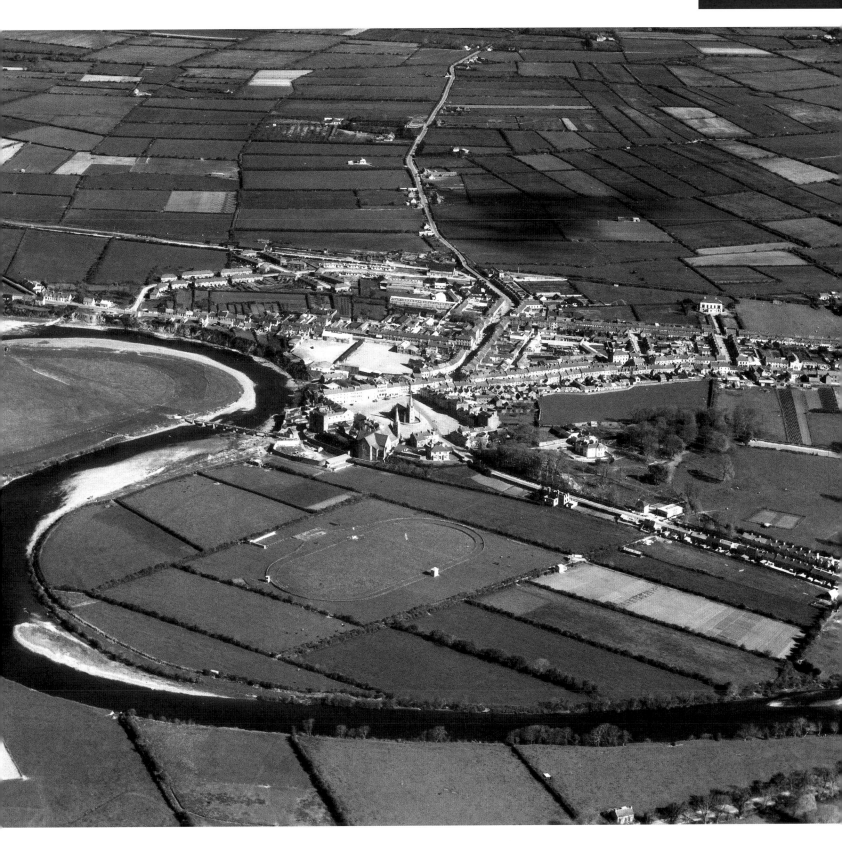

14 January 1955 Listowel, an inland Kerry town between Limerick and Tralee on the River Feale, good for salmon and trout fishing. The ruined castle once belonged to the Lords of Kerry and was the last to hold out against the Elizabethan forces during the Desmond revolt. **A269**

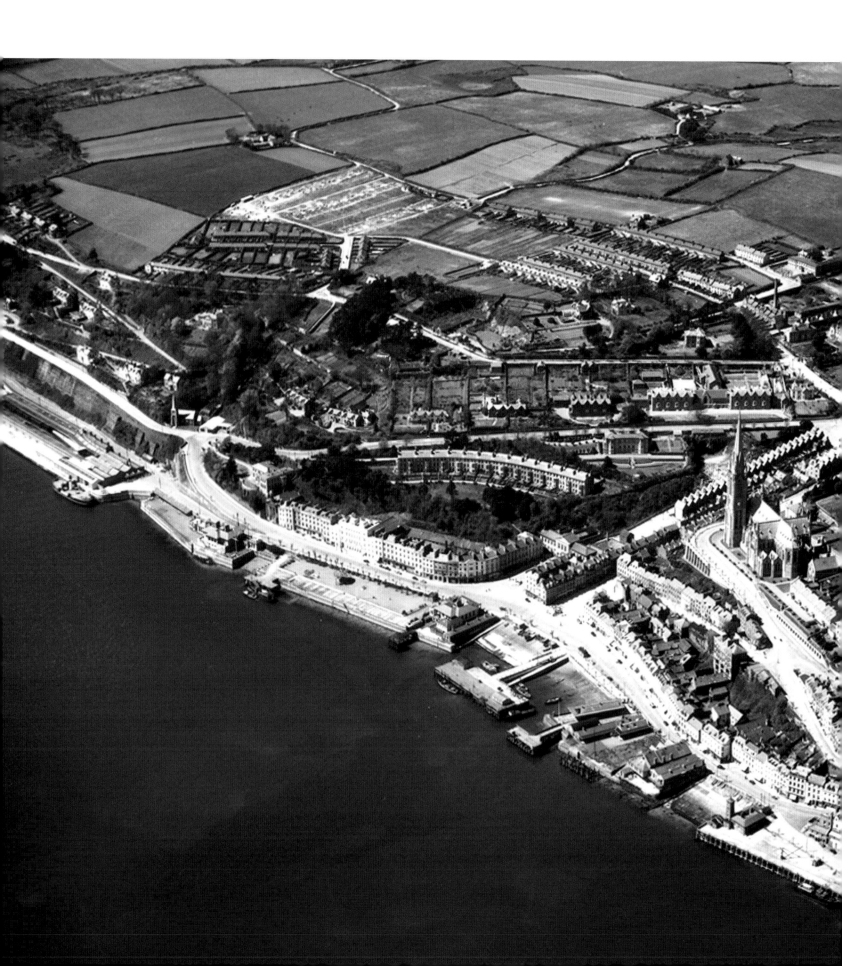

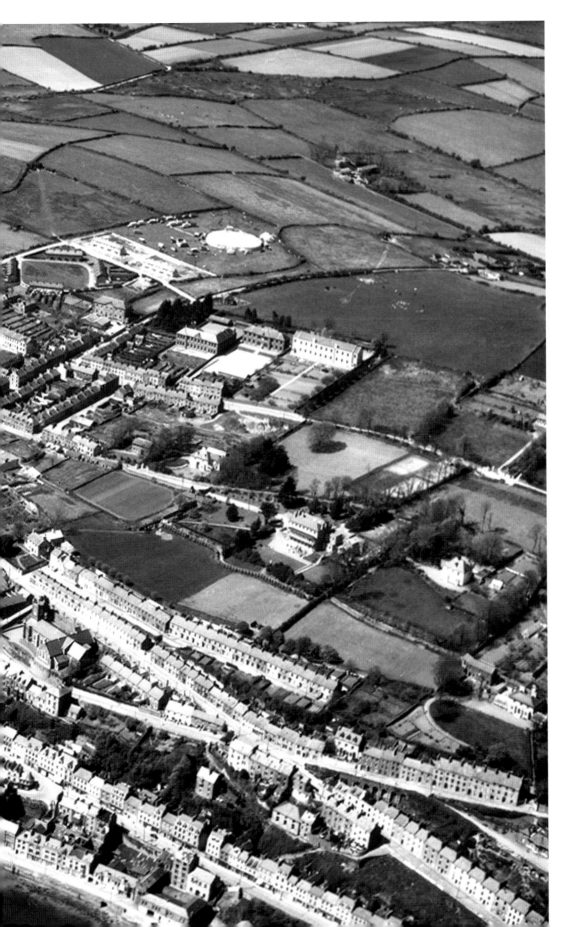

7 January 1955 Cobh, the Cork port that is often the visitor's or returning exile's first step into the country. From the sea it ascends in terraced formation, with the Cathedral of St Colman magnificently reigning over all. **A127**

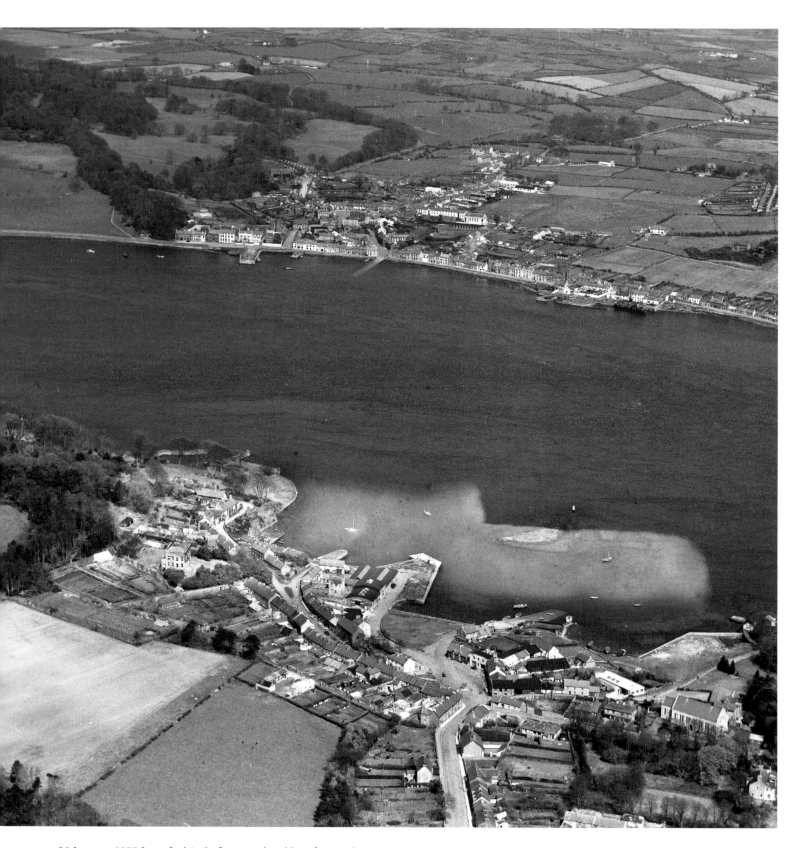

21 January 1955 Strangford, in the foreground, and Portaferry on the opposite
bank of the entrance to Strangford Lough in County Down. A ferry operates
across the narrow waters between the two towns. **A411**

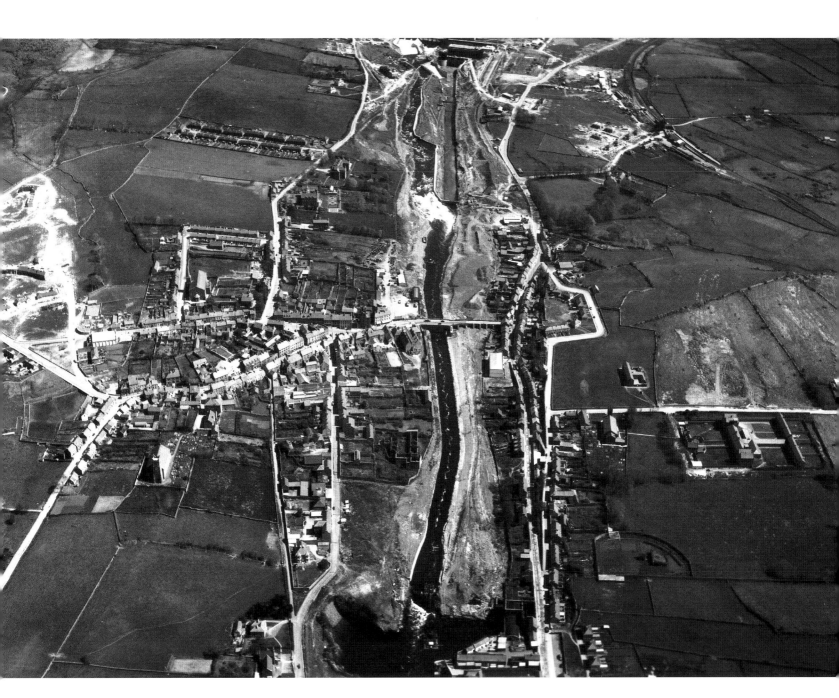

4 February 1955 Ballyshannon, County Donegal, on the banks of the swift-flowing Erne, focal point of the hydroelectric plant which serves north and south of the border. **A46**

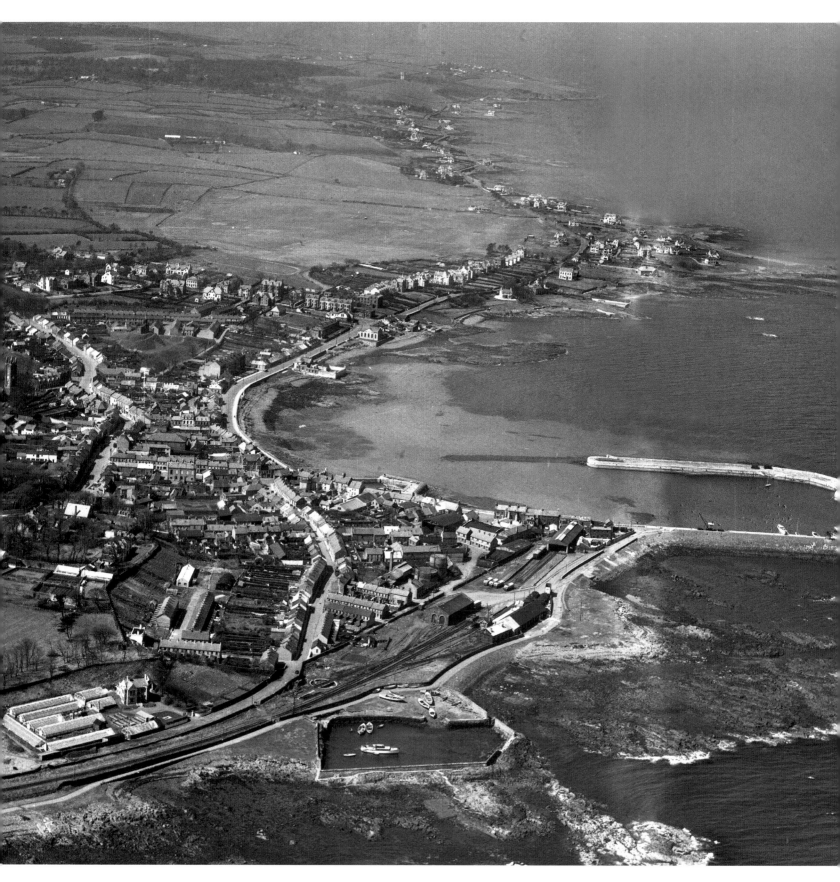

18 February 1955 Donaghadee, County Down, with its harbour and pier lighthouse, once the port of a mail packet service to Portpatrick in Scotland, which was abandoned for the Larne–Stranraer route. **A155**

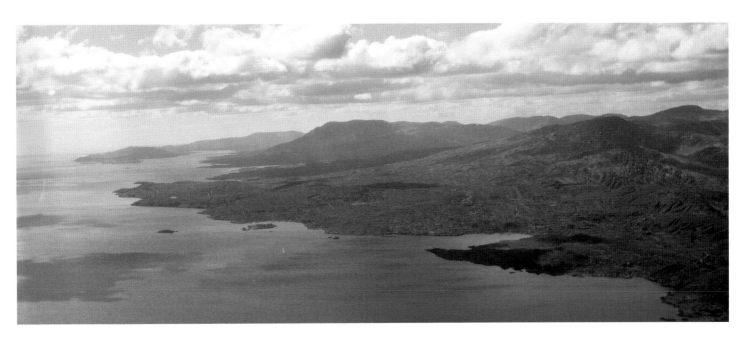

25 February 1955 Bantry Bay, County Cork, one of the loveliest bays on the Irish coast and clear in the memory of historians as the scene of gallant efforts by France to come to the aid of Irishmen in 1689 and 1796. **A50**

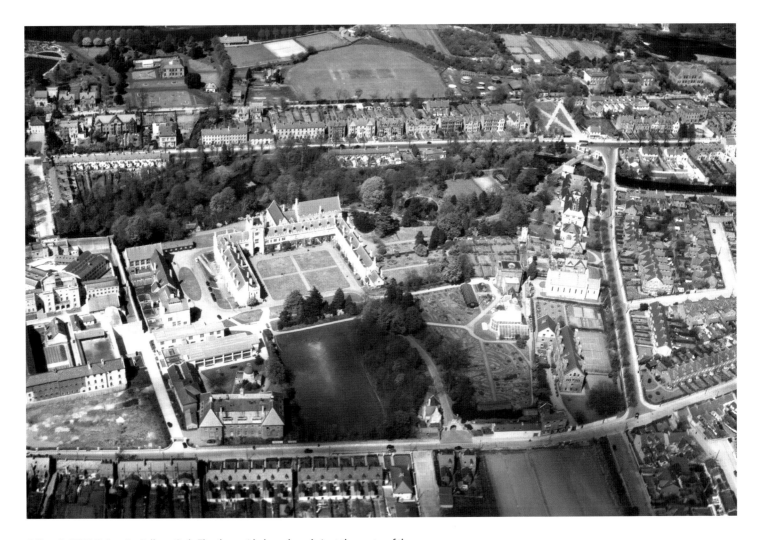

4 March 1955 University College Cork. The three-sided quadrangle is at the centre of the picture, with the Dairy Science Institute and gardens to the right. Cork Jail is on the left. At the top is the River Lee and below it Western Road. **A431**

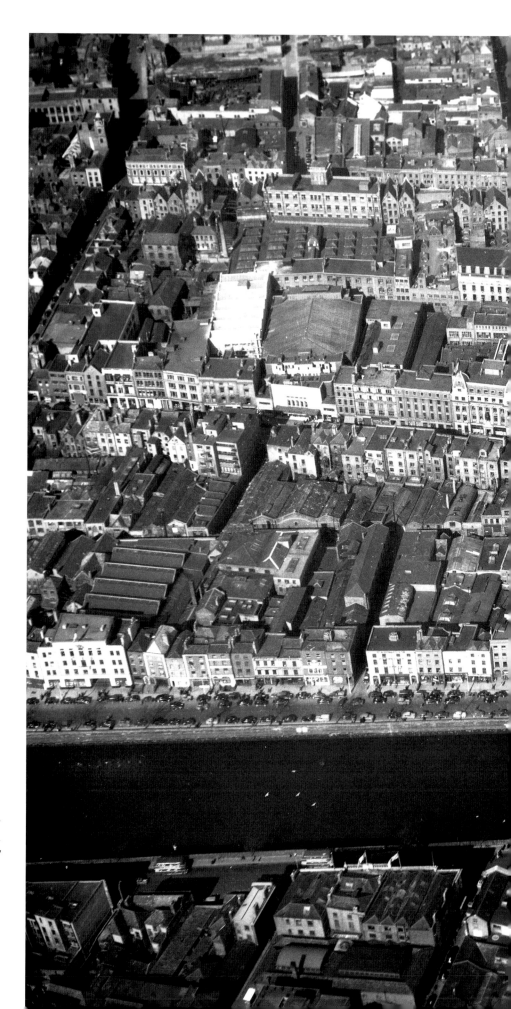

18 March 1955 Dublin city yesterday, enjoying the brilliance of a lovely day for the national St Patrick's Day holiday. The picture was taken as the industries' parade passed up and down O'Connell Street. Amongst the buildings, highlighted by the midday sun, is Independent House (to the left), identified by its familiar twin turrets in Abbey Street, which runs across the centre of the picture. **A170(1)**

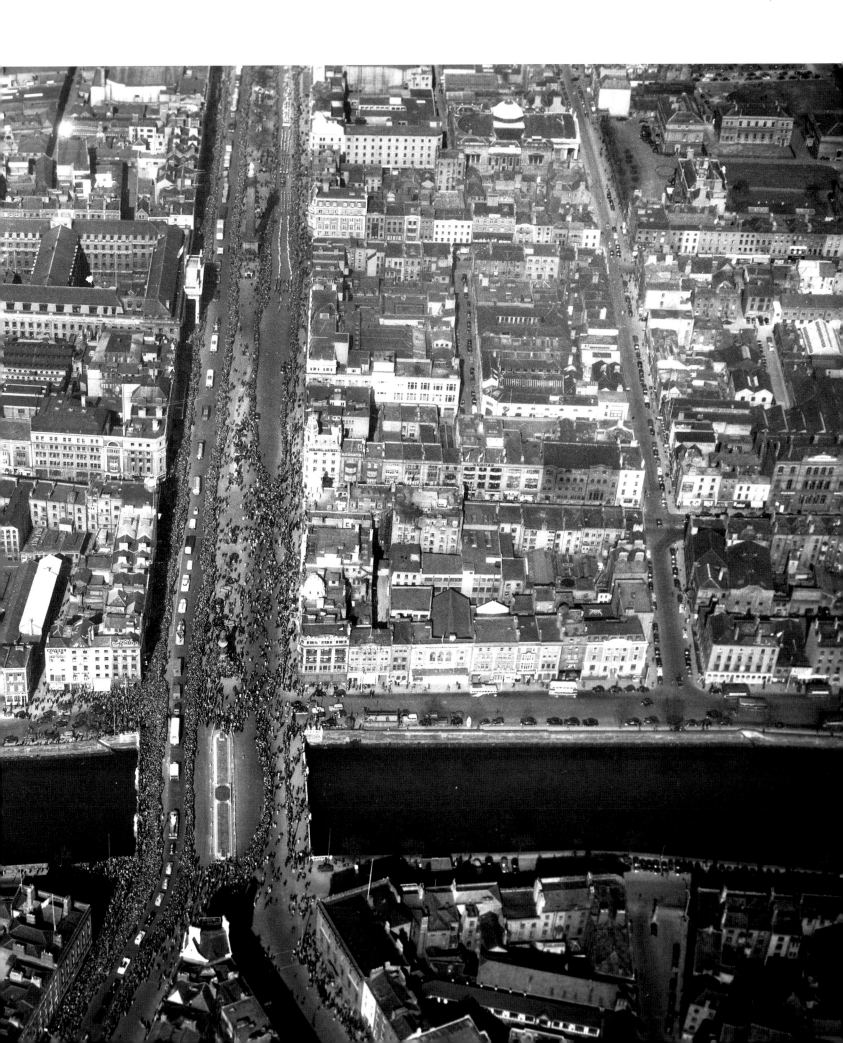

25 March 1955 Dooagh, the village on the western extremity of Achill Island. Its sheltered beach and the road ascending Croaghaun Mountain are plainly visible. The many little houses, with their gable ends towards the road, give the village a unique appearance whether viewed from the air or ground level. **A1**

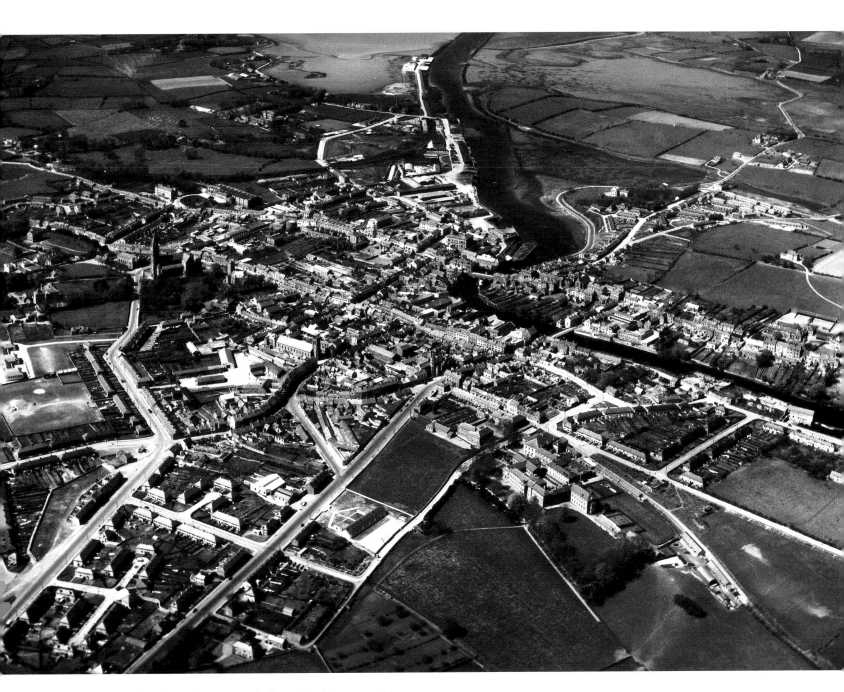

15 April 1955 Sligo, the north-west town, is of exceptional importance this week, when talented contestants from many parts of the country meet in the Feiseanna. Situated between the sea and Lough Gill, it is a pleasant resort at any time for the holidaymaker, be he angler or antiquarian. **A414(A)**

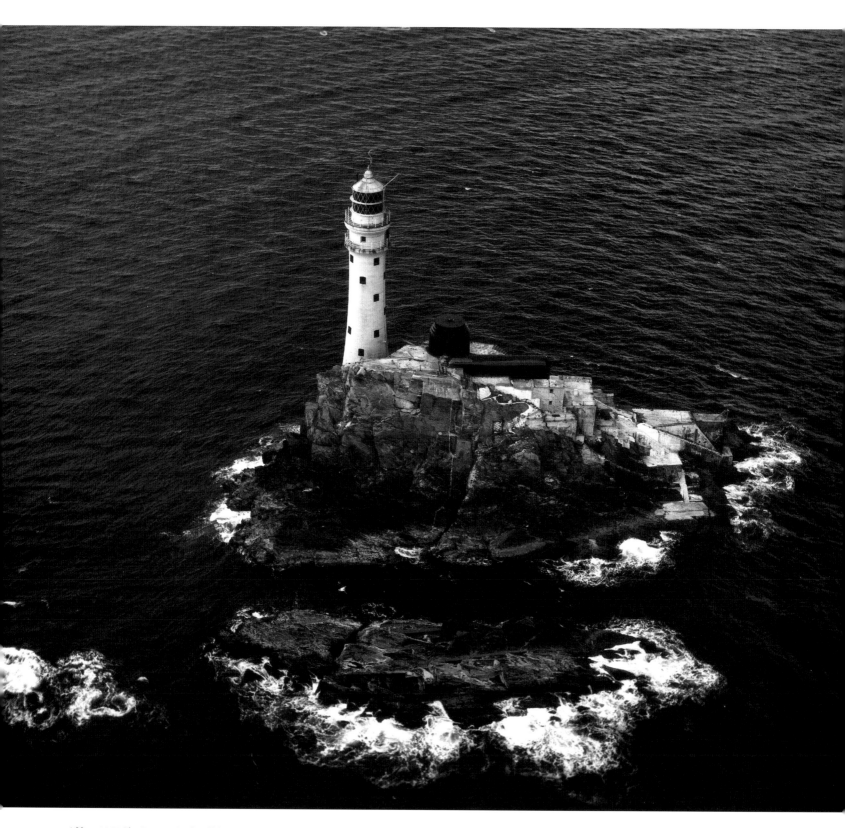

6 May 1955 The Fastnet Rock, off the Cork coast, with its lighthouse, sturdy outbuildings and numerous steps, facilitates the men who, in isolation, man the light and keep watch for the safety of users of the high seas. **A197**

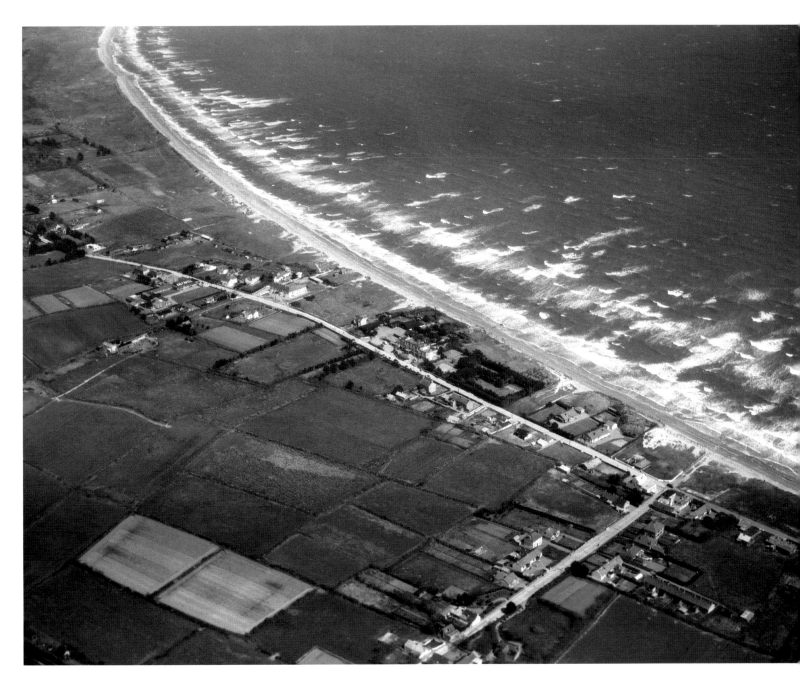

13 May 1955 Rosslare, County Wexford. 'White horses' hurry along the extensive strand that makes this a popular and restful holiday centre. In their more angry winter mood, those same waves give rise to much concern because of coastal erosion at this point. **A352**

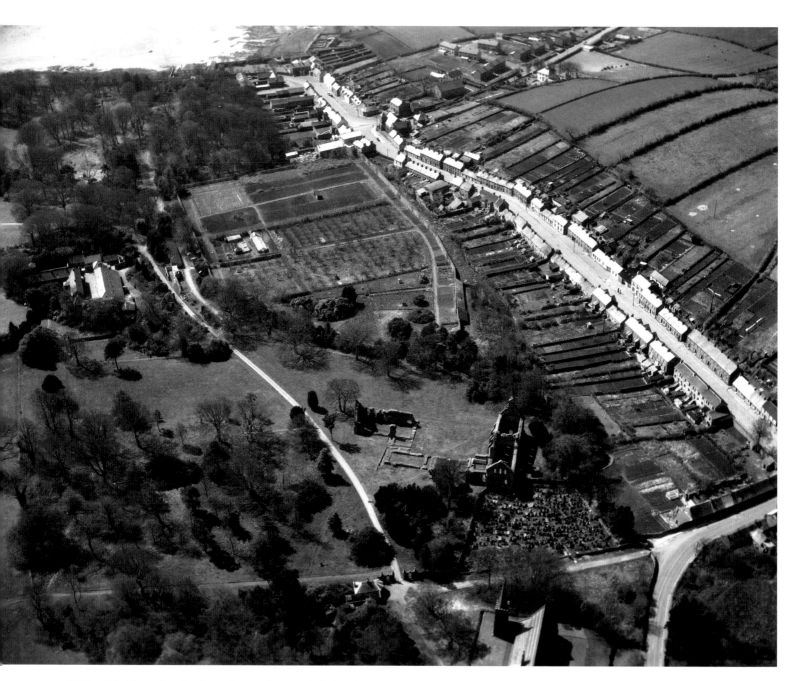

27 May 1955 Greyabbey. This County Down village is called after the Cistercian abbey founded there in 1193. The ruins are extensive and embody a fine West door. The churchyard has the grave of Rev. James Porter, Presbyterian member of the United Irish Society, hanged in Greyabbey in 1798. **A216**

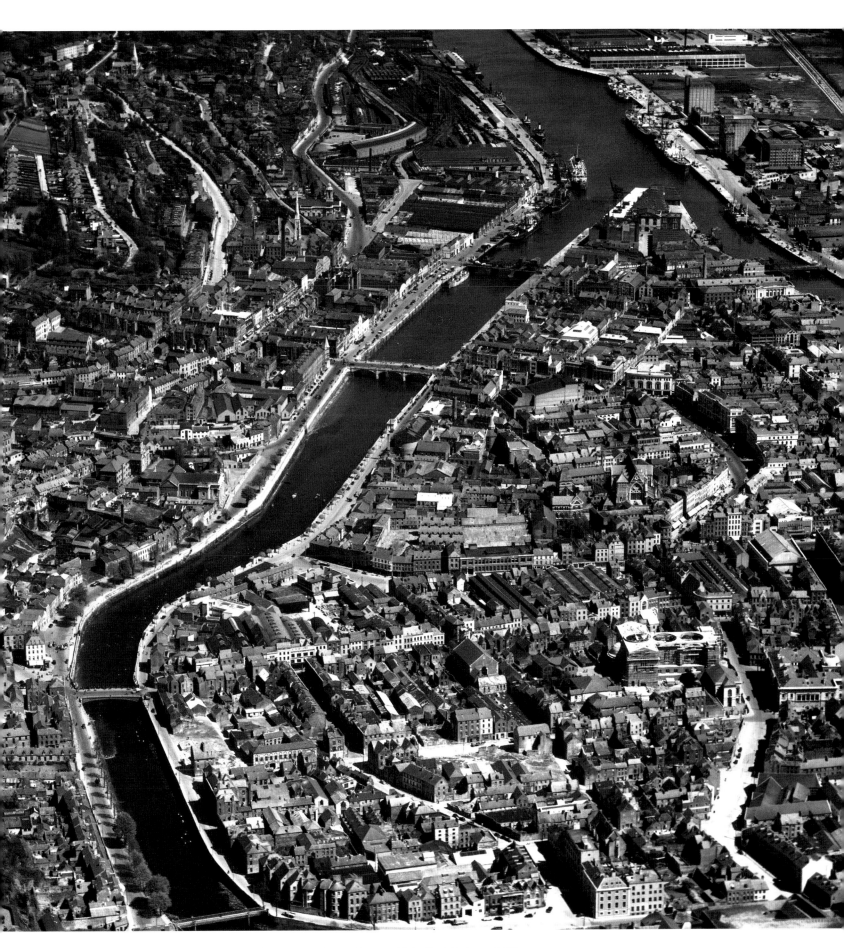

28 May 1955 An aerial view of Cork city, looking over North Main Street and Saint Patrick's Street. **A132**

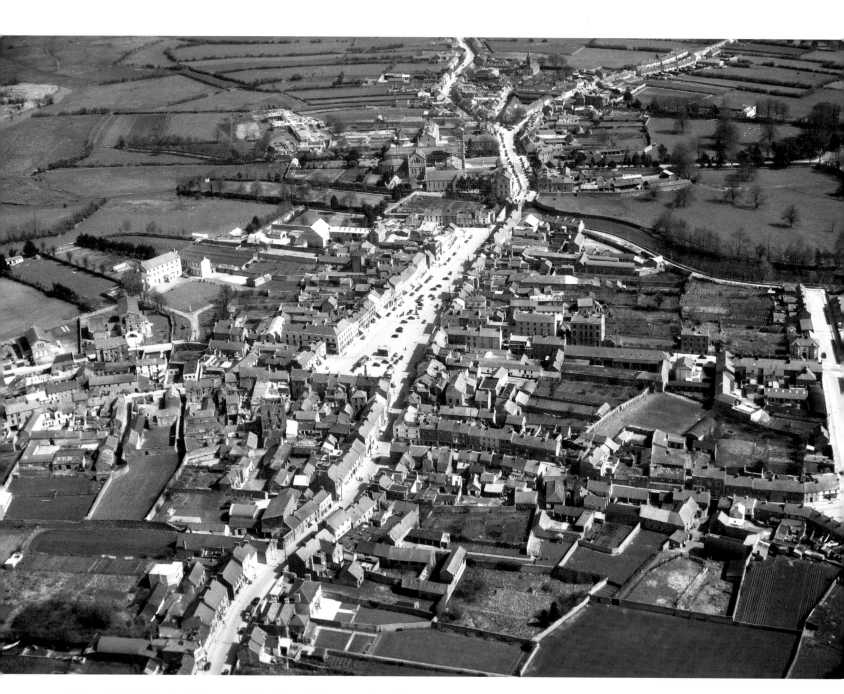

17 June 1955 Thurles, County Tipperary. Liberty Square is the centrepiece of this view. At the near side stands the statue to Dr Croke as a reminder that here, in 1884, was the foundation of the GAA. Nearer to the top of the photograph is the cathedral for the archdiocese of Cashel and Emly. The building of it commenced in 1857, seven years after the Synod of Thurles, at which it was decided to establish Dublin's Catholic University. **A421**

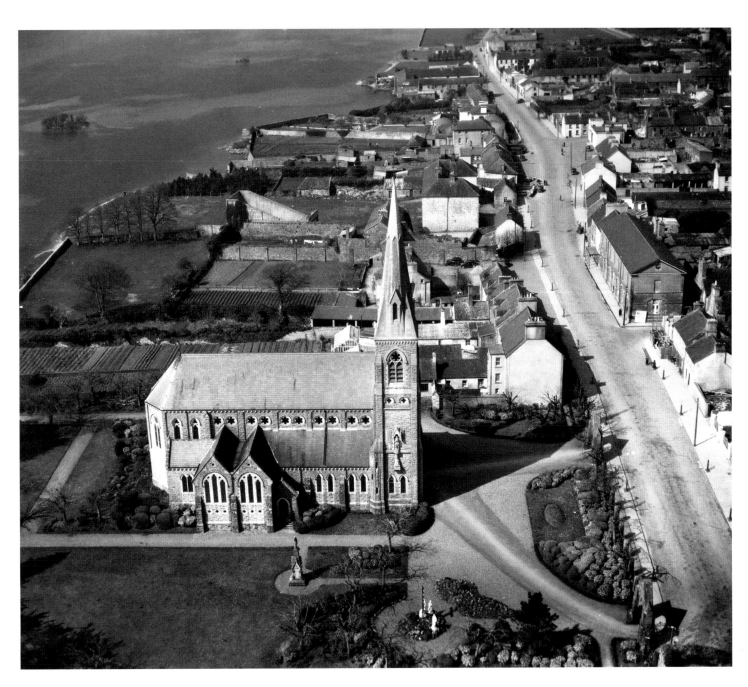

24 June 1955 St Brendan's Cathedral for the Diocese of Clonfert stands on the shore of the 'grey lake' in Loughrea, County Galway. **A279**

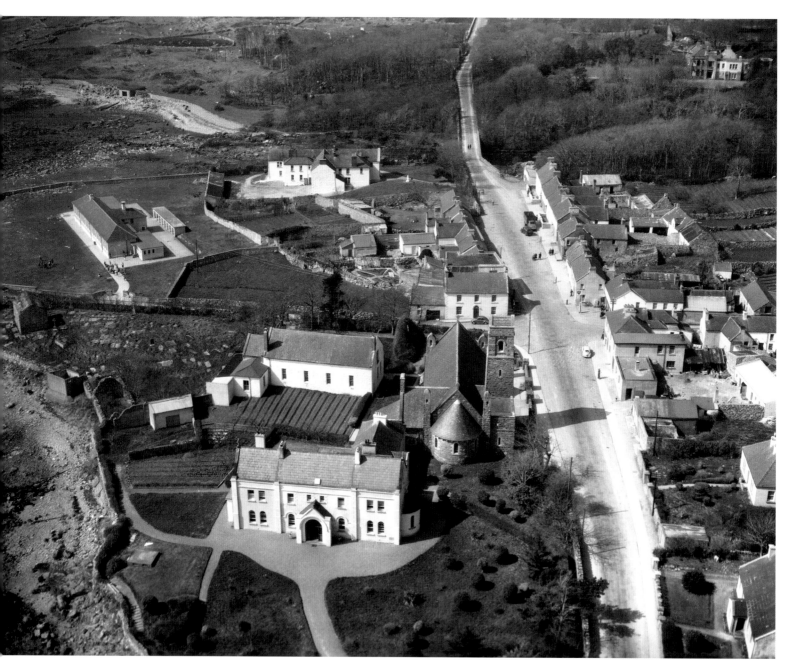

30 September 1955 Spiddal, County Galway. In the foreground is the Convent of Mercy and Boarding School. The Irish College, Coláiste Chonnacht, is in the centre background, and to the left the Boys' National School. **A408**

28 October 1955 Carysfort College: the Convent of the Sisters of Mercy and primary teachers' training college at Carysfort Park, Blackrock, County Dublin. **A91**

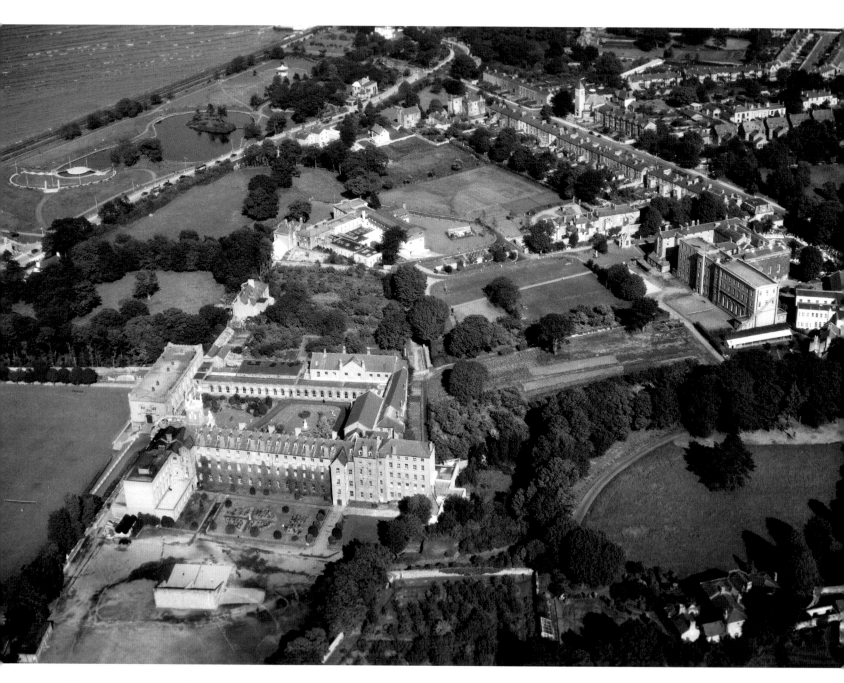

9 December 1955 Blackrock College of the Holy Ghost Fathers at Blackrock, County Dublin. **A62**

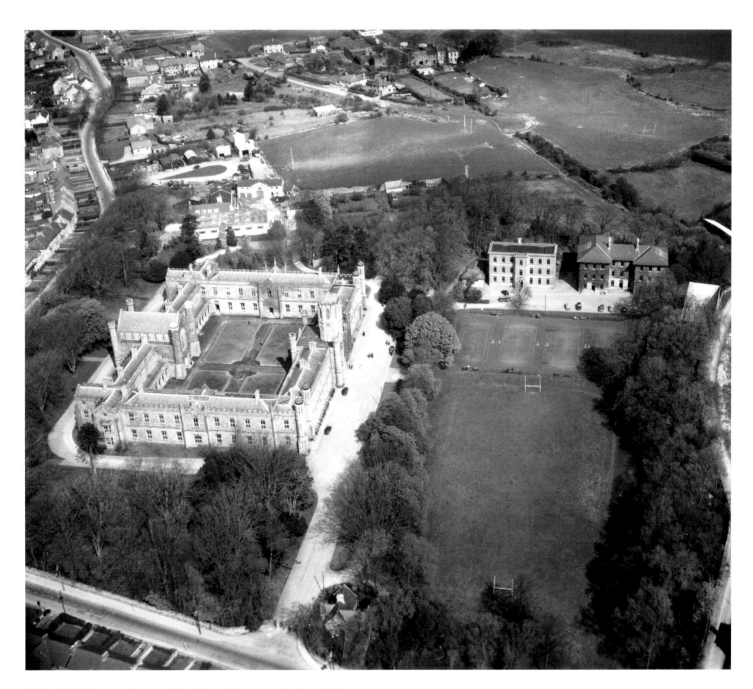

13 April 1956 Galway's College of the National University of Ireland. **A432**

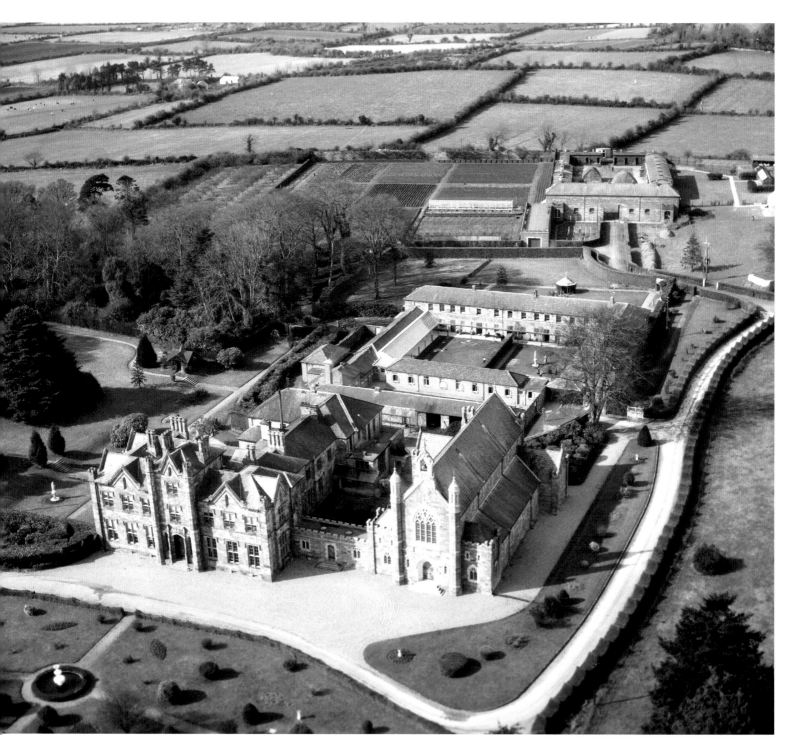

29 June 1956 Bon Sauveur Convent, Carriglea, Dungarvan, County Waterford, established in 1904. **A68**

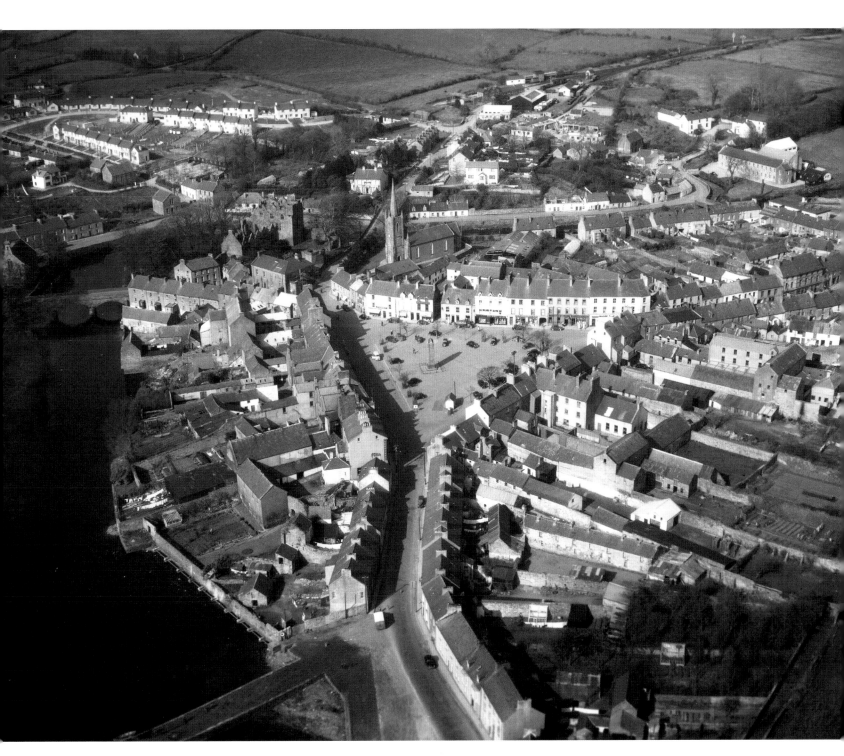

25 January 1957 Donegal town on the River Eske. The Four Masters Memorial obelisk marks the centre of the Diamond. **A157**

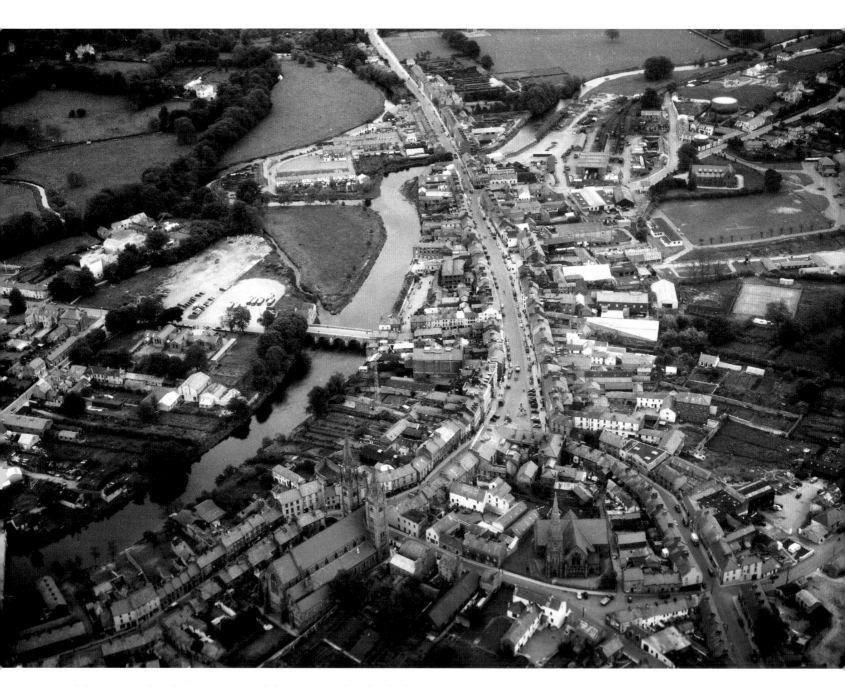

1 February 1957 Omagh, County Tyrone, with the twin spires of the Church of the Sacred Heart prominently in the foreground, and the River Strule to the left. **A339**

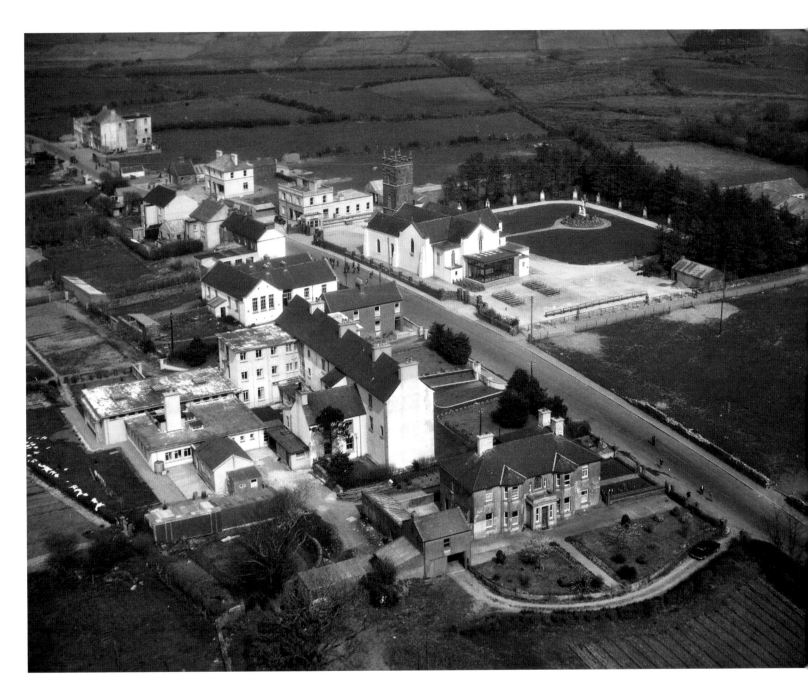

8 February 1957 Knock. The Mayo village with the covered shrine at the gable end of the parish church, marks the scene of the apparitions of 1879. In the foreground is the convent and hostel of the Sisters of Charity of St Vincent de Paul. **A252**

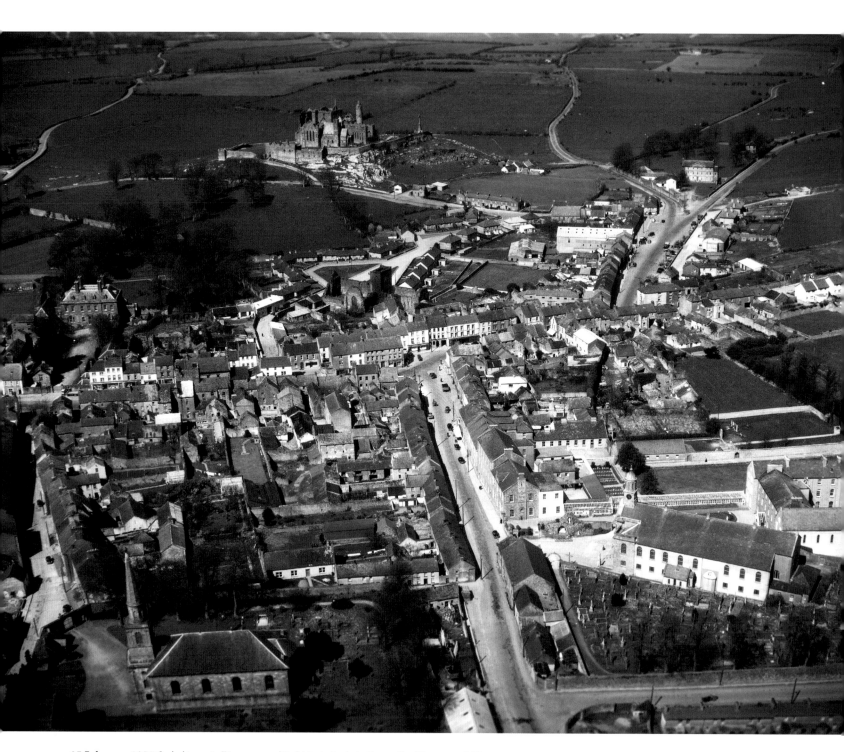

15 February 1957 Cashel town in Tipperary and its historic Rock, to the north of the town. **A92**

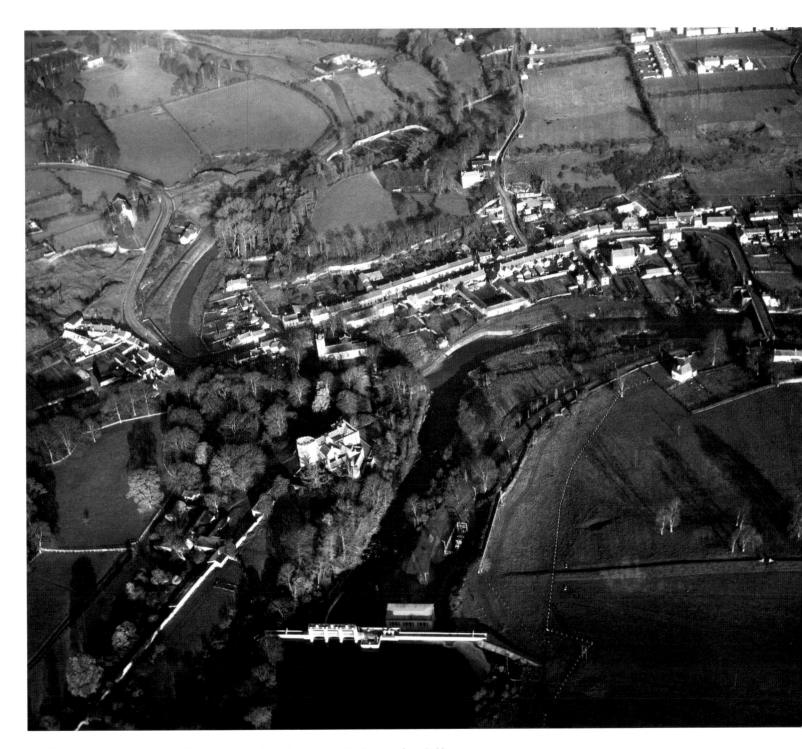

22 February 1957 Leixlip, County Kildare, situated where the trunk road to the west, from Dublin, winds up out of the Liffey Valley. The town's hydroelectric dam is in the foreground. **A256**

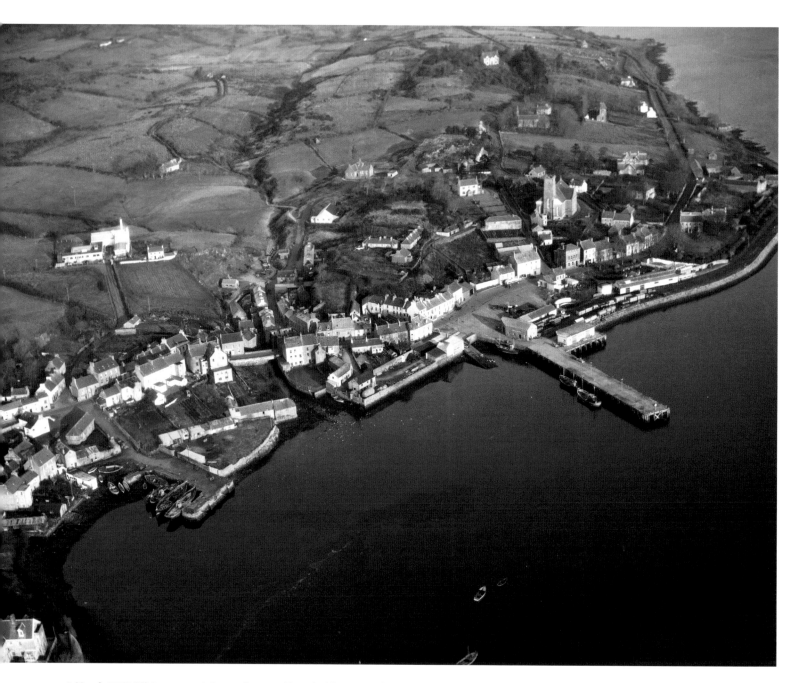

1 March 1957 Killybegs, a south Donegal port and boat-building centre for the fishing industry. **A243**

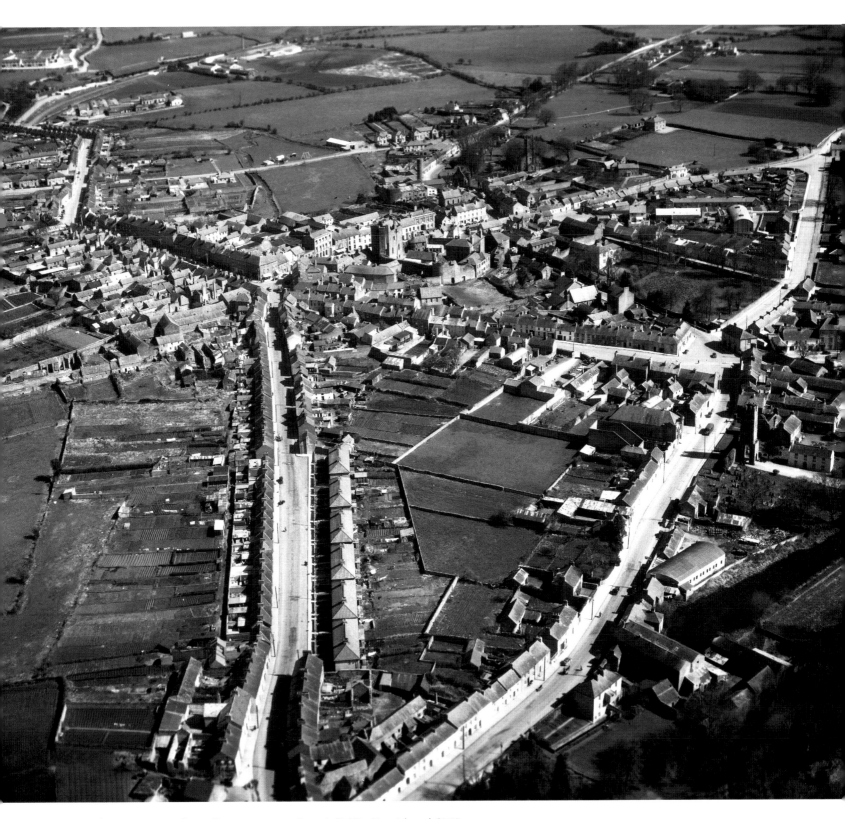

8 March 1957 Roscrea, a County Tipperary town on the main Dublin–Limerick road. **A349**

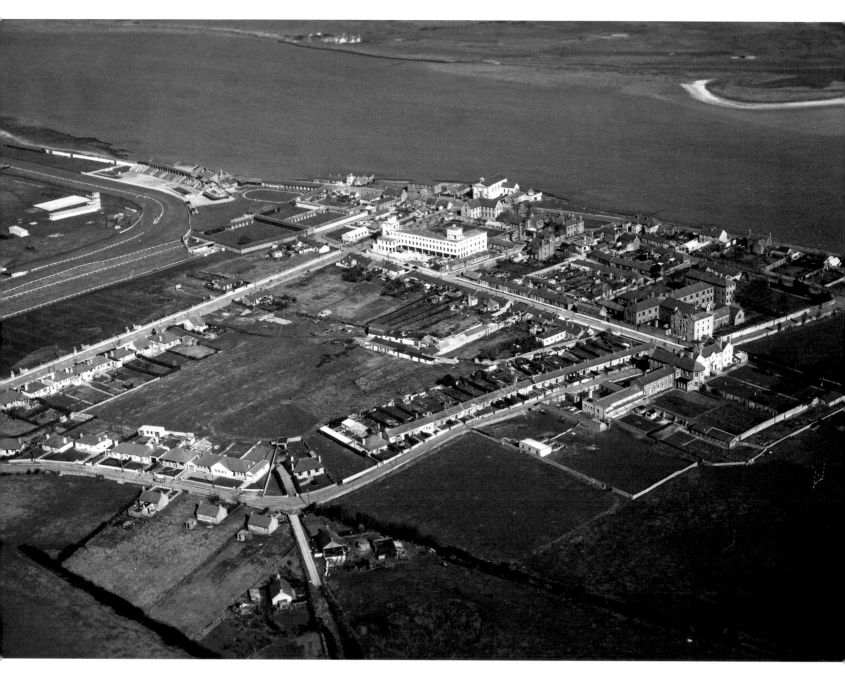

22 March 1957 Baldoyle, County Dublin, showing the racecourse to the left with Portmarnock Golf Club across the inlet. The prominent white building is the children's ('Little Willie') hospital of the Irish Sisters of Charity. **A30**

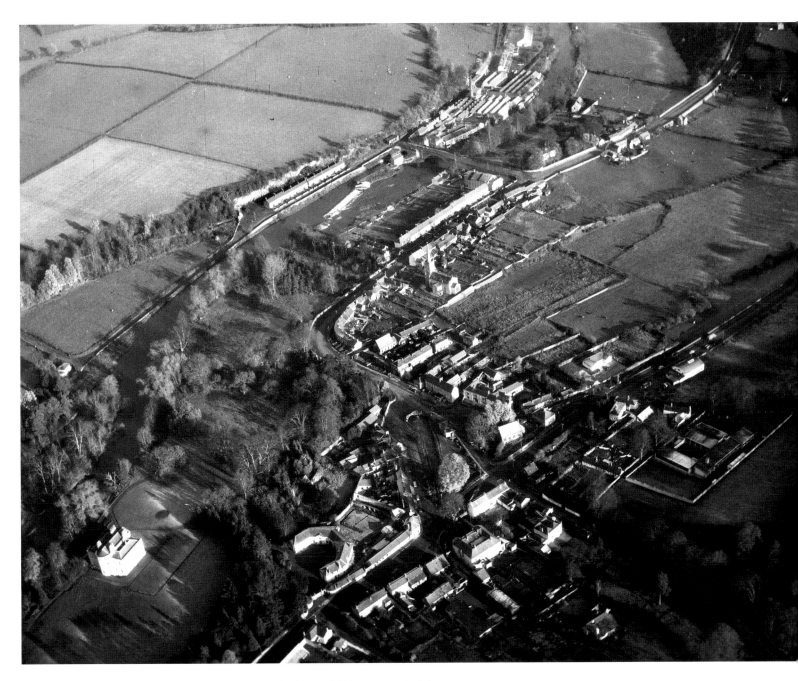

5 April 1957 Lucan, County Dublin, with the Liffey flowing by the Sarsfield Demesne at the left foreground and the Lucan Mills at the top of the picture. **A281**

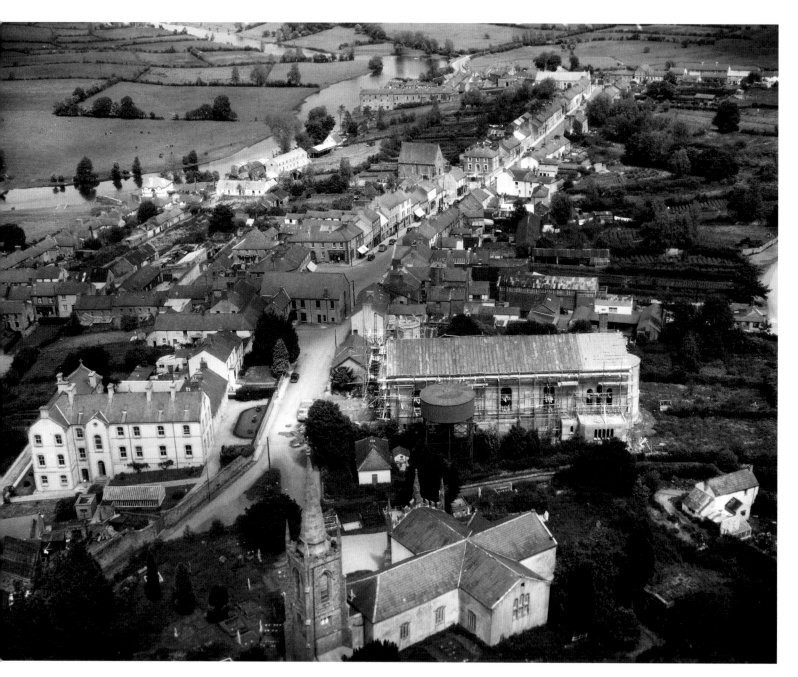

12 April 1957 Belturbet, County Cavan, with the River Erne running to the top left. The new Church of St Mary in the foreground has been completed since this picture was taken. To the left is the Convent of Mercy. **A61**

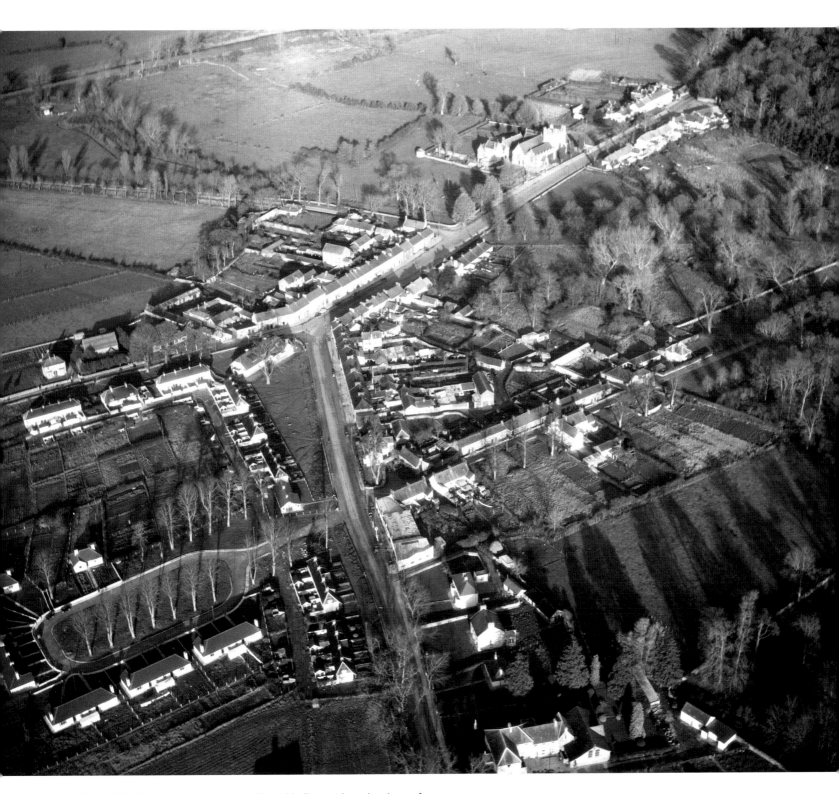

26 April 1957 Adare, County Limerick, an old-world village with an abundance of trees adding to its charm. **A5**

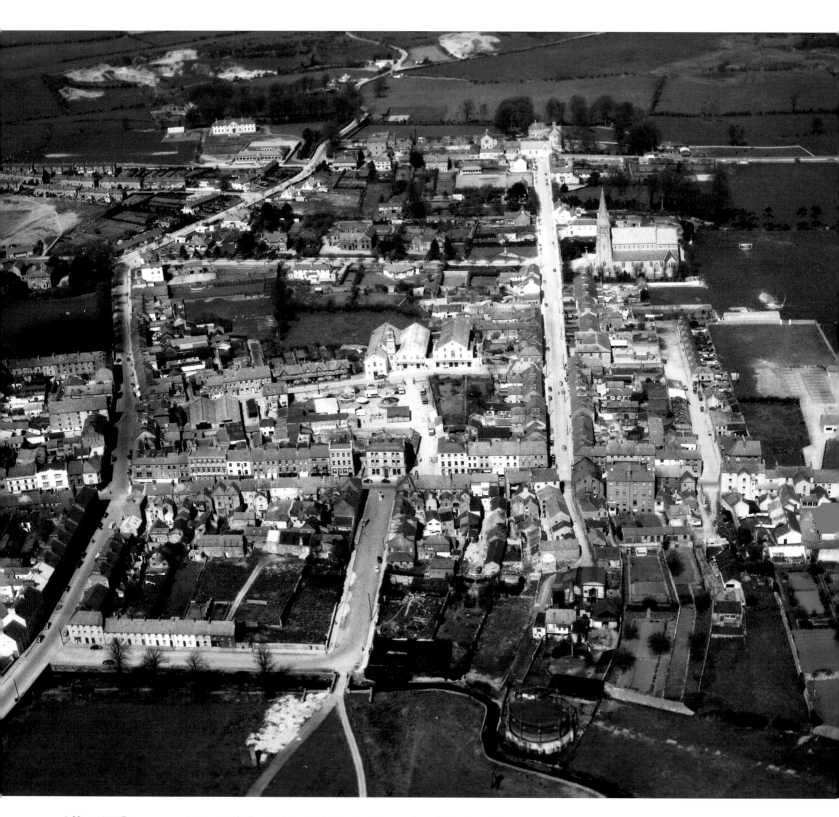

3 May 1957 Tipperary, county town in the heart of Munster's dairy farming country and the place where Muintir na Tíre was founded twenty-six years ago by the late Canon Hayes. **A423**

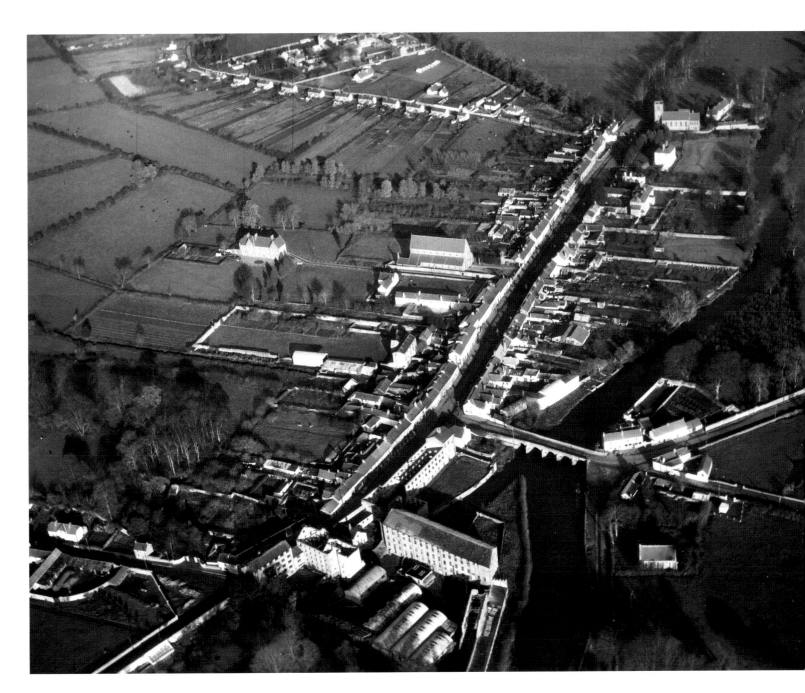

10 May 1957 Celbridge, County Kildare. The bridge carrying the Dublin road over the Liffey is seen at the right centre. **A105**

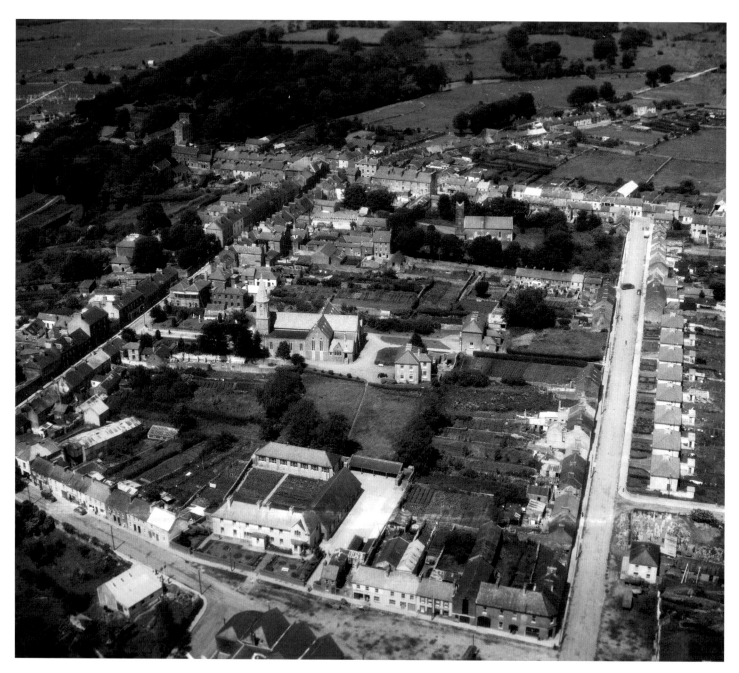

24 May 1957 Ballinrobe, County Mayo, on the Robe River, is a
convenient centre for Lough Mask fishing. **A35**

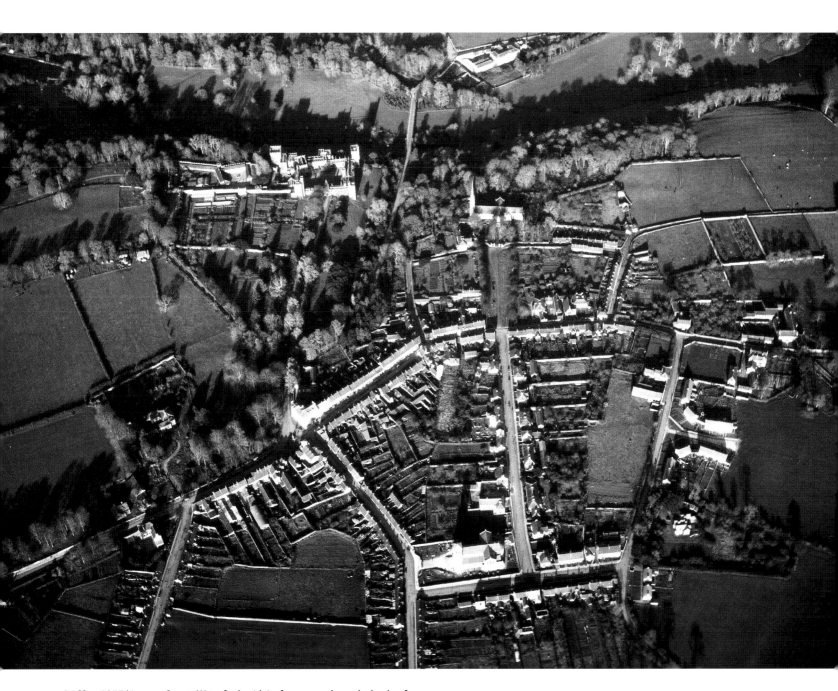

31 May 1957 Lismore, County Waterford, with its famous castle on the banks of the Blackwater River at the top of the picture. **A267**

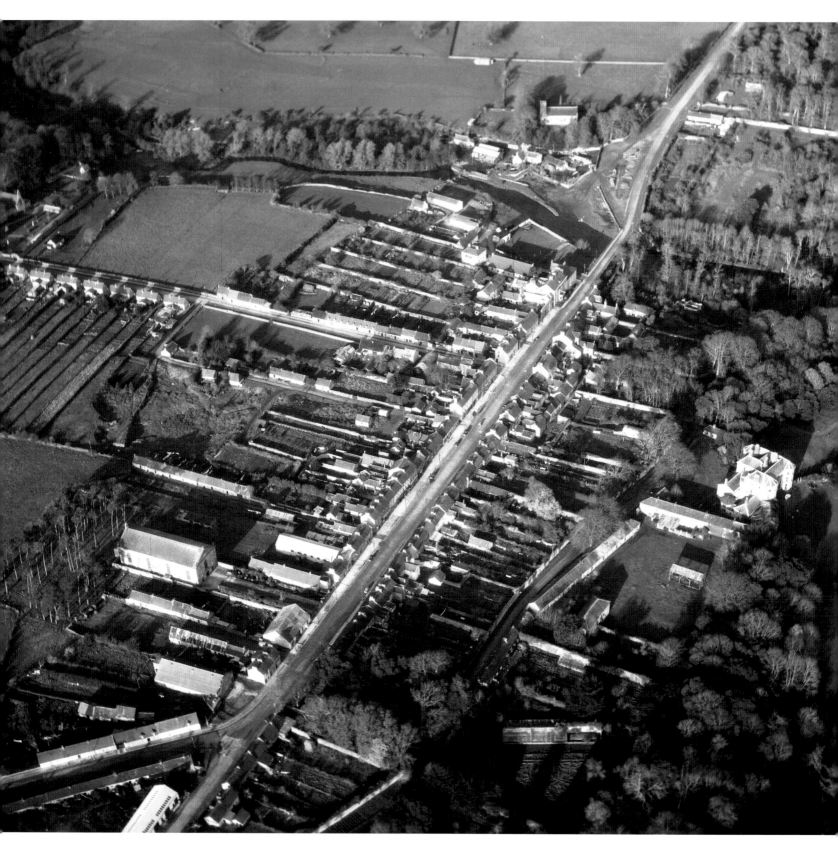

14 June 1957 Doneraile. This north Cork town is rich in association with Canon Sheehan.
His statue stands outside the parish church at the lower left-hand corner of the picture.
His house and garden, where he wrote, are by the Awbeg River to the top, and at the top left is
the Presentation Convent where many of the author's belongings are treasured. **A158**

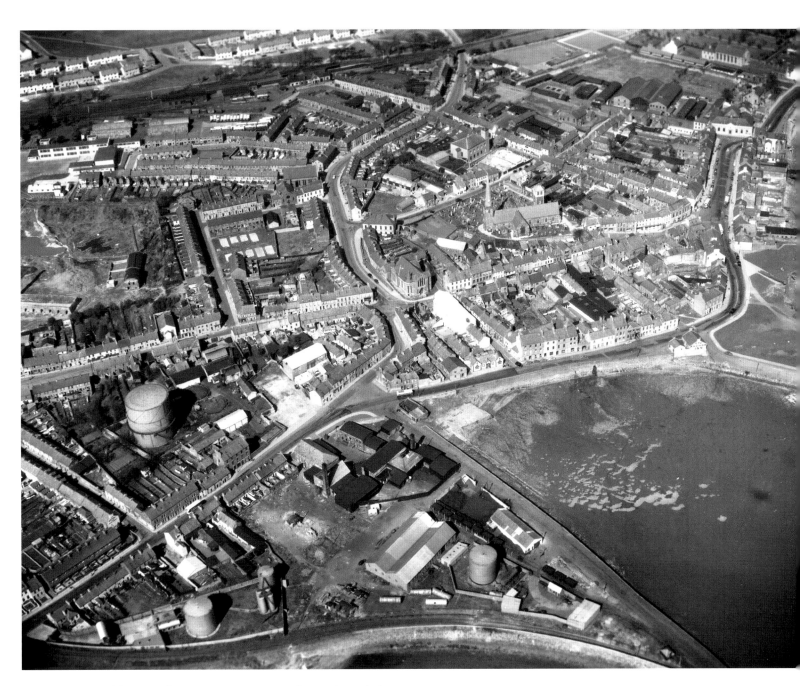

28 June 1957 Carrickfergus. On the Antrim coast, it is a town of interesting antiquity and present-day industry. **A87**

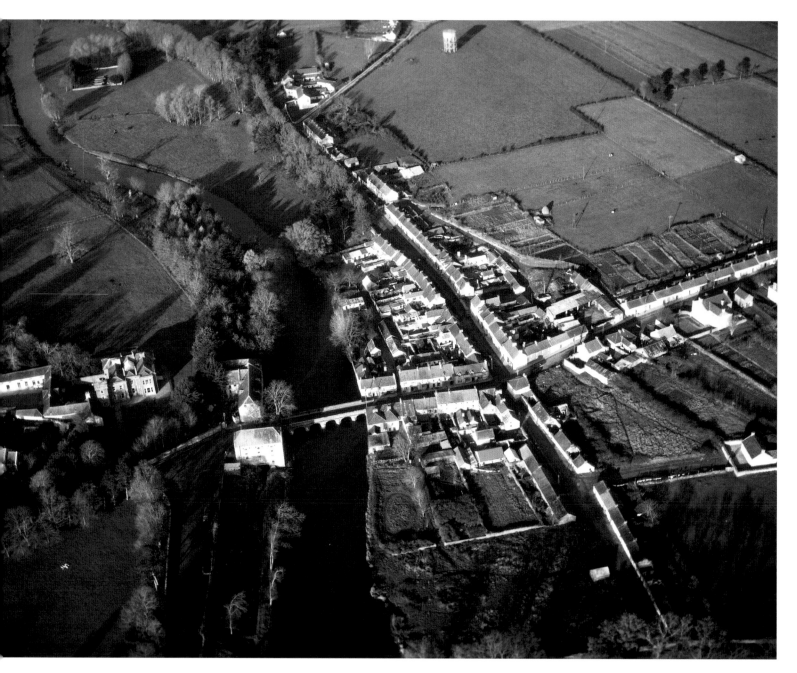

5 July 1957 Croom, a noted fishing centre in County Limerick. The remains of Croom Castle, an old stronghold of the Fitzgeralds, are embodied in the residence still known as Croom Castle, to the left of the picture. **A142**

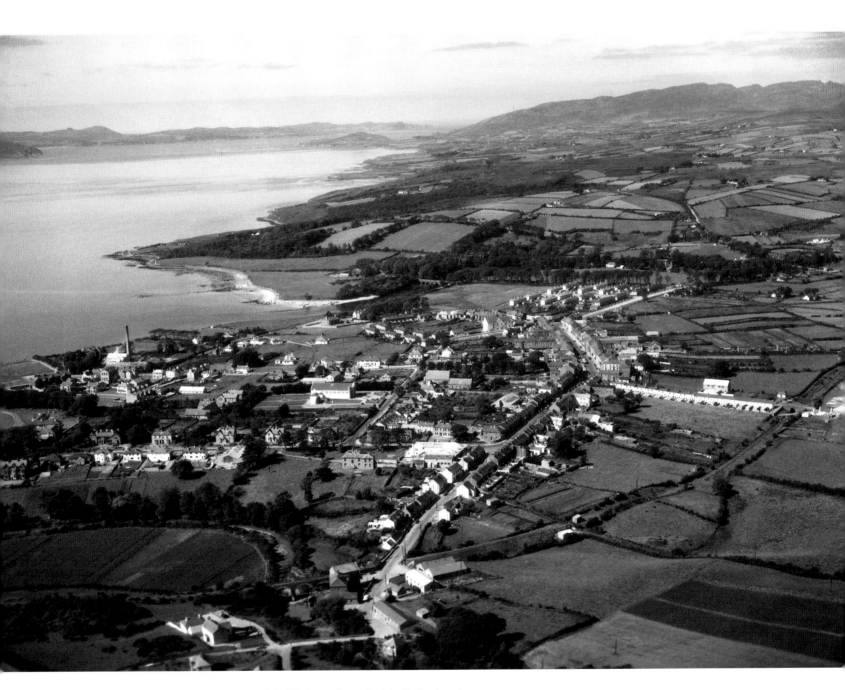

12 July 1957 Buncrana is the historic home of the O'Doherty clan and originally developed around the defensive tower known as O'Doherty's Keep at the mouth of the River Crana. The town moved to its present location just south of the River Crana when George Vaughan built the main street in 1718. The town was a major centre for the textile industry in County Donegal from the nineteenth century. **A72**

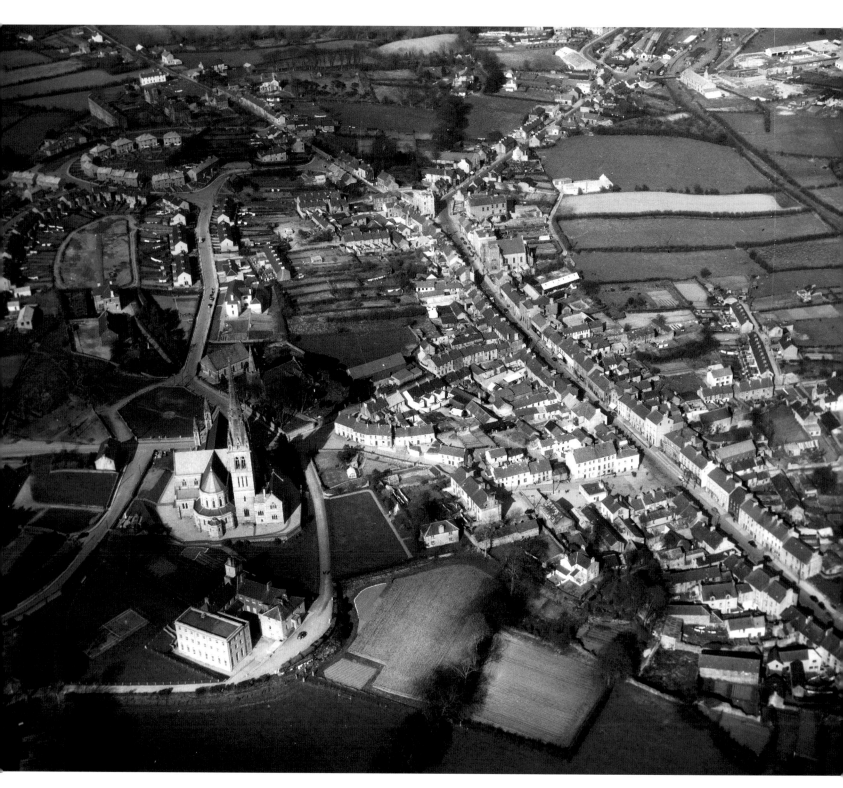

19 July 1957 Letterkenny, County Donegal, with St Eunan's Cathedral for the Diocese of Raphoe. **A259**

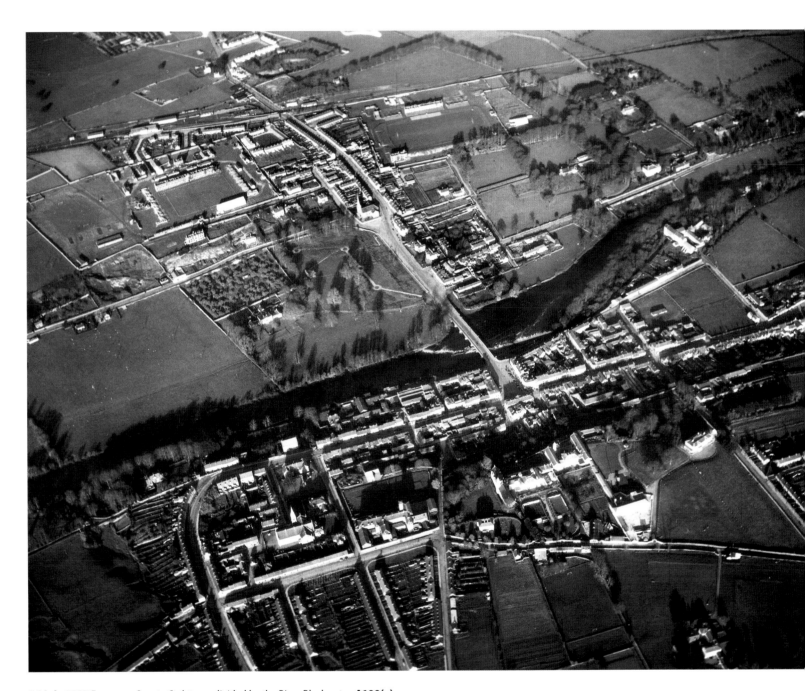

26 July 1957 Fermoy, a County Cork town divided by the River Blackwater. **A199(a)**

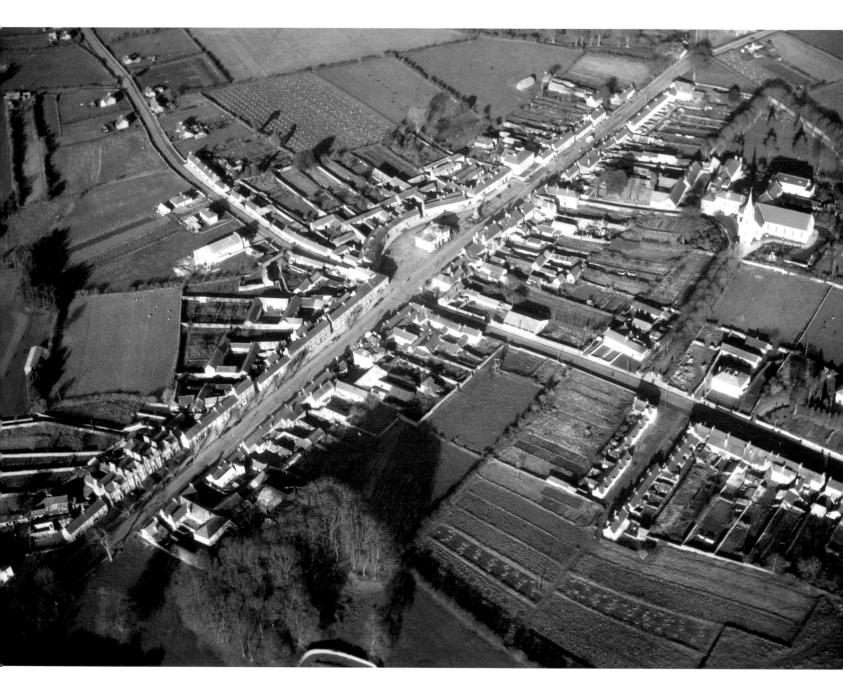

2 August 1957 Abbeyleix in Laoighis derives its name from a Cistercian abbey founded there in 1183. **A4**

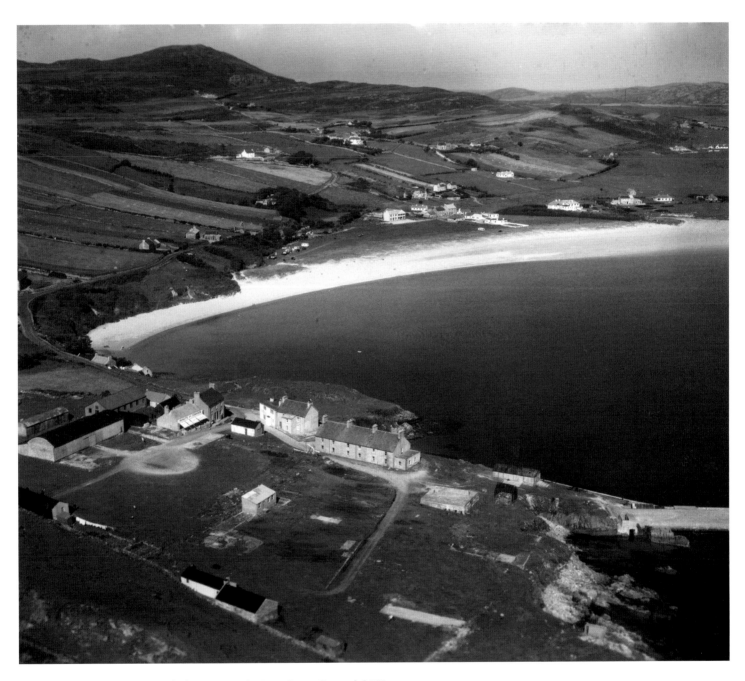

9 August 1957 Downings, a quiet little resort near Carrigart, County Donegal. **A161**

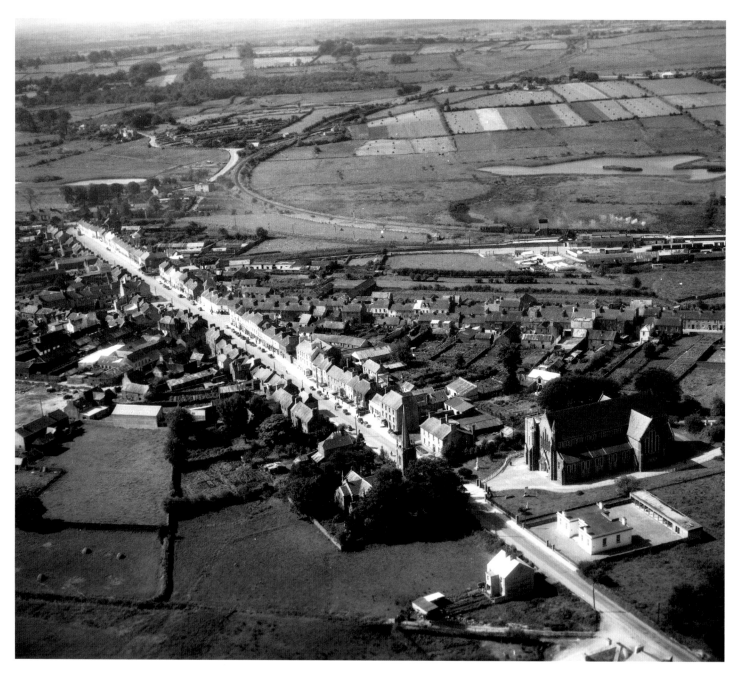

16 August 1957 Claremorris, an important and well-known railway junction on the plains of Mayo. **A111**

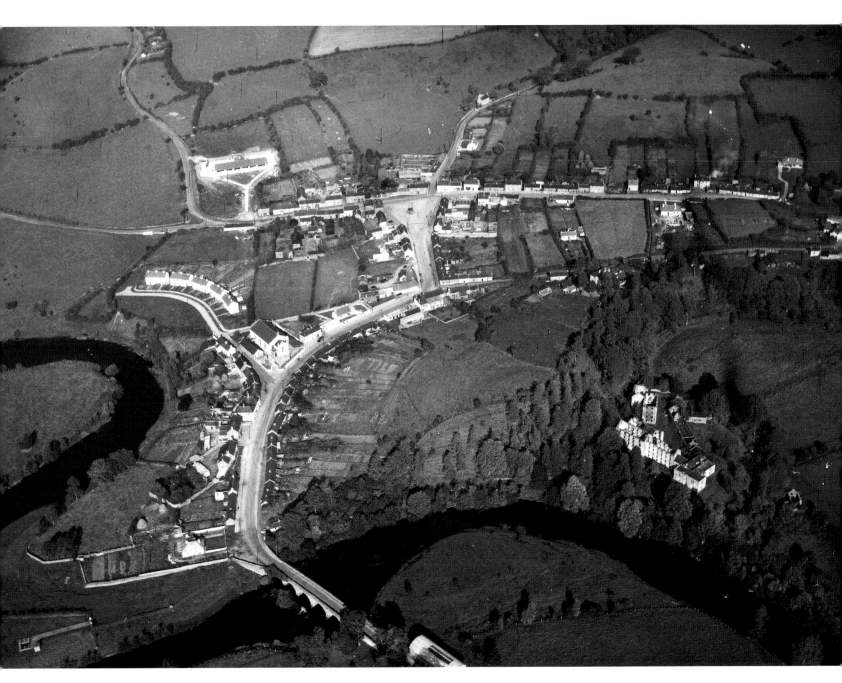

23 August 1957 Ballymore Eustace in County Kildare. **A44**

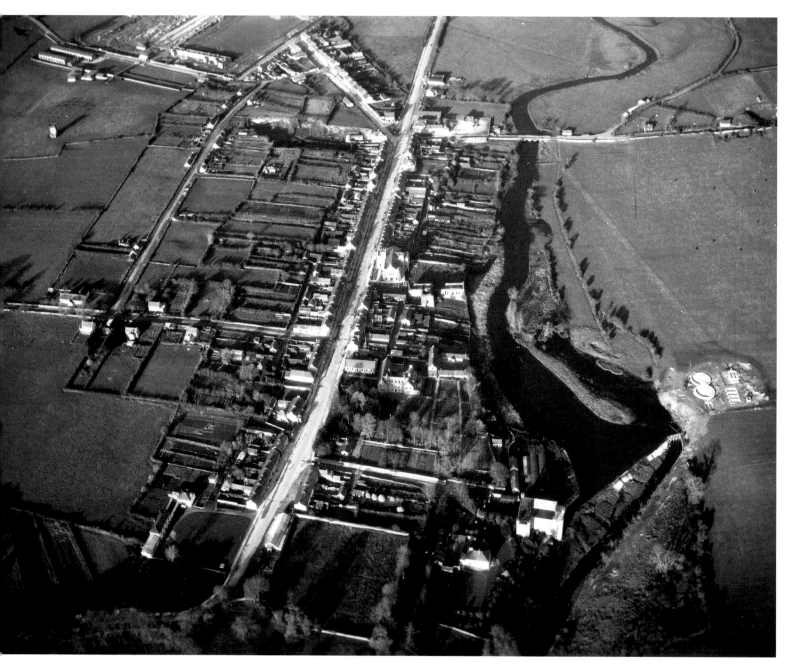

30 August 1957 Buttevant is a medieval market town, incorporated by charter of Edward III, situated in north County Cork, Ireland. The 'steeplechase' in horse racing originated in 1752 as a result of a horse race from the steeple of Buttevant Protestant church to that of Doneraile, four miles away. **A76**

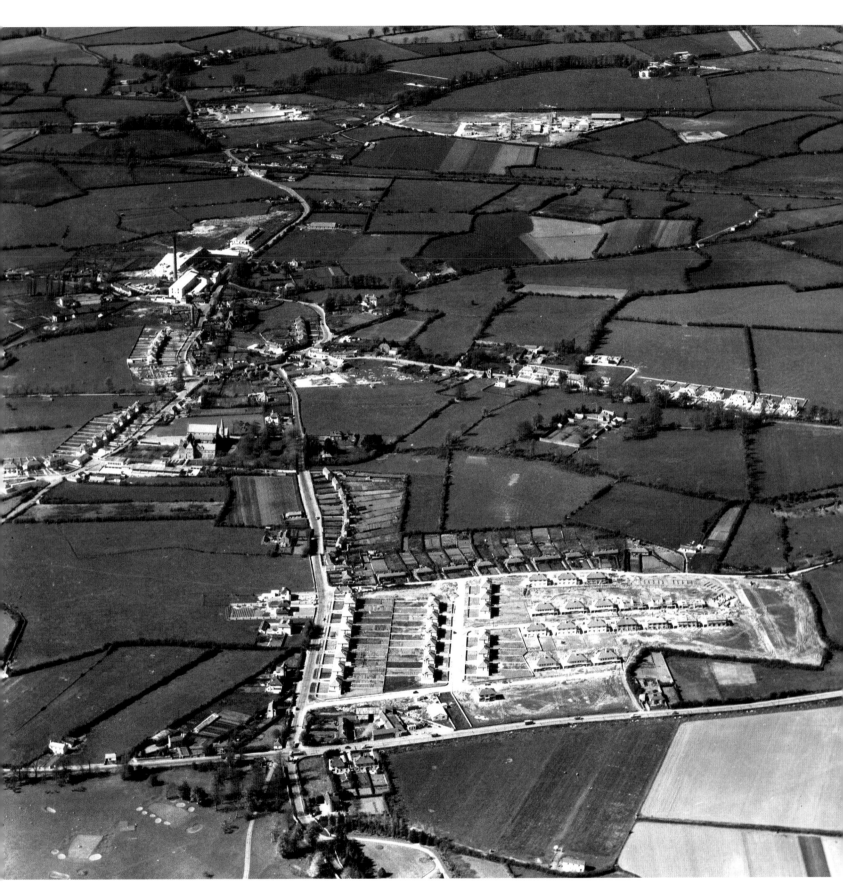

9 October 1957 Clondalkin is a town situated six miles west of Dublin city. It is home to an eighth-century round tower that acts as a focal point for the area. **A118**

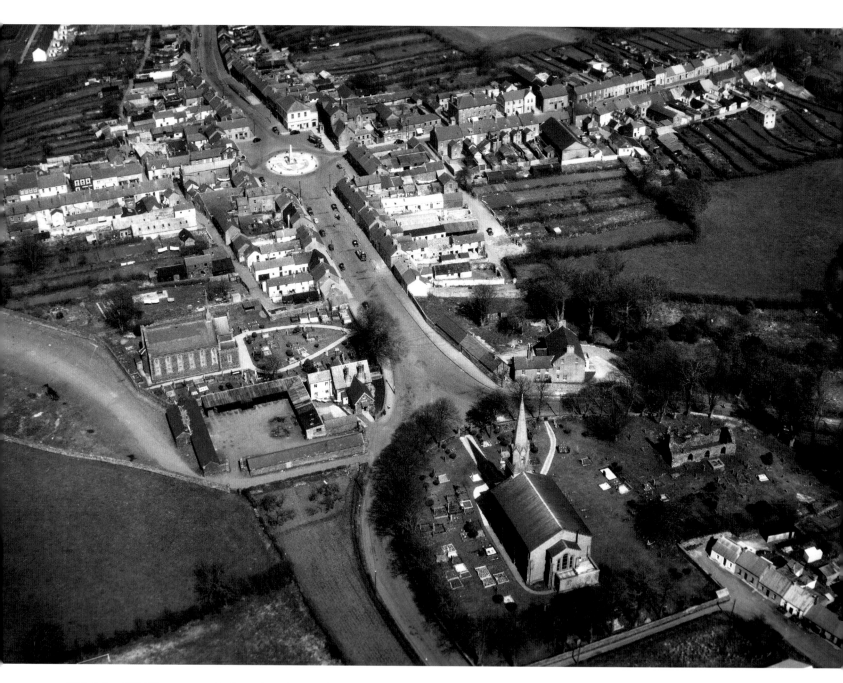

11 October 1957 Kilrea, a centre for the angler in Derry on the River Bann near the Antrim border. **A245**

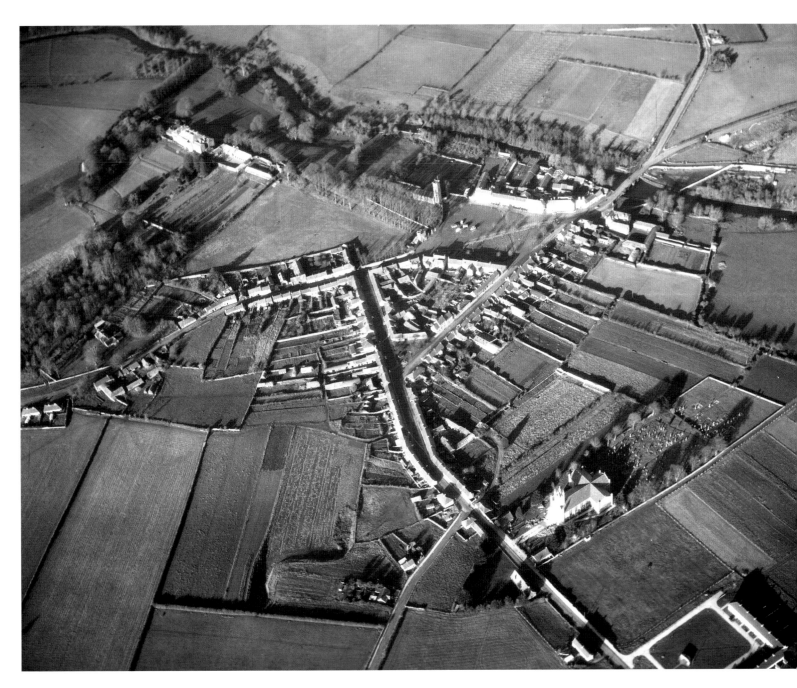

18 October 1957 Durrow, County Laois, with Castle Durrow demesne on the River Erkina. **A189**

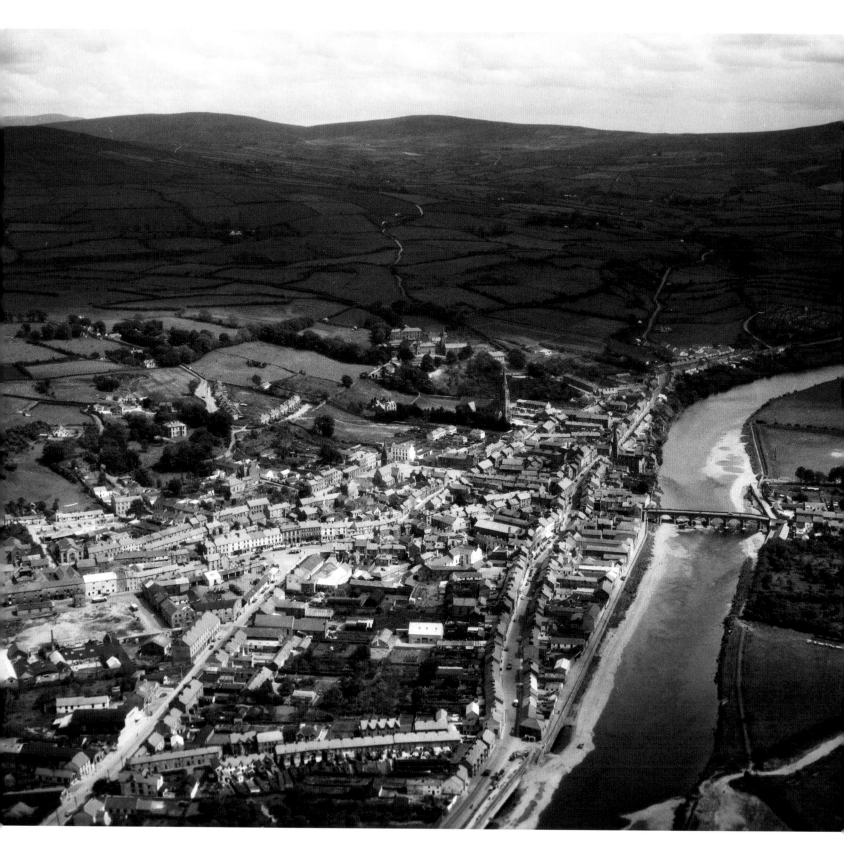

25 October 1957 Strabane on the River Mourne in Tyrone, close to the Donegal border. **A410**

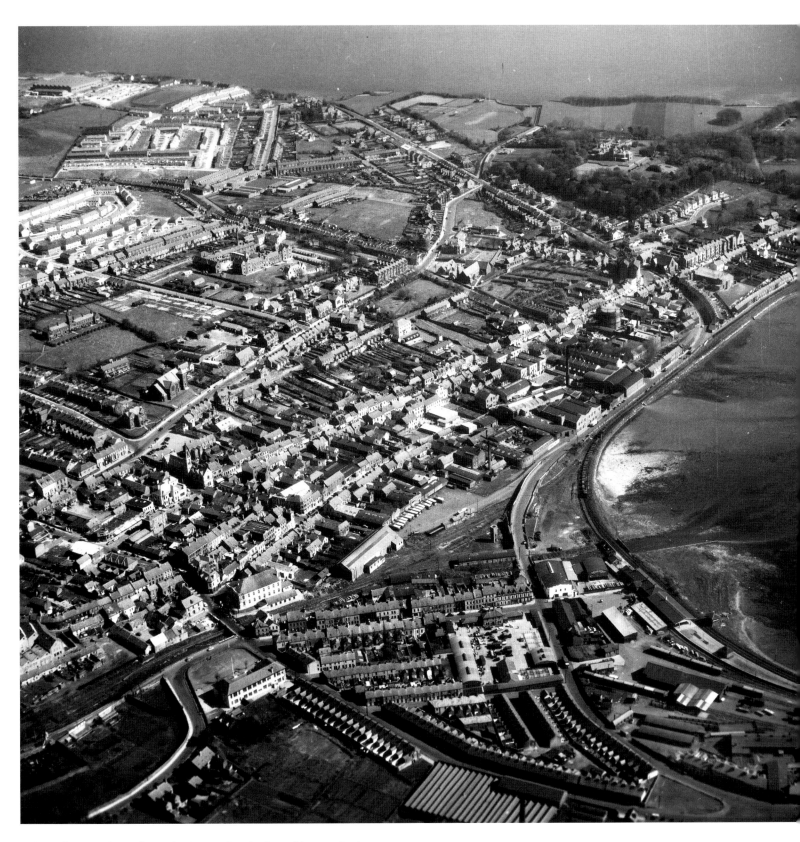

8 November 1957 Larne, County Antrim, terminus for the mail boat on the shortest cross-channel passage (to Stranraer). **A253**

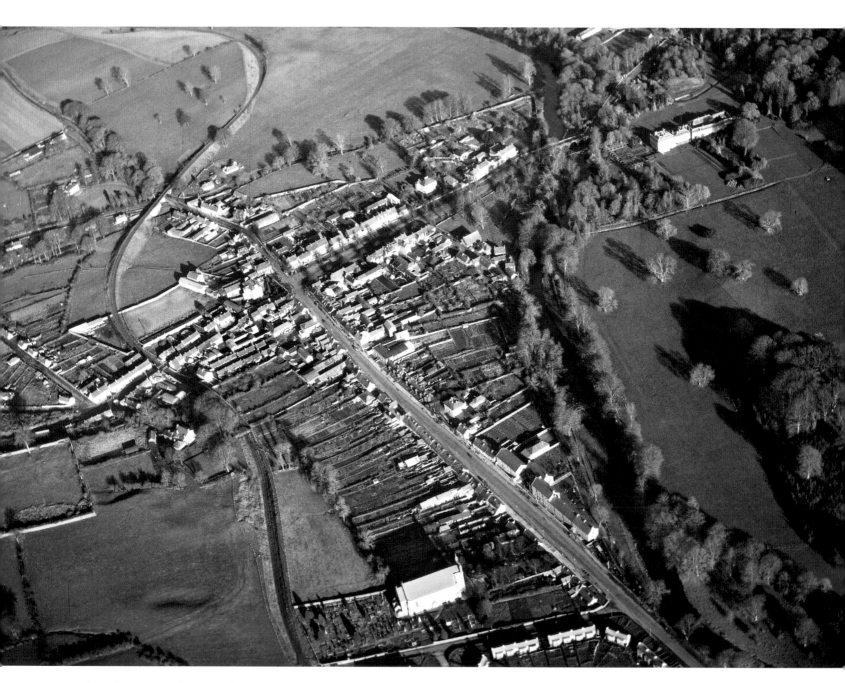

15 November 1957 Castlecomer in the wooded valley of the Dinin, in the coal-mining area of Kilkenny. **A93**

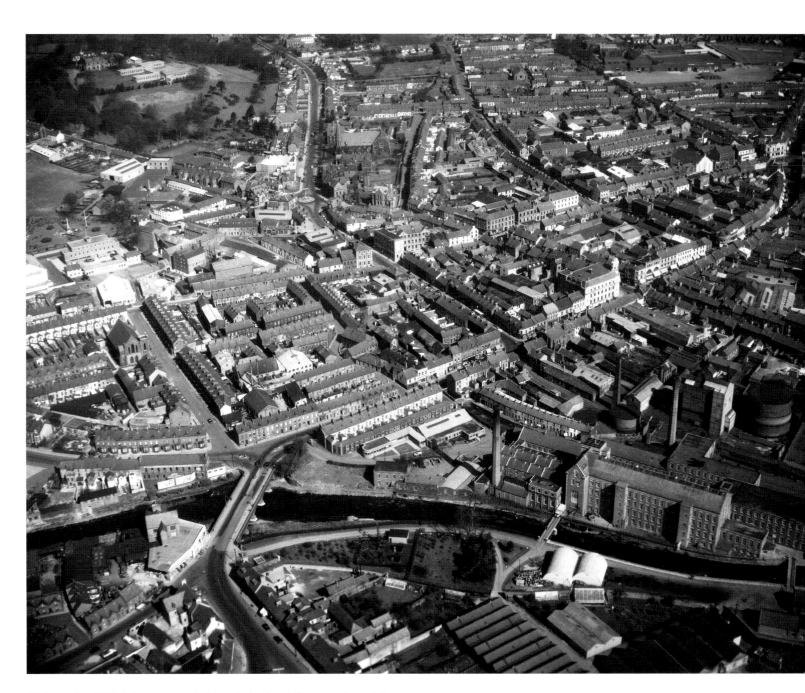

22 November 1957 Ballymena, a central town in Antrim, at the converging point of many of the northern highways. **A42**

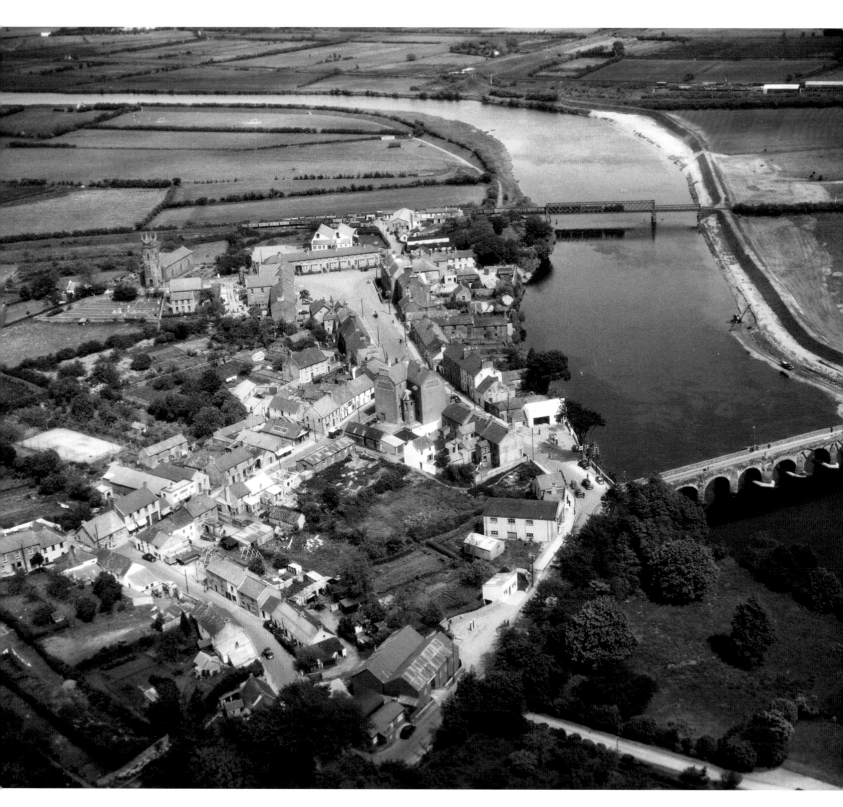

29 November 1957 Lifford, the administrative centre of County Donegal, with Tyrone on the other side of the river. **A260**

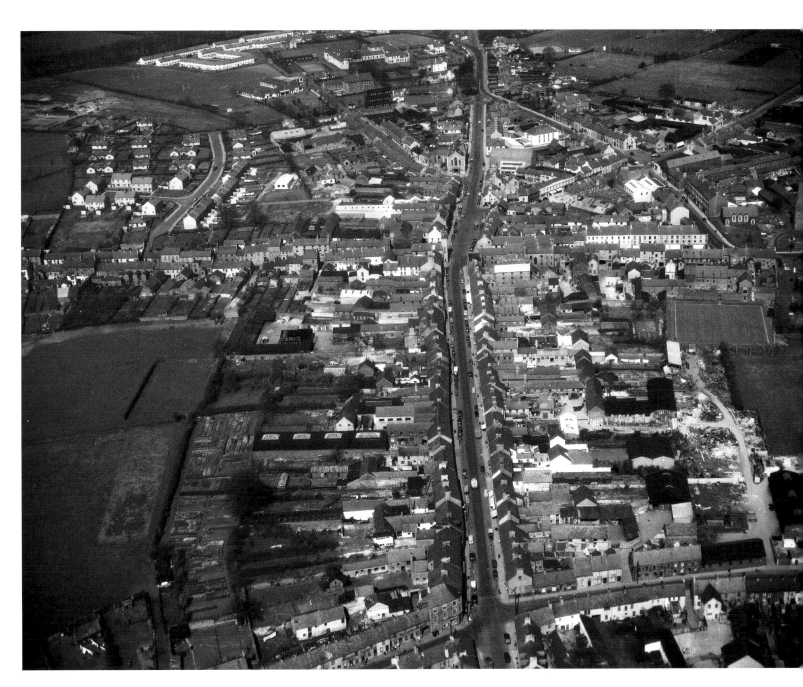

13 December 1957 Ballymoney, a County Antrim market town, in the linen-industry area near the Derry border. **A43**

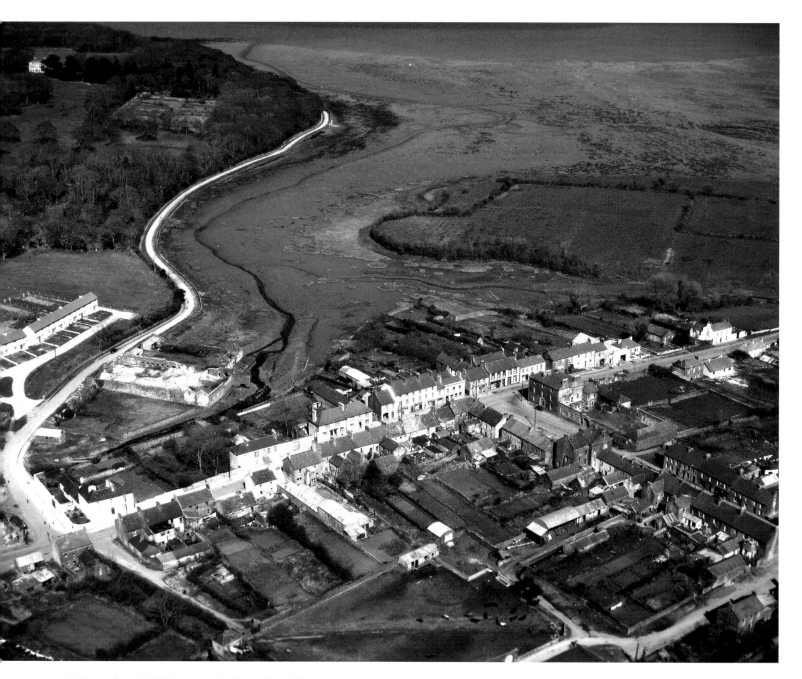

27 December 1957 Tarbert, near the Kerry–Limerick border at the mouth of the Shannon. **A416**

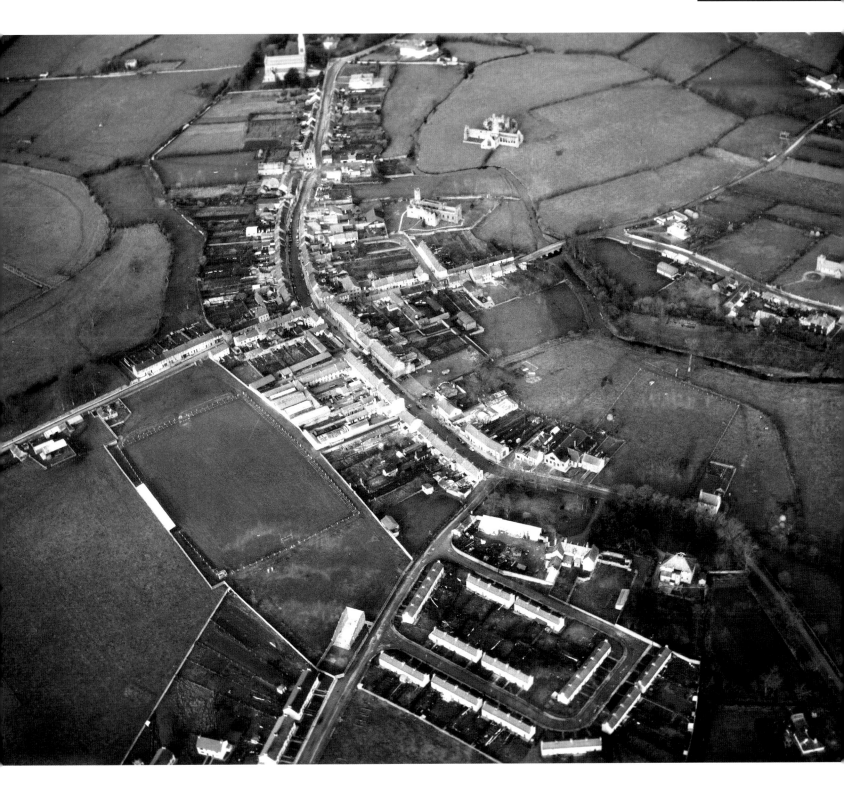

10 January 1958 Kilmallock, County Limerick, rich in ancient monuments attesting to its activity in Munster history. **A244**

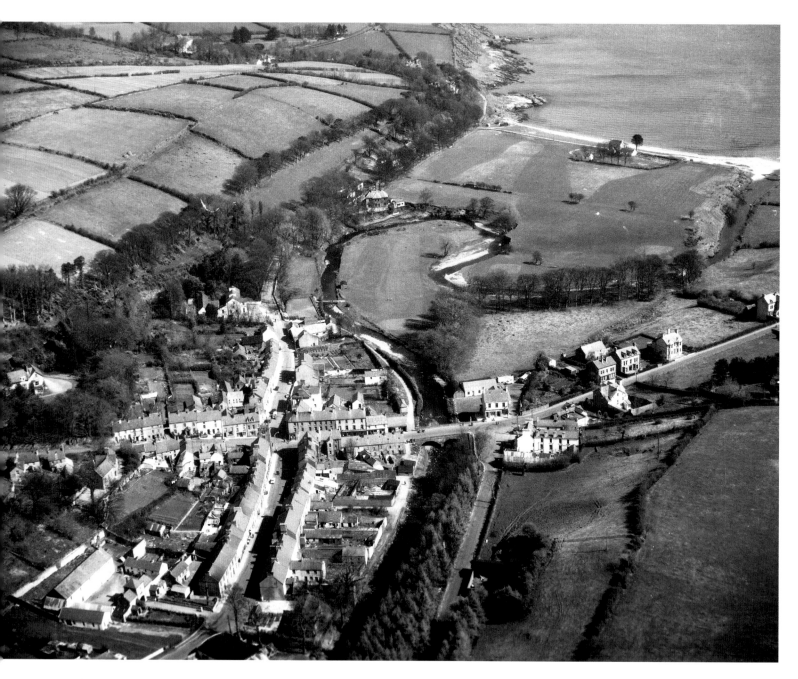

24 January 1958 Cushendall, at the foot of the Dall River on Antrim's Red Bay. **A145**

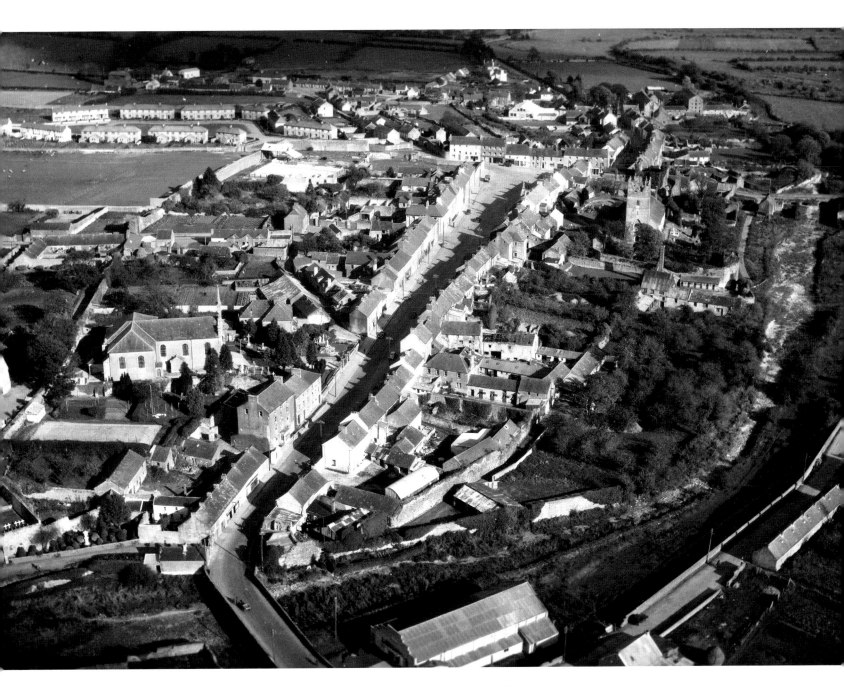

21 February 1958 Fethard, a little Tipperary town that has great associations with medieval times. **A202**

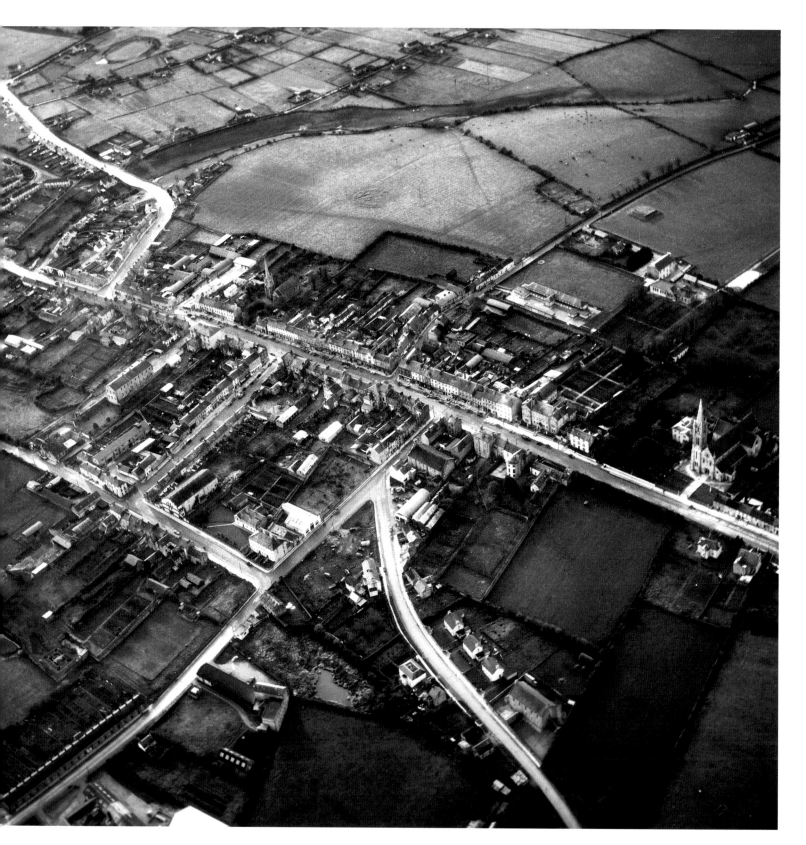

28 February 1958 Rathluirc (Charleville), County Cork, a well-known town on the Mallow–Limerick road. **A346**

21 March 1958 Ballylongford, on the Kerry side of the Shannon Estuary. **A41**

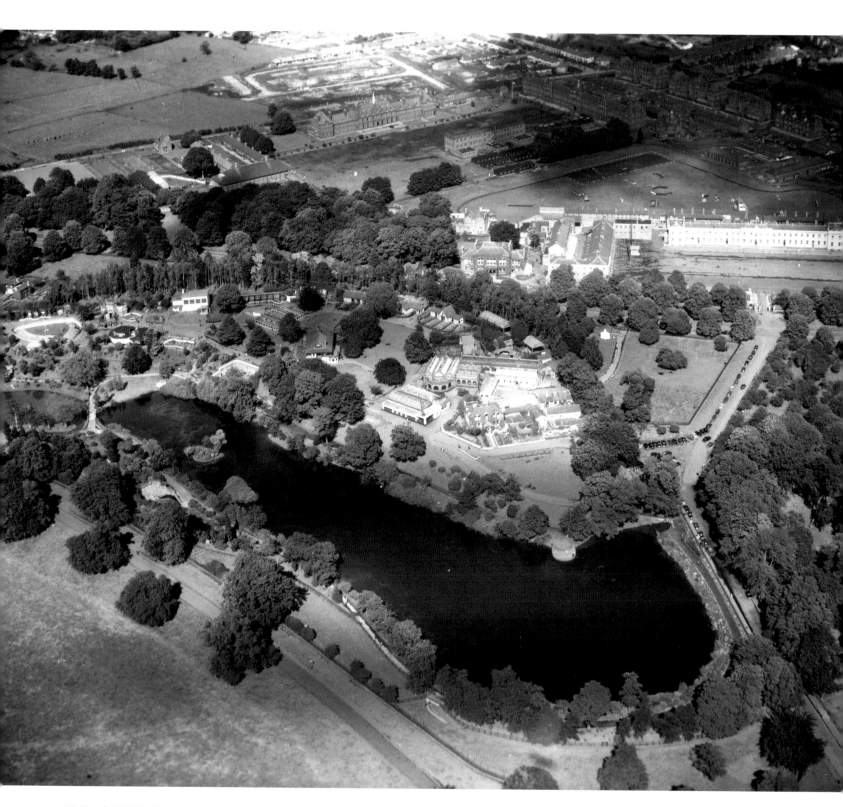

28 March 1958 Dublin Zoological Gardens, Phoenix Park, where Gilbert the Hippopotamus is due to make his new home today. The white building to the right is the Garda Depot. **A452**

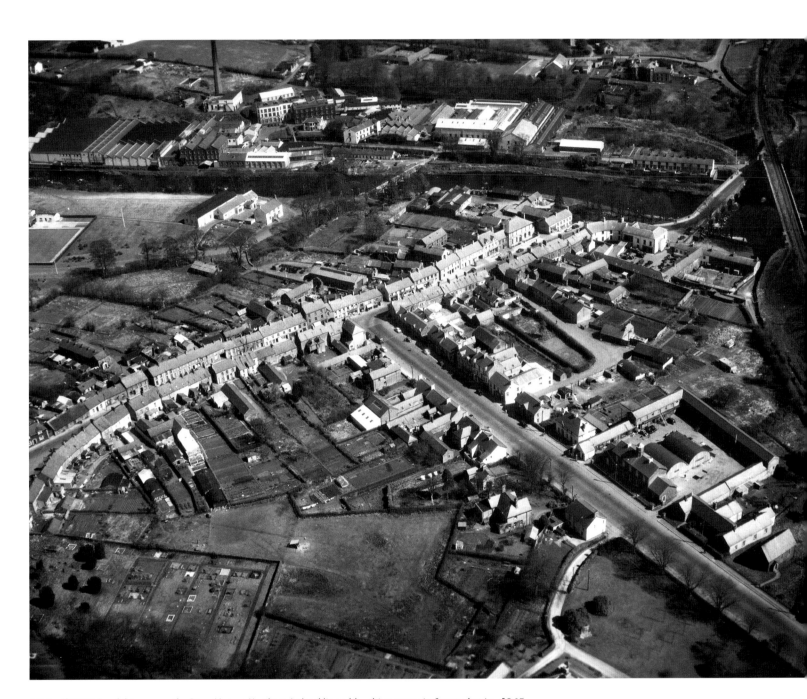

11 April 1958 Randalstown, on the River Main, a Northern Ireland linen-bleaching centre in County Antrim. **A345**

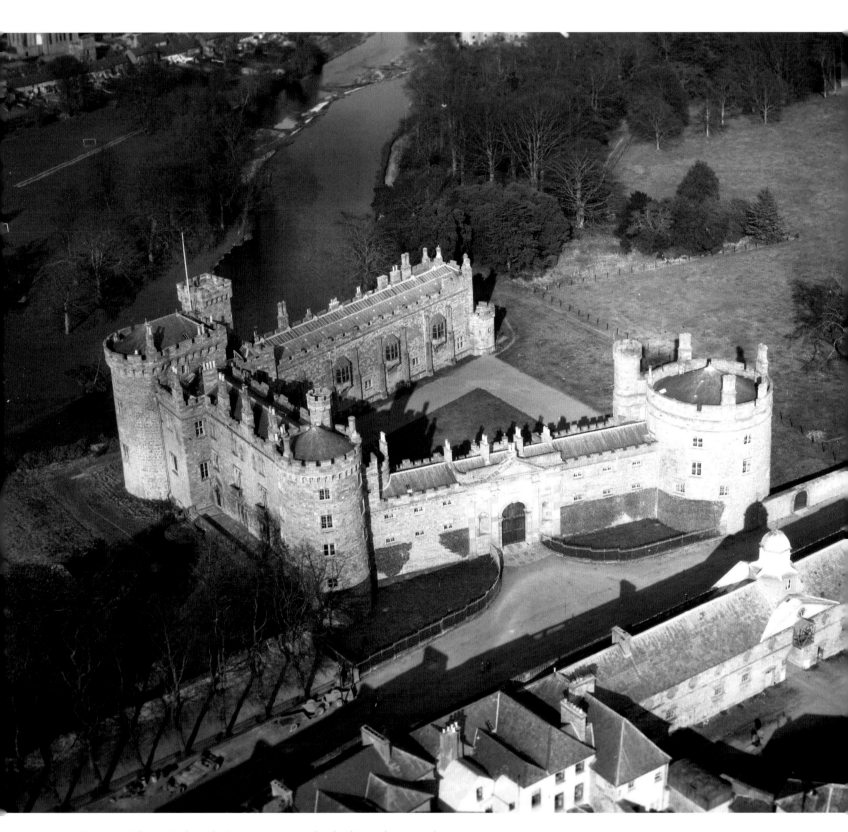

2 May 1958 Kilkenny Castle on the River Nore originated in the thirteenth century; the towers still show some of their original stonework. **A340**

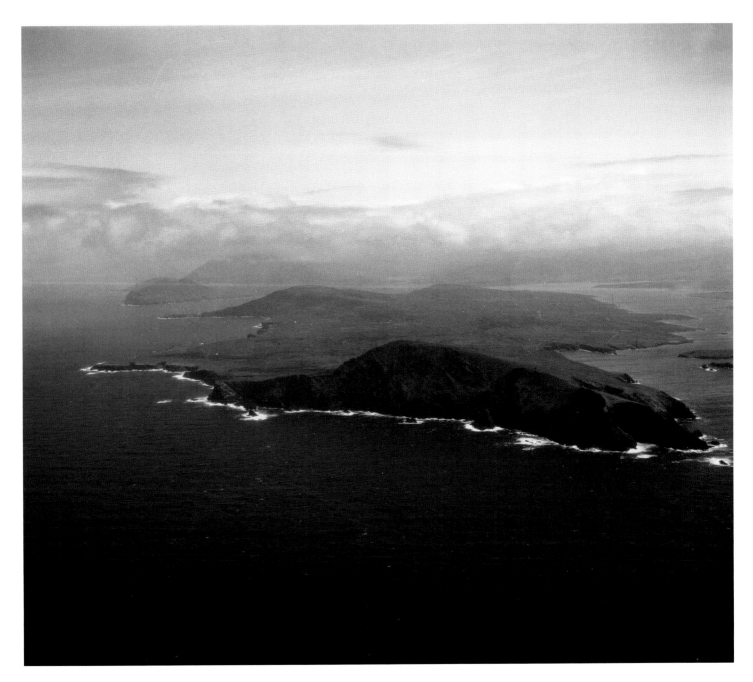

16 May 1958 Valentia Island, County Kerry, seen from the sea, where the transatlantic cable connects with Trinity Bay, Newfoundland, and has been carrying messages now for over 100 years. **A434**

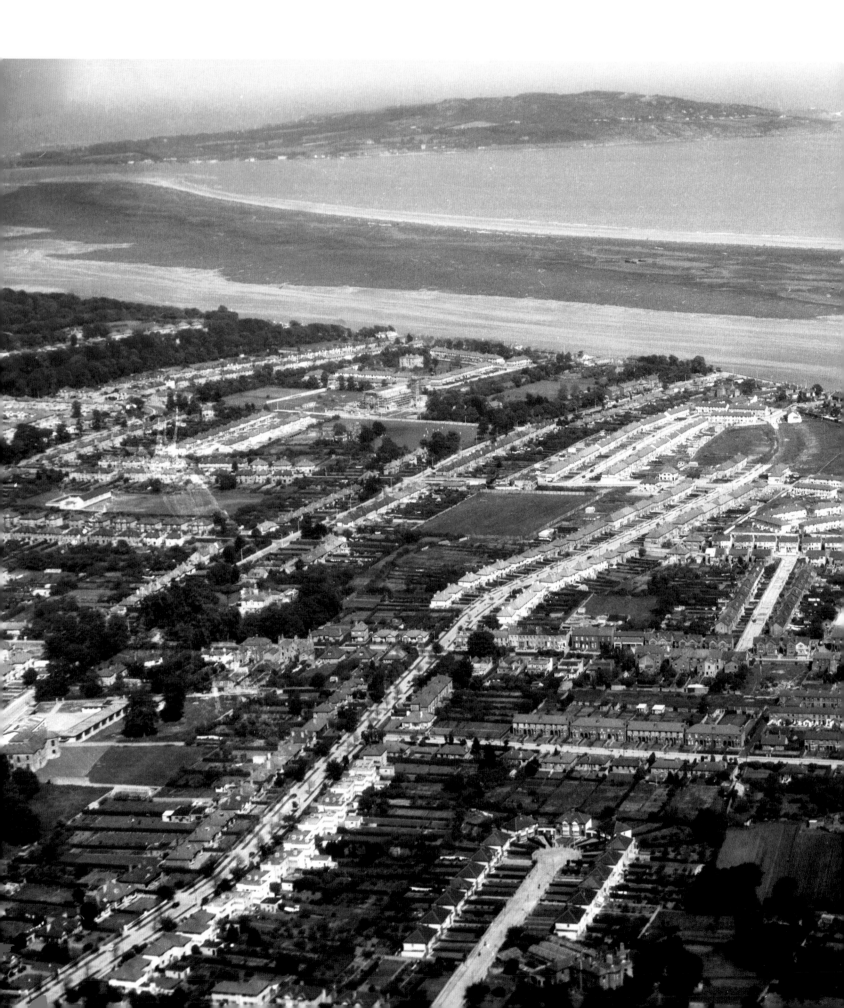

9 May 1958 Clontarf, Dublin, with the recently reclaimed boulevard along the seafront extending to the Bull Wall and Dollymount. Royal Dublin Golf Links and Howth Head are towards the top of the picture. **A151**

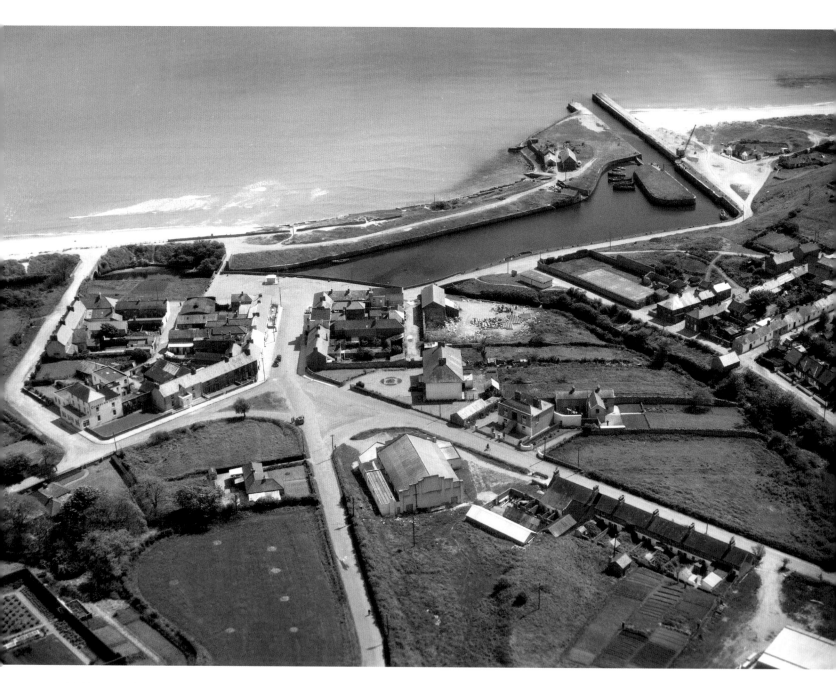

30 May 1958 Courtown Harbour, one of Wexford's most popular seaside resorts and angling centres. **A138**

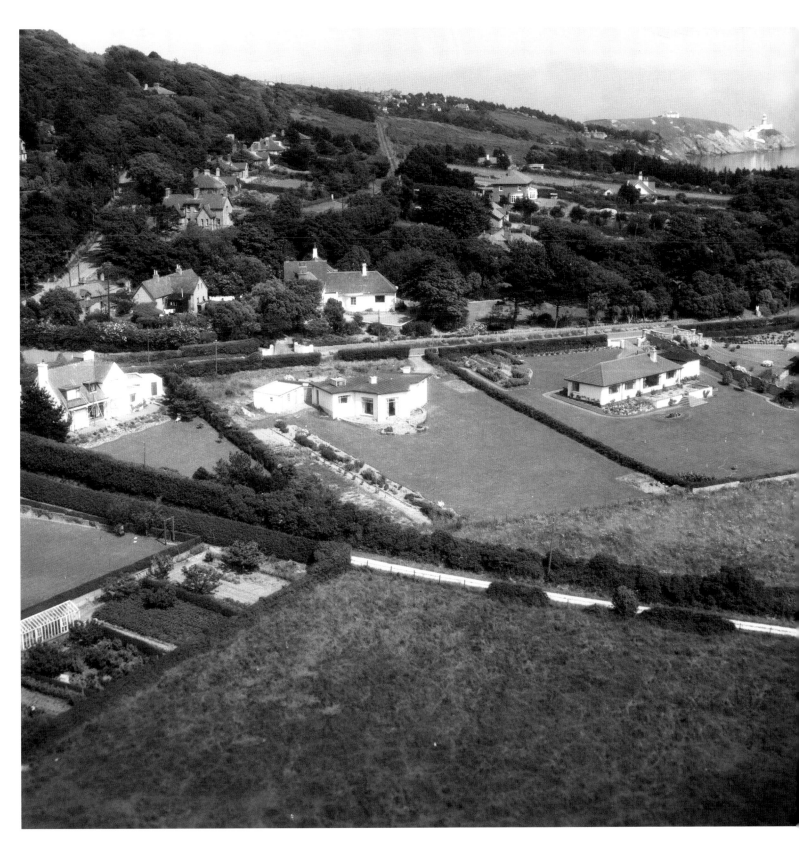

6 June 1958 Howth Head: the southern slopes of the favourite Dublin Bay promontory, with the Baily Lighthouse at the top right. **A222**

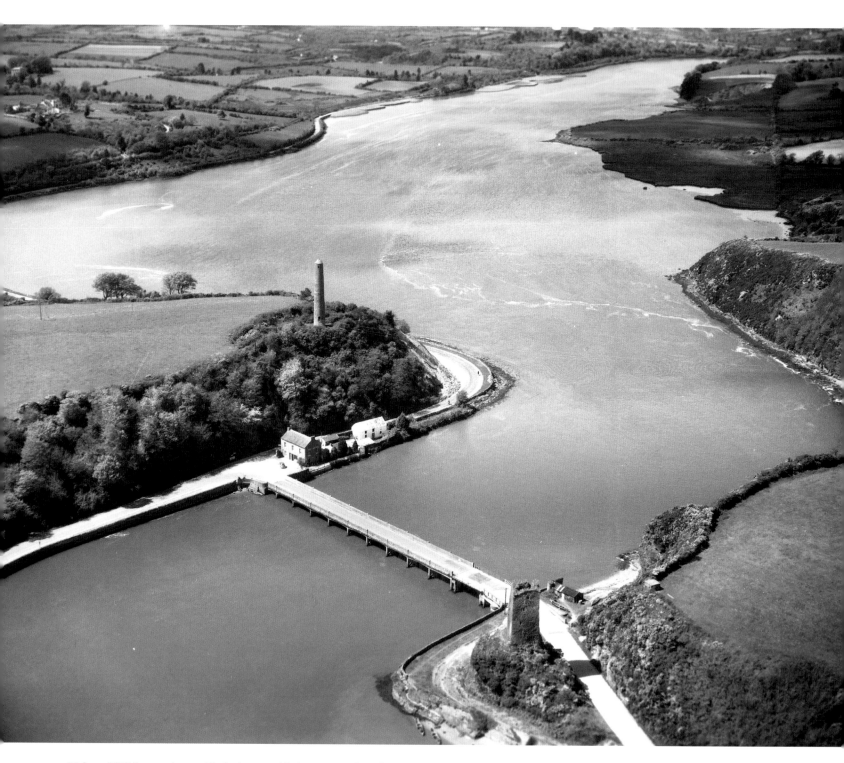

13 June 1958 Ferrycarrig, near Wexford town, with the sweeping River Slaney and a round tower memorial to the Crimean War Dead. **A201**

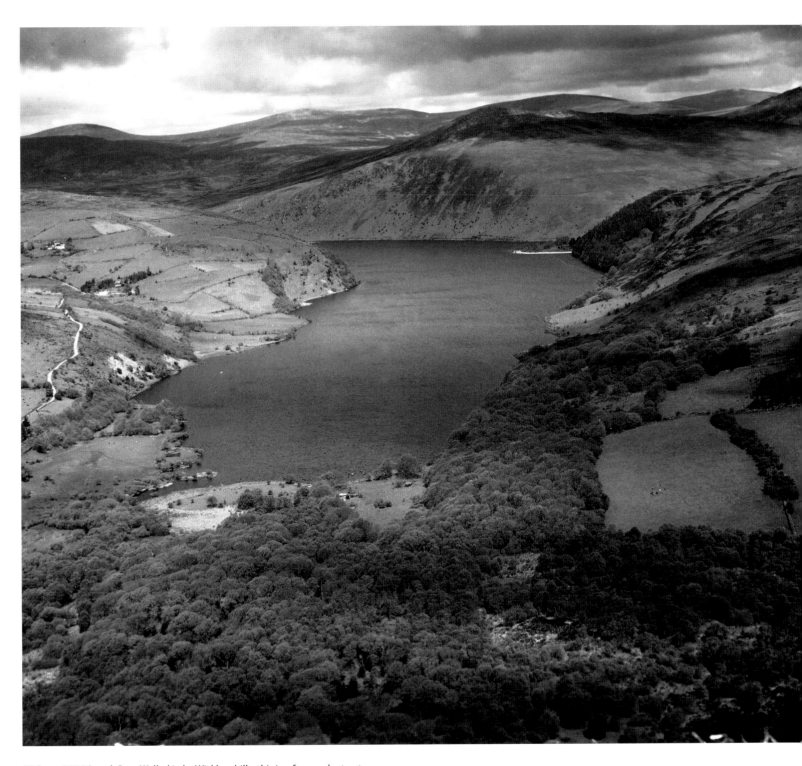

20 June 1958 Lough Dan. Walled in by Wicklow hills, this is a favoured retreat for a picnic or angling within thirty miles of Dublin city. **A275**

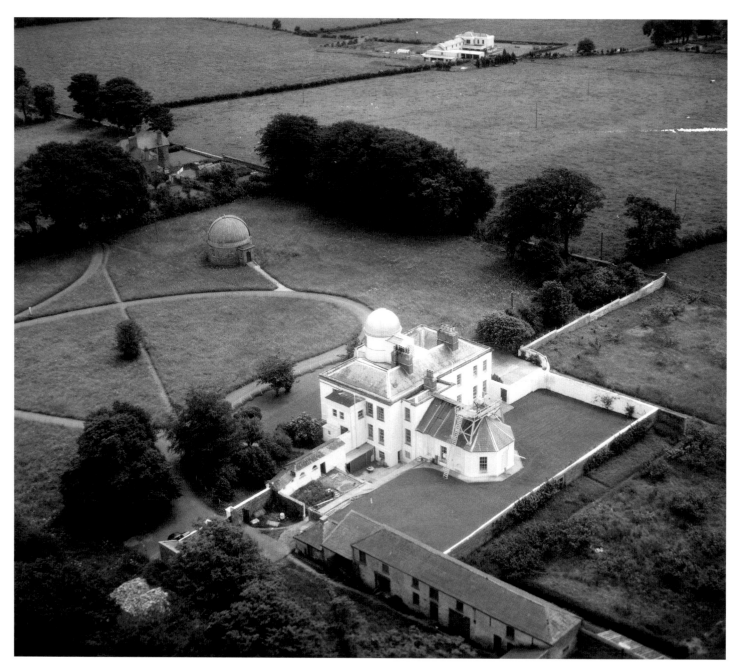

14 November 1958 Looking down at Dunsink Observatory, which is constantly looking up from Castleknock, County Dublin, with intensified interest in recent times, since the development of artificial bodies in the heavens. **A188**

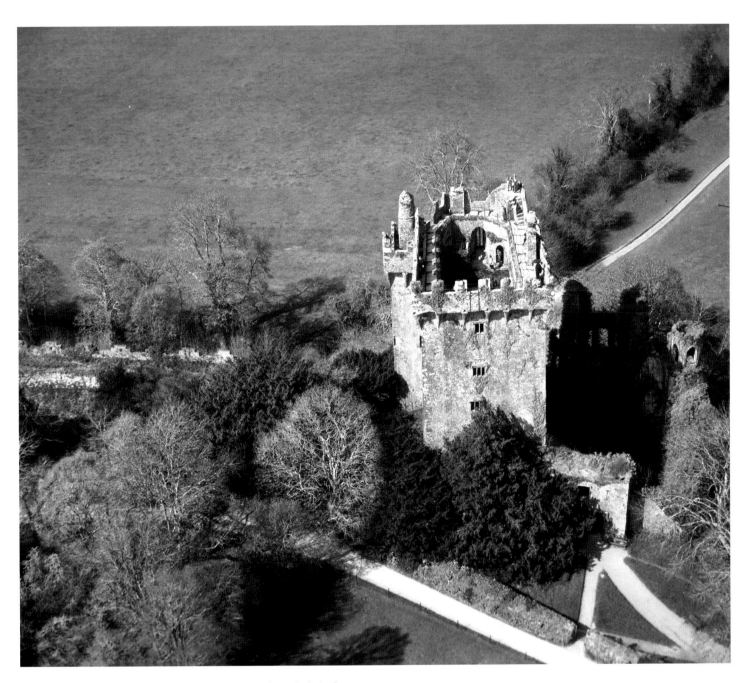

21 November 1958 Blarney, the old castle in County Cork in which the famous
Blarney Stone is located beneath the parapet that faces the camera. **A65**

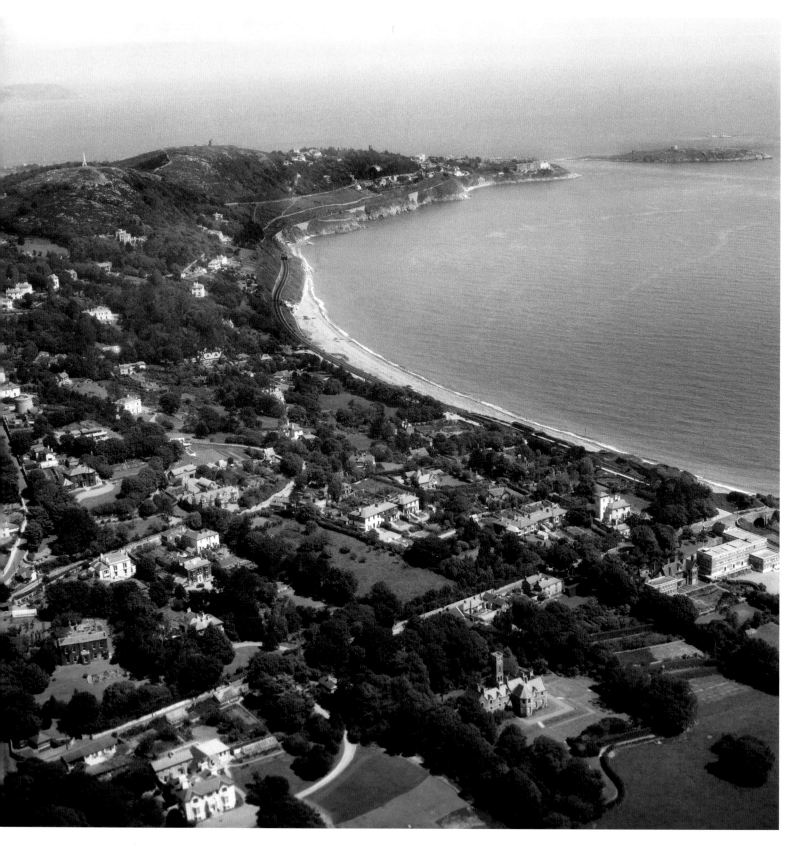

28 November 1958 The slope of Killiney Hill, south of Dublin, with its many
pleasant homes and Dalkey Island off the coast. **A241**

5 December 1958 Ballina, County Mayo. The shallow sweep of the River Moy through Ballina, a river renowned for its salmon and trout. **A33**

1959

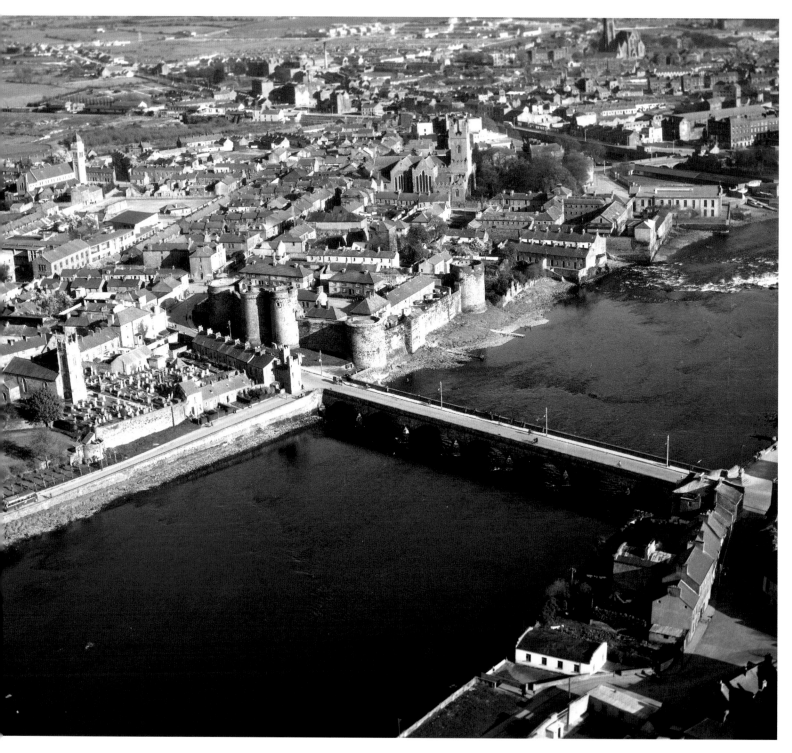

2 January 1959 Thomond Bridge, Limerick city, with King John's Castle on the far side of the Shannon and the Treaty Stone at the near end of the bridge. **A420**

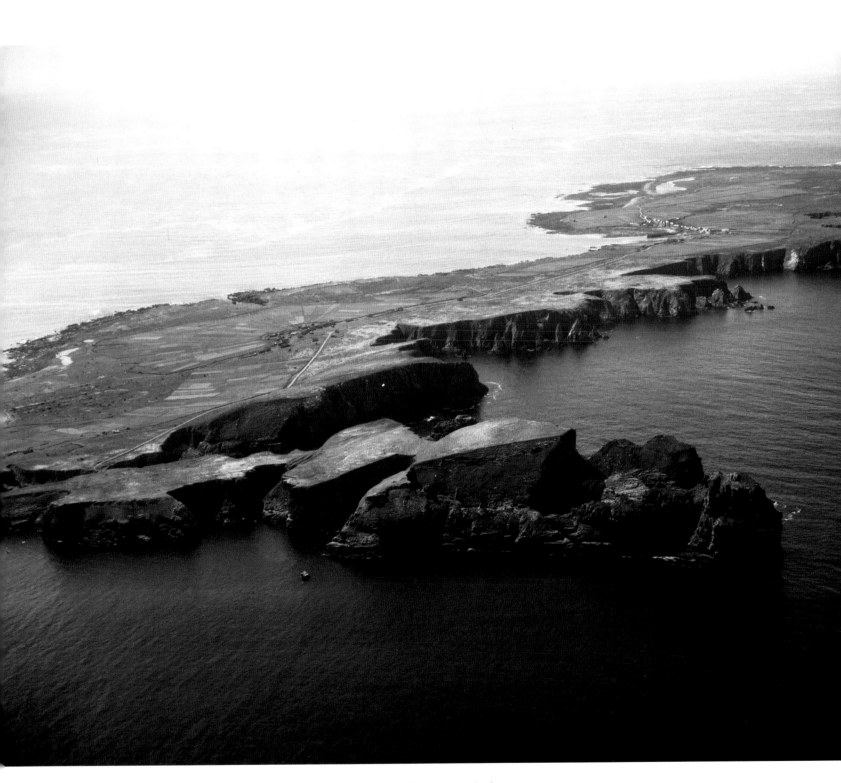

30 January 1959 Tory Island, nine miles off the Donegal coast, is often cut off from the mainland by the storm-lashed ocean. There are 200 inhabitants. **A424**

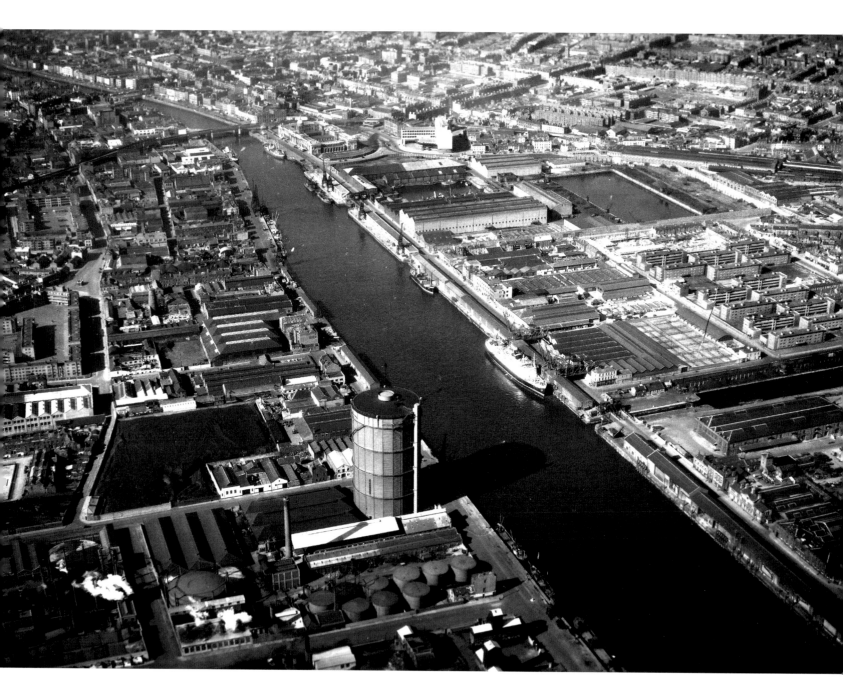

6 February 1959 Dublin and its quayside near the mouth of the Liffey. Gasworks and tanks are in the foreground with the North Wall berths and sheds on the far side of the river. **A172**

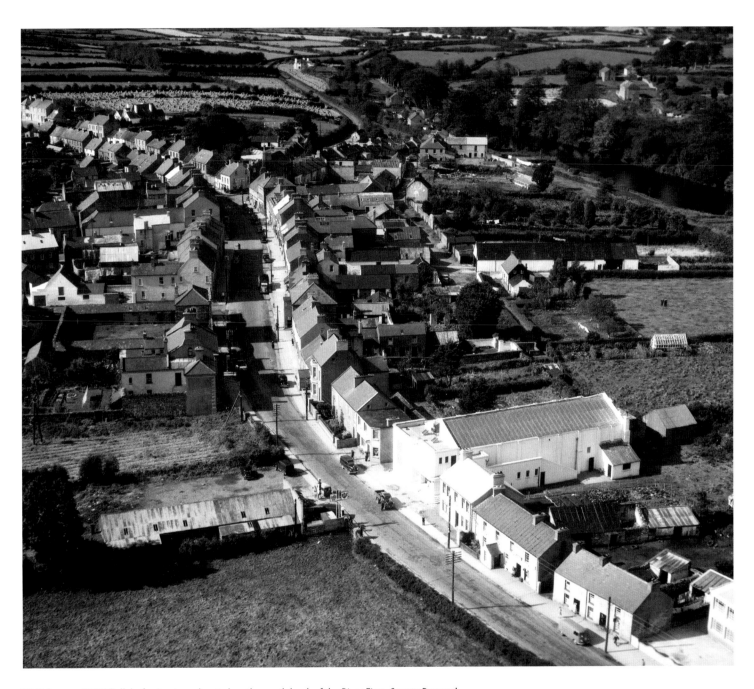

14 February 1959 Ballybofey is a town located on the south bank of the River Finn, County Donegal, Ireland. Along with the smaller town of Stranorlar on the north side of the River Finn, Ballybofey makes up the Twin Towns. **A36**

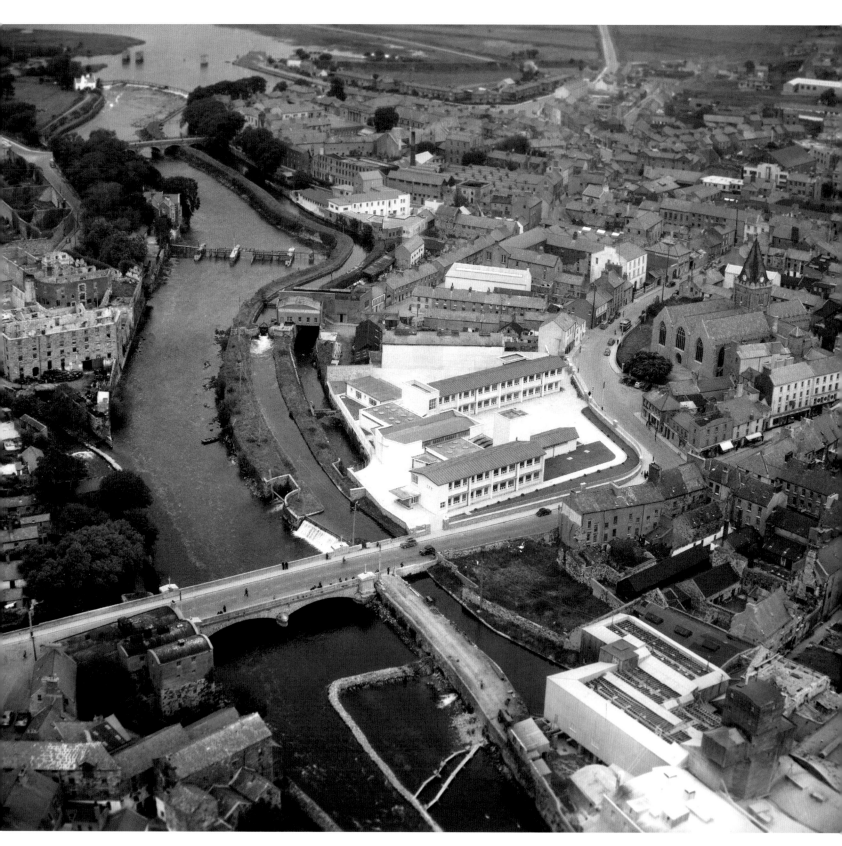

13 March 1959 Galway. The River Corrib flowing under Bridge Street, with the ancient fourteenth-century Church of St Nicholas (clock tower at the right of picture) contrasting with the new Patrician Brothers' Boys' school (in centre). **A210**

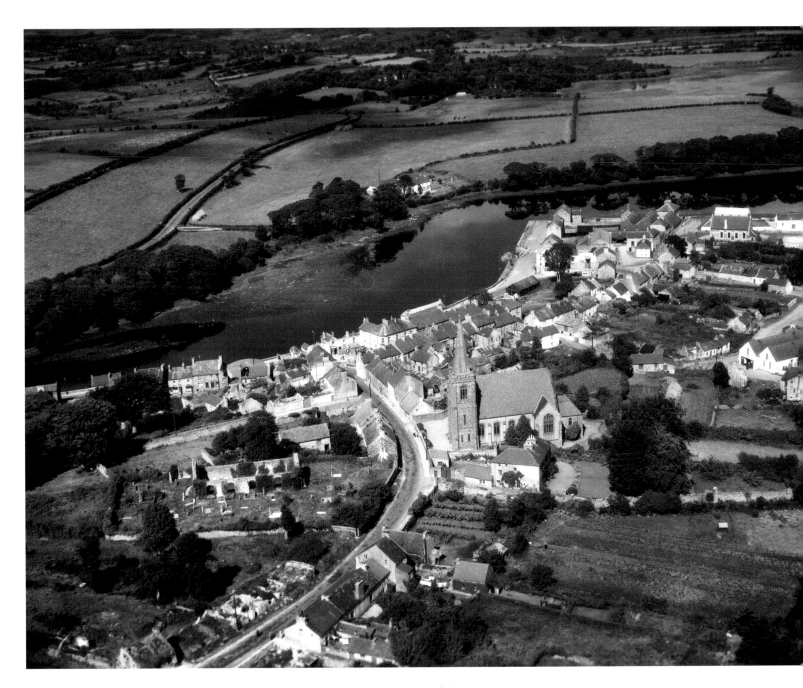

20 March 1959 Ramelton, in the Lennan Valley, on Lough Swilly – a pleasant village in Donegal. **A344**

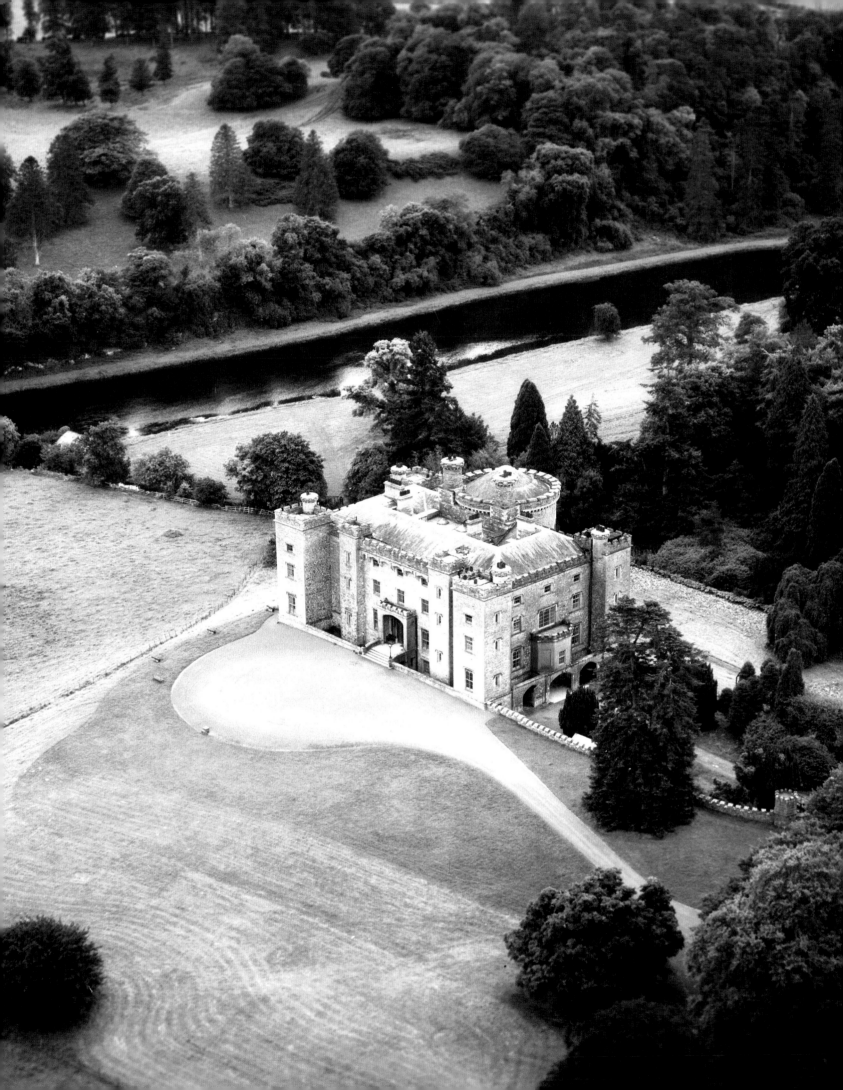

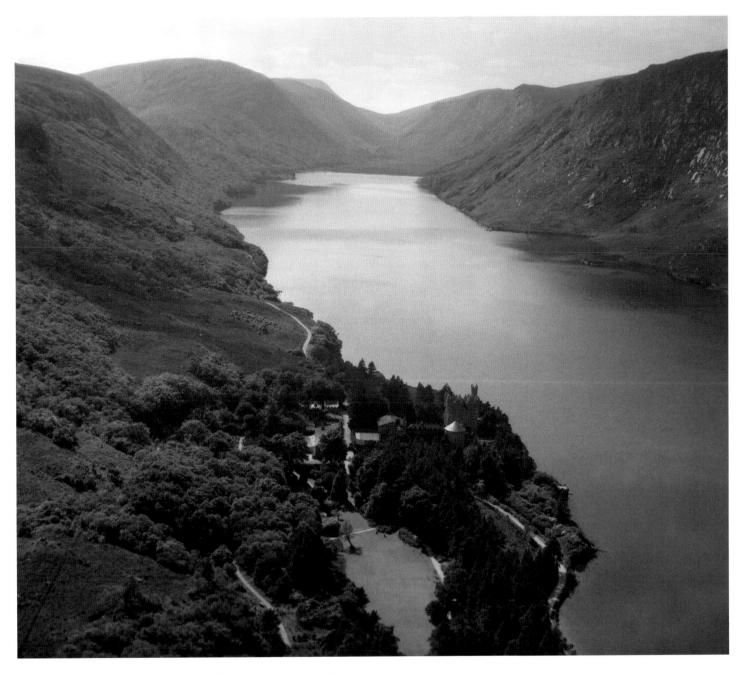

1 May 1959 Lough Veagh, in the Glendowan Mountains in Donegal, with the waterside castle giving the view a Rhineland quality. **A278**

24 April 1959 Slane Castle, County Meath, in the richly wooded demesne on the banks of the Boyne, which is seen flowing by beyond the castle. **A404**

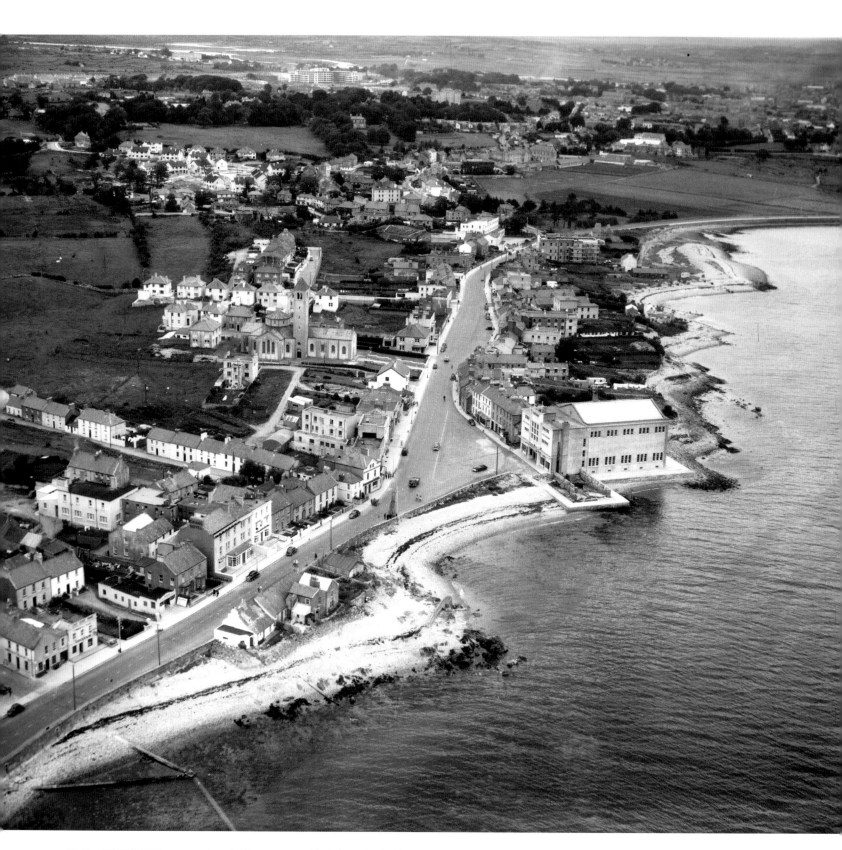

15 May 1959 Salthill, renowned as a holiday resort outside Galway city. **A393**

22 May 1959 Doe Castle, the sixteenth-century fortress of the Mac Suibhne clan, stands on a strip of land running into the sea near Creeslough, County Donegal. **A150**

MICHAEL HINCH worked for Independent Newspapers for over forty-six years and retired in 2015. He was responsible for setting up the first digital library and is currently Archive Adviser to the company. He lives in Dublin.

FIRST PUBLISHED IN 2016 BY
The Collins Press
West Link Park
Doughcloyne
Wilton
Cork
T12 N5EF
Ireland

A CIP record for this book is available from the British Library.

Hardback ISBN: 978-1-84889-291-0

Design and typesetting by Fairways Design
Typeset in Myriad Pro and Minion Pro
Printed in Malta by Gutenberg Press Limited

Photographs
Endpapers: **12 October 1951** Armagh: St Patrick's Cathedral of the Archbishop of Armagh and Primate of All-Ireland stands on its eminence at the top of this aerial view of the primatial city in Northern Ireland. In the left centre is the old Cathedral of St Patrick, on its rath site. **A20**
Page 1: The hydroelectric power station at Ardnacrusha in County Clare is Ireland's largest river hydroelectric scheme and is operated on a purpose-built headrace connected to the River Shannon. **A15**
Pages 2–3: **19 January 1955** A view over the Blesssington Lakes during the winter snows of 1955. **A66(1)**